CHRIS GOLLON

Humanity In Art

Tamsin Pickeral

H̶H̶

HYDE AND HUGHES PUBLISHING

Cover:
If That's All There Is Let's Break Out the Booze
Acrylic on canvas
74 x 61 cm (29 x 24 in.)
2006
Private collection

Back Cover:
Still Life With Guitar & Fruit
Acrylic on canvas
30 x 79 cm (31 x 11.75 in.)
2009
Private collection

Page 1:
The Dancing Philosopher I
Monotype
71 x 56 cm (22 x 28 in.)
2010

Page 2:
Study For Eve
Acrylic on canvas
51 x 40.5 cm (20 x 16 in.)
2008
Private collection

First Published 2010 by Hyde and Hughes Publishing
15 Burdens, Headcorn, Kent, TN27 9SG
www.hydeandhughespublishing.com

Text copyright © 2010 Tamsin Pickeral
Images copyright © 2010 Chris Gollon
Design and layout copyright © 2010 Hyde and Hughes Publishing

Editing: Lucinda Hawksley (www.lucindahawksley.com)
Proof reading: Peter & Lucy Noble
Design: Mikkel Lundsager Hansen (www.studiolundsager.com)
Photography: Guy Lockwood (www.guylockwood.com)
Printing: PrintHouse Corporation, London (www.printhouse.co.uk).

A CIP catalogue record for this book is available from the British Library

ISBN-13: 978-0956385109
ISBN-10: 0956385109

Mixed Sources
Product group from well-managed
forests, controlled sources and
recycled wood or fibre
www.fsc.org Cert no. TT-COC-002715
© 1996 Forest Stewardship Council
FSC

CONTENTS

ACKNOWLEDGEMENTS

*My very grateful thanks to the following people who made this book possible,
and sincere apologies if I have forgotten anyone:*

Chris Gollon and David Tregunna for their time, patience, help, humour and wine
Chris Adams for everything
Guy Lockwood for his time, his help and fantastic photography
Mikkel for his hard work and dealing with my indecisiveness
Lucinda Hawksley for her time and generosity
Professor Judith AK Howard for her time and advice
Bjorn and Justine van der Horst, and the staff at Eastside Inn for their hospitality
Fiona McMorrough and Annabel Robinson of FMcM for their hardwork and advice
Durham University, particularly the Institute of Advanced Study and St Mary's College
The staff of IAP Fine Art for their help in locating paintings in private collections

Special thanks to all of Chris Gollon's collectors and patrons, particularly:

Jon Bowles
Benedict Marsh
Peter and Lucy Noble
Judith AK Howard
Tim Santini
Paul and Julie Fitzsimmins
Penny Gilbert and John Whittaker
Ray and Pauline Treen
Simon and Sarah Freeman
Diana Fox and Rebecca Kindred
Lucy Blaylock
Claire Shaw
Geoffrey Harrop and David Gledhill
David Buckley

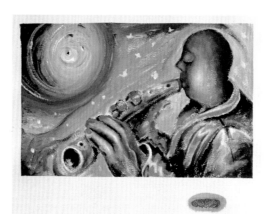

Flute Player
Acrylic on paper
79 x 61 cm (31 x 24 in.)
2000
Private collection

Opposite page
Head
Acrylic on paper
23 x 15.2 cm (9 x 6 in.)
1999
Private collection

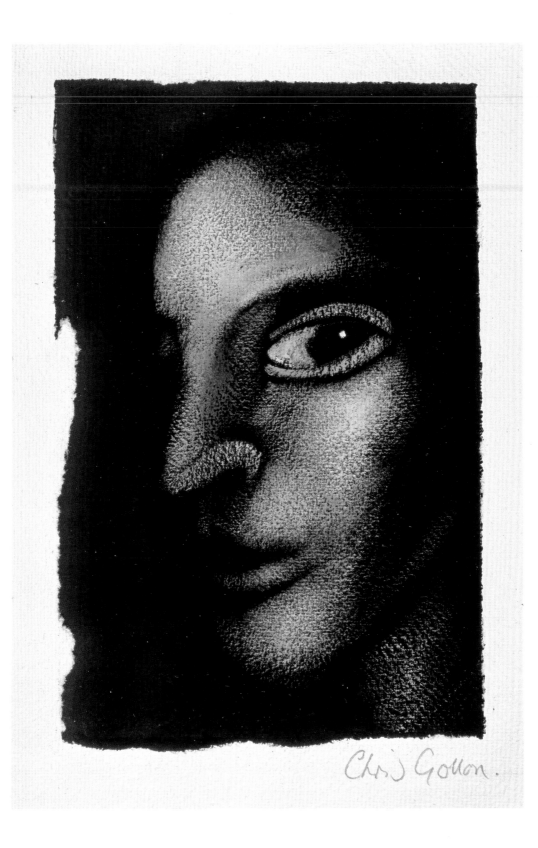

Chris Gollon *Humanity In Art* **7**

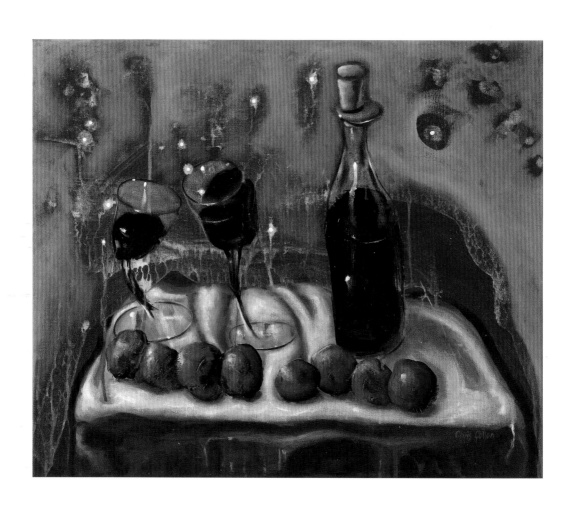

INTRODUCTION

'True painting is the sum of all parts, of the life before, of experience, loss, love, longing, of the moment and of the life to come. Each and every painting should be a reflection of the past and a springboard to the future.' Anonymous

Superlative novels transport the reader to a different world, to a world and its adventures encapsulated within the few hundred pages wrested from a creative mind. Equally Chris Gollon's paintings bring to life a different realm: one of mystery and irony, a little off kilter, where the ugly attain beauty, inanimate objects shudder into life and the bare soul of humanity is brought forward for questioning. His subjects unfold mostly within an ethereal twilight zone, or under cover of darkness where nothing is quite normal and the laws of time and space career off on a course of their own making. This realm of Gollon is one of cities at night with darkened doorways, beckoning candied-neon lights, a rush of faceless people expediting their demise – the bowels of life stirring under night's shadowy mantle. He draws his characters from these adumbral recesses to expose human weakness, vice and folly with striking perceptiveness and often marked humour, revelling in the ridiculous without being judgemental. Occasionally a saint creeps in. Gollon is a painter of life, good and bad.

A Drink To Soutine
Acrylic on canvas
50 x 61 cm (19.75 x 24 in.)
2010
Private collection

Like Francis Bacon, Gollon is entirely self-taught and received no formal art training. He is a figurative painter first and foremost, and one of significant technical skill honed through intense study of classic art books and years of hard work. Through these years his painting has continually evolved; he has developed a new mode of expression for the nude – that most classic of art forms – and has taken figurative work to a different level where the body becomes indicative of an idea; capable of holding a concept. Despite the intellectual sub text that underpins much of his work, his paintings are balanced by often ironic and sometimes dark humour. Gollon paints big ideas, but his self-deprecation prevents pretension filtering into his work.

Gollon's approach is defined by its innovativeness and a sense of organic growth that is reflected through the constant evolution of his style and ideology. Aside from the groundbreaking developments in his figurative work, he has redefined still life painting allowing objects to assume identity and enact their own mini-dramas. He blurs the boundaries of genre, investing his still lifes with a tangible sense of humanity – portraits of wine glasses cavorting, cheese escapades and pots in battle – while his landscape paintings are part still life and some of his figurative works are part landscape. He combines these still life, landscape and figurative genres together in his extraordinary religious paintings. Gollon does not consider himself a religious painter, yet in 2009 his epic series of paintings the *Fourteen Stations of the Cross* was unveiled in the Church of St John on Bethnal Green. The paintings, which took ten years to complete, have caused waves through both the art world and religious communities on an

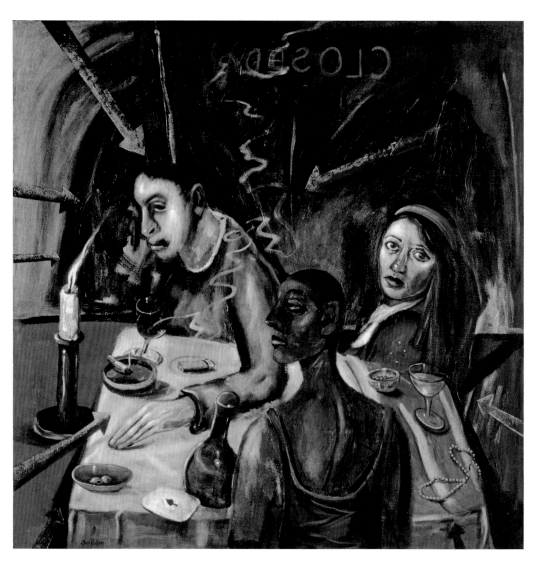

The Prodigal Son
Acrylic on canvas
91.5 x 91.5 cm (36 x 36 in.)
2003
Private collection

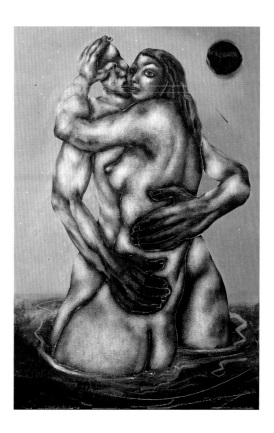

Figures With Shooting Star
Acrylic on anvas
91.5 x 61 cm (36 x 24 in.)
2008
Private collection

international scale from Europe to North America and Australia to Sri Lanka, and form the basis for Somerset Maugham prize-winning novelist Sara Maitland's book, *Stations of the Cross*. These avant-garde works have pulled religious art into the twenty-first century and redefine this traditional art form; they are controversial and they are brilliant in their simple logic.

The body of Gollon's work comes from a small, old barn in Surrey. Barn is a grandiose term, the building is a lean-to shed; ivy grows through the roof, there is no heat and the one huge window is taped in the middle where a bird flew into it. Canvases dating back to the 1970s are stacked against the walls, the floor is piled with books, hundreds of books, atop which are bundles of paper, tubes of paint, ashtrays, brushes and a pair of snakeskin boots. A mannequin hovers in the corner at a rakish angle, wearing a sombrero and a smile, and from the rafters hangs a yellow felt hat and a broken guitar. The outdoors is trying desperately to invade, the ivy has made it and so has the odd rat. Wonderful, bizarre plants are gathered outside the window, their seed heads knock on the glass when the wind lifts, grass has grown through the doorstep and creeping tendrils of something persistent have wound their way across the wood cladding. It is Gollon's studio of choice, far more salubrious locations rejected in favour of this small pocket of isolated, lived-in charm.

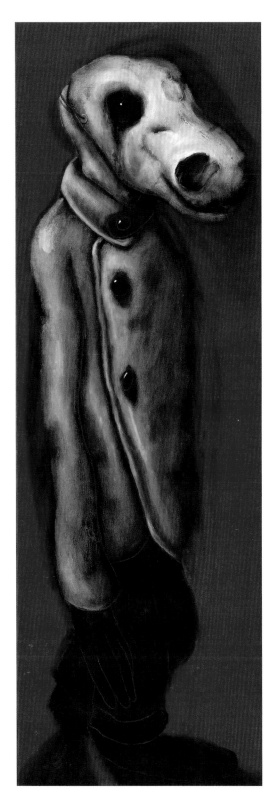

House Of Sleep (Morpheus)
Acrylic on canvas
122 x 40.5 cm (48 x 15 in.)
2006

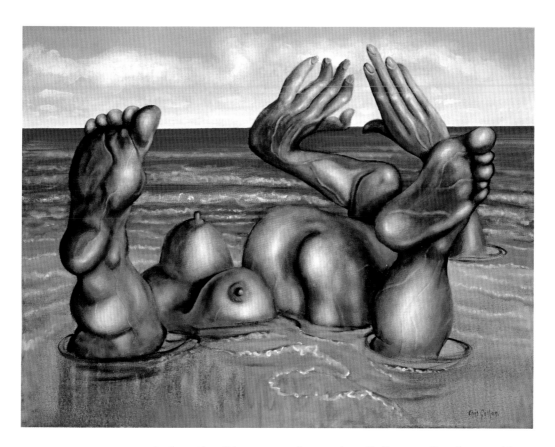

Nude (Bathers Series)
Acrylic on canvas
61 x 91.5 cm (24 x 36 in.)
2000
Private collection

In the midst of this creative chaos is the self-effacing Gollon, former wild man, paintbrush in one hand and cigarette in the other, usually accompanied by Bob Dylan playing on an ancient cassette player. Music is prerequisite for Gollon in his studio. The artist was a teenager in the late 1960s, fully embracing the accompanying hedonism, and later in the 1970s became a small but integral part of the emerging music culture, hanging out with friends in bands like Tomorrow, The Skids and The Cult. Norman Smith, aka 'Hurricane Smith' who worked with The Beatles, Pink Floyd and The Pretty Things, was Gollon's neighbour and a frequent visitor to the Gollon home. Even once he was established on his path as an artist Gollon continued to affiliate himself with the music culture choosing to remain on the peripheries of the art world and forging his own singular path independent of the changing artistic trends. This was a brave move on behalf of an artist whose career has been littered with huge hurdles. His arrival amongst the main fold of contemporary artists is due only to his single mindedness, the support of his family and his agent, David Tregunna, a little bit of luck and enormous natural talent, helped along with a lot of tobacco and restorative elixirs.

The Arcadian chaos that is Gollon's workplace is a world away from the cool, white interiors and quiet sophistication of the IAP Fine Art gallery who represent him, and their current space in Imperial Wharf, London. Yet out of his shambolic studio the artist has produced some cornerstones of contemporary art, paintings that will form part of the fabric of tomorrow's art history.

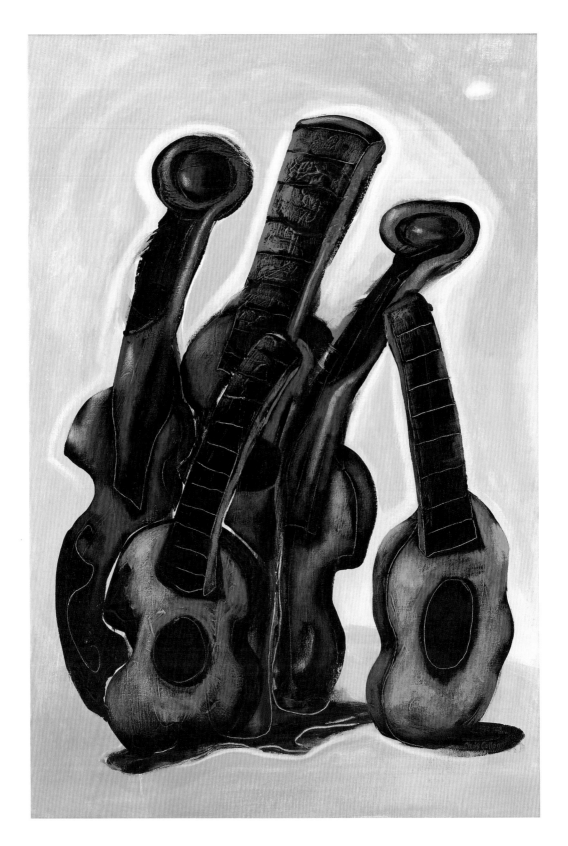

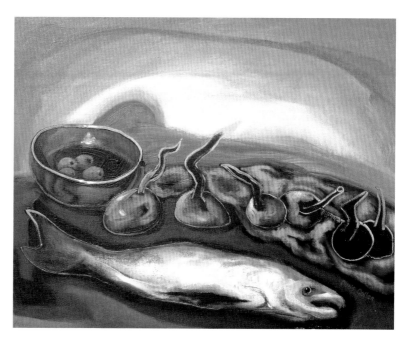

Still Life With Fish After Soutine
Acrylic on canvas
40.5 x 61 cm (16 x 20 in.)
2007
Private collection

Still Life With Stringed Instruments 2009
Acrylic on canvas
91.5 x 61 cm (36 x 24 in.)
2009
Private collection

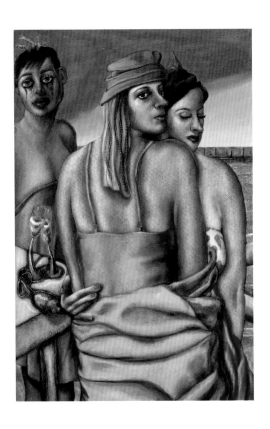 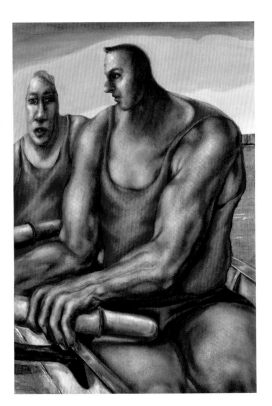

Chapter One

BEFORE THE BEGINNING

Chris Gollon's paintings are extraordinary, brilliant, ironic and periodically unsettling. They are the product of a roaming and intensely imaginative mind, one of infinite creativity and boundless intellectual pursuit. To examine these paintings is to take a walk in Gollon's world, a place that, like his paintings, combines the real and the surreal – his life is a theatre of the unexpected, peopled with fantastic characters from sword swallowers to rock musicians. It is here that the story of Chris Gollon, contemporary artist, starts: in "Gollon's World", a surreal place of the bizarre and humorous that resonates with the music culture of the late 1960s and 1970s.

At odds with the traditional perception of an impoverished artist, or the poor boy made good, Gollon was brought up in an affluent family in Isleworth, Middlesex, not far from the River Thames. A town whose other noted artistic affiliations lie with Vincent Van Gogh (1853–1890), who briefly moved there in 1876, and Joseph Mallord William Turner (1775–1851) who lived at Sion Ferry House from 1804–1805. Turner was drawn to the great, charismatic river Thames that glides past the town, and painted scenes from along the banks of the river, and nearby Hampton Court. Unlike Turner, Gollon's work reflects scant interest in his surroundings and, despite living and working consistently within reach of the Thames, he has granted her little canvas space. The only references to the sliding, ribbon-like river that has been such a consistent landmark in his life is a series of works from 2007 based on the famous Henley Regatta – and the artist's abiding fear of fish. Although whether this phobia and his subsequent reference to fish, many of them open-mouthed and gasping in his paintings, such as *Fish in a Landscape* (2004) can truly be blamed on the Thames or not is subjective.

Gollon's early life has had a huge impact on the nature of his paintings, not topographically, but through the collection of experiences, faces, people, characters and insight that the artist has acquired and carefully filed in his capacious mental library. He is an artist most accurately described as working *en tête*; his paintings, which reflect immense creativity and inquiry, evolve from the reams of random and frequently poignant flashes of life catalogued within his head, which surface sometimes years later, and are bolstered by hefty layers of imagination. *Mason's First Kiss*, painted in 1996, is a particularly good example of Gollon's recollective approach and reflects a narrative significance underlying the work, which is characteristic of his early paintings. The rather beautifully structured painting, faintly echoing early Renaissance Virgin and Child compositions, is based on an incident that occurred when Gollon was thirteen. He and his friend Mason, were loitering outside Woolworths on Hounslow High St at Christmas time with the nonchalant insouciance of burgeoning youth. A rapacious mob of teenage girls arrived, clip-clopping down the pavement in unsuitable shoes, smoking with feigned belligerence, when one, a tall girl of ample proportions and vivid lips, descended on Mason to give him a Christmas kiss. She swooped down

Diptych Study For Gollon At Henley
Acrylic on canvas
91.5 x 122 cm (36 x 48 in.)
2007
Private collection

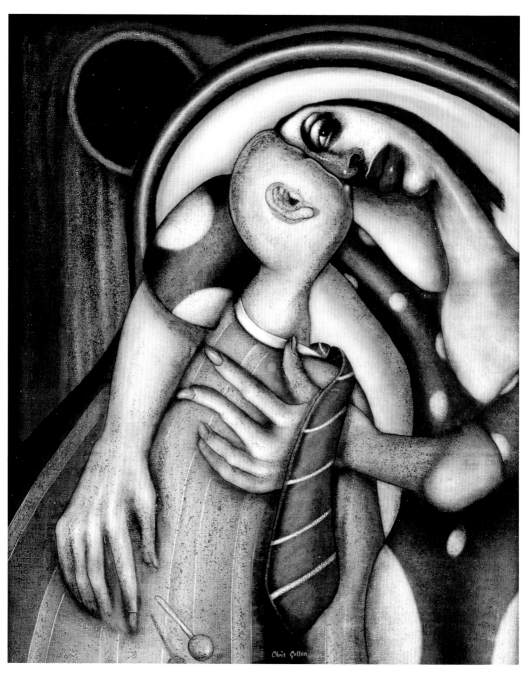

Mason's First Kiss
Mixed media on canvas
56 x 51 cm (22 x 20 in.)
1996
Private collection

upon the unsuspecting schoolboy, pinning him with a shot-putter's arm, ready it seemed to all but swallow him whole. As Gollon recalls, the acutely embarrassed Mason was mortified by the predatory girl, but also wore the kiss as a badge of honour, bouncing back to school on the airy, winged sandals of a one-time hero, preceded by his puffed-up chest.

School was stifling and restrictive for the artist, and provided no arts education, with all emphasis on academia or sport. Gollon's greatest early aim was to arrive at an eligible school-leaving age as quickly as possible and forge his own, independent path. This attitude, of single mindedness and independence, is most apparent in his approach to painting and has aided him in maintaining self-belief in his artistic goals, which have been outside the parameters of fashionable contemporary art with its self-absorbed conceptualism and rejection of painting. Whilst still within the school system's clutches, Gollon developed more than a passing talent for football, though he recounts in his quirky humorous way that he was not *quite* good enough. When his team made it into the district finals, nine members were scouted and chosen for premier sides, the only two not to be chosen were Gollon and the goalie. These early school years are significant in light of his later development, his desire to excel in a specific area, to earn recognition and professional respect, and perhaps most importantly in the shaping of his dogged determination.

It was at school that Gollon befriended Keith Downey, another extraordinary character who became one of the single most influential people in Gollon's life. Downey, flamboyant, rebellious and reckless, left school with Gollon at sixteen. After he married the last Mrs Downey (of whom there have been several) the couple moved to a small house in Weymouth. One night they had a blazing row, their furniture suffered and they caused such uproar that the neighbours called the police to report a murder. Downey was arrested and thrown in jail, but his wife had disappeared. After several days of fruitless searching, the police called Mrs Downey's parents in America to break the news of their daughter's suspected death. By chance she was seated next to her parents on the family sofa, so the news was received with some surprise. Eventually she returned to England, Downey was released without charge and the couple reunited, albeit rather briefly. Downey lived hard and died young; his death at just forty in 1993 would have a tremendous effect on Gollon and led to one of his early masterpieces, *Figure on Road to Narragonia I* (1995).

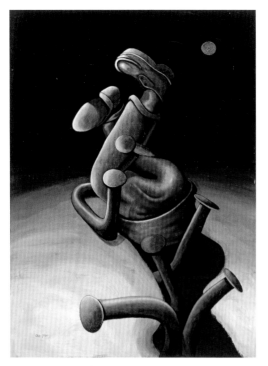

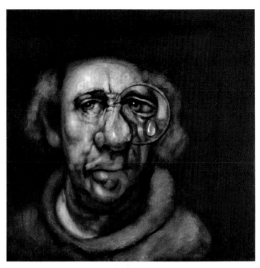

Rembrandt Lookalike I
Acrylic on canvas
40.5 x 40.5 cm (16 x 16 in.)
2001
Private collection

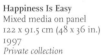

Happiness Is Easy
Mixed media on panel
122 x 91.5 cm (48 x 36 in.)
1997
Private collection

Downey came from an eclectic and artistic family; his father was a jazz musician and poet but, when crippled by arthritis, was relegated to taking a job as a baggage handler at the airport. The frustration and the irony of this deeply talented musician's life is projected by Gollon through many of his early paintings, including the strikingly simple, yet profoundly moving *Happiness is Easy* (1997) and *The Happy Musician* (2000) – the title being a Gollonesque-style inversion, this time of the truth. It was Downey, himself inspired by his father, who at the age of seventeen persuaded Gollon to visit the National Gallery with him, to see Rembrandt's (1606–1669) *Self Portrait Aged 63* (1669). This was a defining moment for Gollon, who decided, on the strength and impact of this painting, that he too would become an artist. This early experience of Rembrandt has had a long-lasting effect on the artist with elements of Rembrandt's self portrait: the sense of haunting insight, honesty and poignancy recurring with periodic consistency through Gollon's work, and most obviously in his tongue-in-cheek series of *Rembrandt Lookalike* paintings (2001).

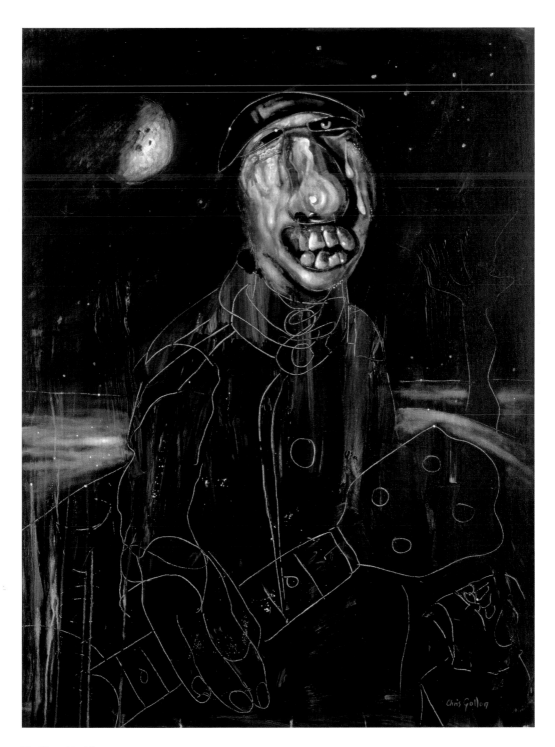

The Happy Musician
Mixed media on canvas
122 x 91.5 cm (48 x 36 in.)
2000
Private collection

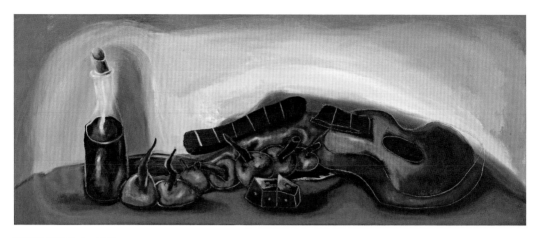

Still Life With Broken Guitar
Acrylic on canvas
40.5 x 99 cm (16 x 39 in.)
2007
Private collection

It was an unusual and happy occurrence for the two seventeen year olds to
venture to the National Gallery, which is not an institution that commonly
appeals to teenage boys. More interesting still is that these two in particular
were at the time living the high life, with little thought to serious careers
and riding tall on the bank balance of part-time jobs, but most significantly
on the pockets of père Gollon. Gollon and Downey were by this time
circulating on the peripheries of the late-1960s early 1970s music culture,
and music remains an inherently important part of Gollon's work from his
actual portrayal of musicians, to his use of musical lyrics for inspiration,
particularly those of Bob Dylan and Leonard Cohen. The Gollon family lived
next door to Norman Smith, better known as 'Hurricane Smith'. Hurricane,
who was a regular fixture at the Gollon kitchen table and partial to tea, was
the sound engineer at Abbey Road Studios, producing Pink Floyd and The
Pretty Things, and working with The Beatles. One of his favourite stories,
told in the Gollon kitchen, was how he had written a song called *Don't Let it
Die,* which he had offered to John Lennon for use by the Beatles. According
to Hurricane, Lennon declined on the basis that they wrote their own songs,
so Hurricane went on to release the record in 1972 to massive success.
Hurricane and Lennon remained great friends and Lennon later gave him
a pair of cufflinks as a present. Hurricane was so fond of the cufflinks
that when he went on holiday he hid them in a hollowed out loaf of bread,
since he reasoned no self-respecting thief would look there. Unfortunately
the loaf was discovered by a family member and, because it was mouldy,
was thrown away.

Just down the street from the Gollons lived Uncle Bert and Auntie Rose, with
their son Tony. The family were not blood relations, but close family friends.
Their home became a frequent pit stop for a bear of a boy who later became

known as Big Jim Sullivan, one of the most sought-after session guitarists of the 1970s. Before leaving to go on tour with Tom Jones for five years in the 1960s, Big Jim gave Gollon a banjo, which still hangs on Gollon's wall.

Gollon, Keith Downey and their friends all played the guitar, spending long, smoke-filled evenings jamming together. Despite pointers from Big Jim, Gollon was not *quite* good enough, like his football abilities, and later relegated his guitar to the corner of his room, alongside the banjo. In subsequent years guitars have made frequent appearances in his paintings, often in highly humanised ways reflecting emotions such as grief, pain and elation.

Two of Gollon's friends who *were* good enough, were Keith West and Steve Howe. These two, together with 'Twink' and 'Junior' formed the psychedelic rock band Tomorrow. Keith West went on to write the lyrics, and was vocalist, for the song *Grocer Jack (Excerpt From A Teenage Opera)*, which shot up the charts in 1967, while Steve Howe eventually joined the rock band Yes, who are still together today. Part of the same crowd was the base guitarist Russell Webb who later joined the punk band The Skids, and the guitarist/songwriter Billy Duffy, a founding member of the band The Cult. Gollon still recalls Duffy's excitement when the band made its first appearance on the popular television show, *Top of the Pops*, and how, rather touchingly, Duffy's mother had bought him a new guitar for the occasion.

Music, and rock music in particular, was a unifying culture for the young Gollon. It was a scene in which he thrived, particularly in his early career, and was most unlike the art world. The succinctly anti-establishment Gollon found the art world stifling in a manner not dissimilar to George Melly, who once famously said that his dislike of it drove him to music. Gollon has remained hovering at its peripheries, unaccepting of much of the political and commercial engines that drive it. This was a bold choice that has made his path undeniably difficult, yet the exponential popular and critical acclaim his work is now achieving, is testament to his unwavering ideology and belief in what art truly is, and what it should be.

Gollon and his posse were a formidable collection of rebellious, young creative talents, with Keith Downey in particular becoming a life-long friend, and part-time partner in crime. In the early 1970s the pair of them were befriended by Sir John Waller (1917–1995), an eccentric poet and flamboyant gentleman who took a shine to the boys. Apart from his World War II poetry, Waller also penned the humorous subversion of Christopher Robin, 'Hush, Hush! I'm rather afraid, Christopher Robin is looking for trade'. In order for Waller to inherit a substantial legacy, he was required to marry and father a child, a daunting task given his preferences. Gollon and Keith Downey were instructed to help find him a suitable, or a willing, wife, which they did, in their local pub. Although Waller did marry Anne Eileen Mileham in 1974, no heir was forthcoming, and the marriage was dissolved amidst tawdry tabloid headlines.

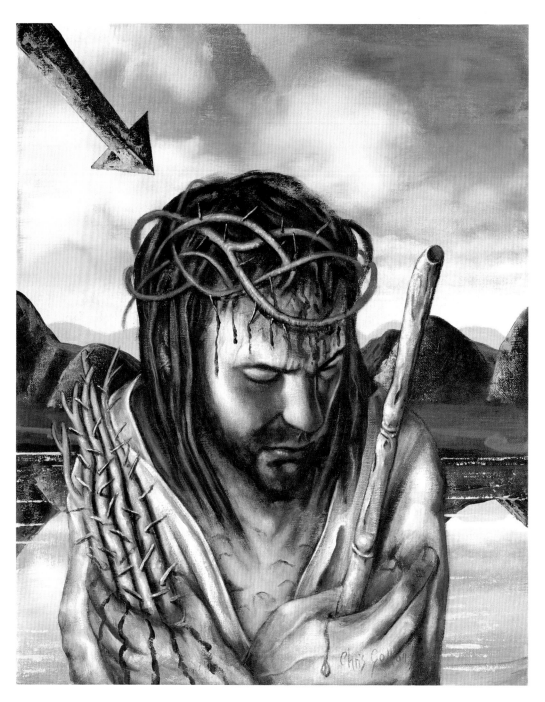

Jesus As The Man Of Sorrows
Acrylic on canvas
51 x 40.5 cm (20 x 16 in.)
2002
Private collection

Despite the unconventional lifestyle of the young Gollon, he was not sidetracked from his chosen route. Following the epiphanous moment in front of Rembrandt's *Self Portrait Aged 63*, Gollon struck onto a path that would eventually see him become a serious contender on the contemporary art scene. He rejected the idea of art school, having already at just seventeen years old an acute awareness of his own direction, which he recognised would not marry with an academy-style training. His father, with striking perception, offered to support Gollon for three years, no more, while he taught himself everything he could about painting. This he did, using Max Doerner's book *The Materials of the Artist*, first published in the early 1900s. The cover of this book states it is "the most valuable book in existence on the craft of painting", no small exaggeration when considering the depth and quality of the text, which covers all technical areas of painting, preparing grounds, stretching canvases, grinding pigments and restoring damaged works.

Of particular importance with respect to Gollon's work is Doerner's chapter on the *Techniques of the Old Masters*, where he examines the methods of Titian (*c*.1485–1576) and the Venetian School, Rubens (1577–1640) and the Dutch painters, and Jan van Eyck (*c*.1395–1441) and the German painters. It was information learnt through studying this chapter in particular that led to Gollon developing a number of his techniques, including his method of working from a dark ground and building up highlights through multiple glazes. Doerner, who was professor of the Academy of Fine Arts in Munich, was to influence a number of twentieth-century German artists through his book, particularly Otto Dix (1891–1969), who has in turn been a significant influence on Gollon. It is a credit to Gollon's drive that at a relatively young age, and circulating within a fairly riotous crowd, he knuckled down and literally taught himself how to paint. Today, aside from his unique and original raw talent, he counts as one of the most technically brilliant and knowledgeable artists of his time, reflected through his understanding of every aspect of the *actual* craft of painting.

The financial support from his family ceased when Gollon was twenty, and in the same year he married his wife Anne, then took a clerical job to support them while his artistic career was in its fledgling stages. At first Gollon set upon portraiture as his chosen field, painting incessantly in his spare time. Although he met with some success in this endeavour, his striking honesty as an artist, and disinclination towards flattery was not always appreciated by the sitter, and by the late 1980s and early 1990s he began to concentrate on his unique figurative and cerebral style. His skill as a portraitist can on occasion still be seen in his works, most recently and notably in his monumental religious series *Fourteen Stations of the Cross*.

A particularly successful early portrait was that of Harriet Bakewell (*c.* 1977), daughter of the television presenter Joan (famously described as "thinking man's crumpet" by the comedian Frank Muir). Following this he was commissioned to paint the American actress Gayle Hunicutt who graced the screens in the television show *Dallas*, but before he could start the commission she was called back to the States for filming and his clerical work had to continue.

It was while working in the back offices of a nondescript building that Gollon befriended Kim, a young man with the extraordinary ambition of becoming a tramp, which he did eventually do very successfully. In later years Gollon, Kim and David Tregunna, Gollon's friend and agent, would become an inseparable trio, before Kim bought a piece of waste land with a caravan on it in Ealing, moved in and then disappeared. He has, rather sadly, now fallen off the radar. Characters such as Kim, those who don't fit neatly into modern society, those who are alienated, or spiritually and morally lost, or off kilter, running along parallel lines to the rest of the world, play a significant role in Gollon's paintings. In many respects although his work has greatly evolved over the past decades, the underlying intentions remain the same, significantly the artist's exploration and understanding of the human condition. The first most poignant artistic manifestation of this occurred in the mid 1990s with Gollon's *On the Road to Narragonia* series, which can be considered the true beginnings of his artistic career.

In the mid-1970s Gollon moved with his new wife to a cottage in Shepperton where their son Lawrence was born. Within weeks of moving they discovered their neighbours were yet more characters destined for his canvas in years to come. The history of tragic circumstances that led to their peculiar nature was unknown, but were significant enough to have rendered the husband permanently speechless and the son prone to excitable confusion with a penchant for loitering in ladies' public conveniences. One painting in particular that evolved at a much later date from these early experiences is *The Shout* (1995–1996), a profoundly moving work which, with an inversion of its title, reflects a bound and gagged man rendered impotently silent accompanied by an androgynous, whispering figure and a circus-like dog. As with many Gollon paintings this image works on different levels and affords the viewer scope to interpret it based on personal perception. It is the ambiguous nature of much of this early work that has rendered it of such interest to a wide audience, since every viewer is capable of identifying with the subjects in their own individual ways. Added to this Gollon has in the past stated that although his paintings carry titles and he is willing to discuss their original intent, by choice he would prefer not to, to allow the audience to discover their own ideas.

The Shepperton neighbours, paled in comparison to Gollon's neighbours in Addlestone, Surrey, where he moved his young family some years later, and where his daughter Alice was born. His time in Addlestone proved to be a major source of inspiration for many of his paintings made after the

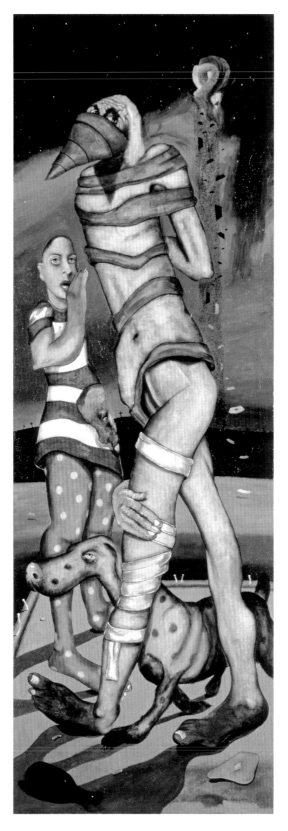

The Shout
Mixed media on panel
183 x 61 cm (72 x 24 in.)
1995/96
Private collection

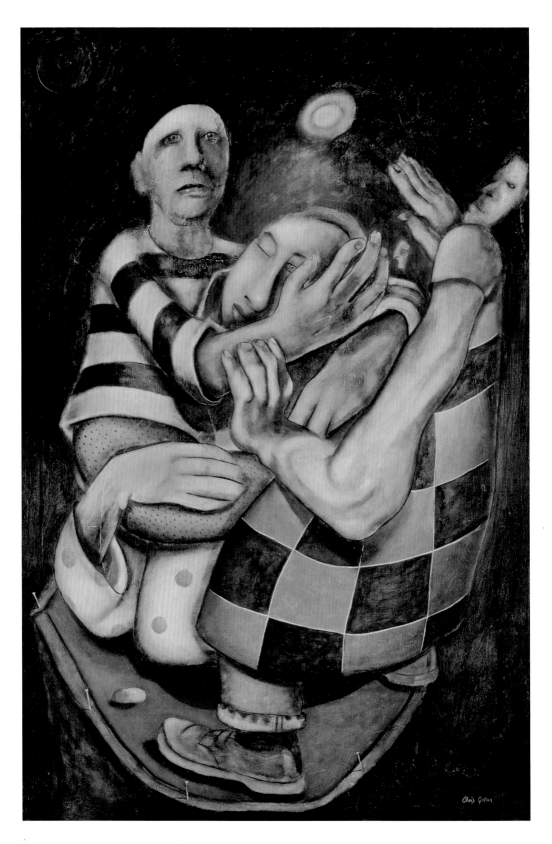

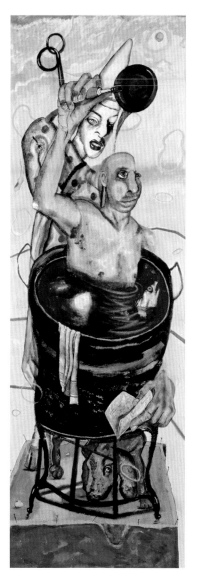

The Feast
Mixed media on panel
183 x 61 cm (72 x 24 in.)
1994
Private collection

fact in the 1990s. Gollon met his new neighbour, Mrs Jones[1], the night he moved in, when she appeared on his doorstep brandishing two pint glasses of gin and tonic, and four digestive biscuits. This marked the beginning of a lengthy and enlivening relationship with Mrs Jones and her extraordinary, tragic family. It transpired over gin and biscuits that her family had a long and lively history that Gollon would refer to years later in a number of paintings. She told one story, the details a little blurred with time and gin, about ancestors who were explorers and had formed part of the expedition that discovered some of the New Hebrides islands. The natives of the islands were, back then, prone to cannibalism, and not appreciating their discovery, devoured some of the explorers, including Mrs Jones' relations. Gollon was fascinated by this tale and referred to it several times in his work during the 1990s, most strikingly in the painting, *The Feast* (1994), which combines humour and malice with unsettling poignancy. This is one of the earliest works to include a gasping fish, an image that recurs frequently throughout his career and is loaded with varying meaning. Following this painting he undertook a number of different works depicting figures in bathtubs (often resembling cauldrons), maintaining the underlying concept of malice/humour inspired by *The Feast*, but placing the figures in more mundane circumstances. His implication in these works is one of ambiguity tinged with discomfort, suggesting an impending sense of possible horror, which might yet dissolve into comedy. He distorts the sense of scale, a technique he uses frequently, so impossibly large figures are jammed into impossibly small receptacles, effectively increasing the pathos and disquiet of their situation.

The Kindred Spirit
Mixed media on panel
91.5 x 61 cm (36 x 24 in.)
1995
Private collection

1 Not the family's real name

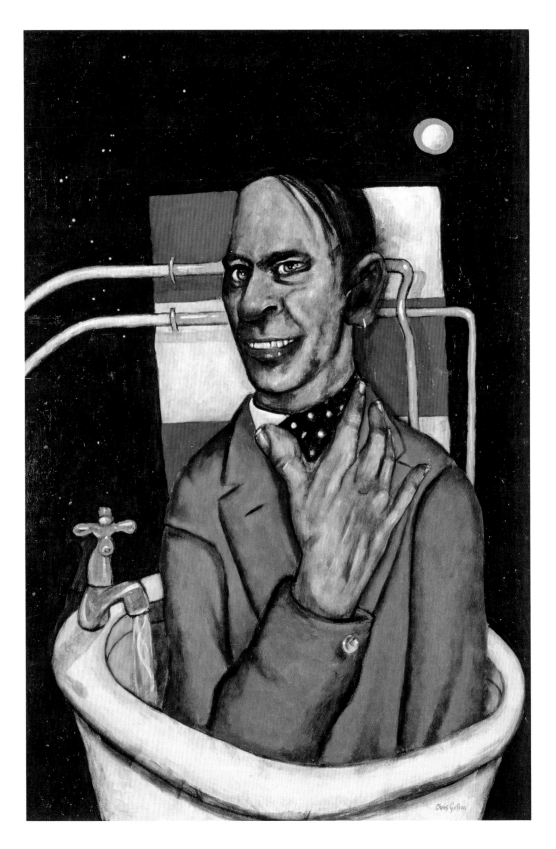

In a sense these works all indirectly relate back to Mrs Jones, who eventually died in truly horrific circumstances in her bathtub, but one painting in particular *A Night Out with Robert* (1994), can be more obviously linked to her. Robert was Mrs Jones's brilliant, though tragically flawed, schizophrenic son, who spent long evenings playing board games (not always to the rules) with Gollon. When he was taking his medication, Robert proved to be an admirable player and companion, but when he stopped taking it, which occurred with some frequency, his behaviour became bizarre and at times darkly humorous. One of his habits was to nurture and feed rats in the family kitchen, preparing lavish rat-banquets for them and weaving trails of breadcrumbs across the floor. The rat population boomed, and the Gollons living next door were plagued for the eight years they were there.

Mr Jones was significantly absent from the scene. He had, it transpired, popped to the local pub, the Woburn Arms, for a pint before lunch on a Sunday and disappeared for twenty-five years. He returned, again on a Sunday, with little explanation for the intervening time lapse and suffering from debilitating Parkinson's Disease. He died not long afterwards and tragically some years later Mrs Jones and Robert each made attempts on their own life in the house. The contact that Gollon had with this family underpins much of his ethos and the concepts behind his painting, certainly through the 1990s and even, in part, to the present. Their devastating lives, so full of tragedy and horror, yet also marked by bitter comedy and flashes of genuine joy, reveal the spectrum of the human condition, one marked by a balance between good and evil, humour and despair. It is this that forms the basis for much of Gollon's work, which explores the inherent irony in life.

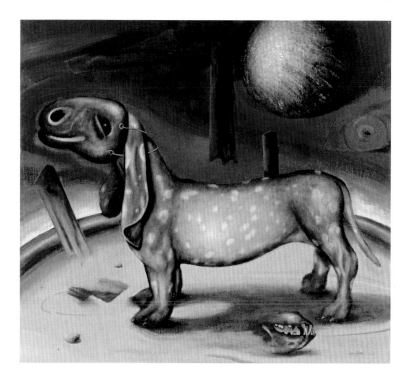

El Fantastico
Mixed media on panel
122 x 91.5 cm (48 x 36 in.)
1999
Private collection

Just down the road from the Gollon house was Addlestone Moor, where
Gerry Cottle's Circus had its winter quarters from 1975 to 2003. Next to
the moor is the Woburn Arms, the pub from where Mr Jones disappeared
and the place where Gollon befriended El Fantastico, an alleged sword-
swallowing lion keeper, in the late 1970s. El Fantastico, the subject of the
Gollon painting, *El Fantastico* (1999), was a tremendous character who
could magic away copious pints of beer and still look good in a leotard. He
did not however wear his leotard to the pub, cutting a rather less assuming
figure in hush puppies and chinos. There is some debate now over the
extent of El Fantastico's activities at the circus, but he told a cracking story
and entertained Gollon during some long evenings in the Woburn Arms, a
memorable one ending with both artist and sword-swallower searching for a
lost wallet in the lions' quarters, apparently to detriment of neither. Loosely
related circus imagery appears frequently in Gollon's work especially in the
series *In the Shadow of the Pleasure Dome* (*c.* 1999) which features comical,
circus-inspired dogs, such as *Carnival Dog III* (1998) with a mask pinned over
its face, and circus imagery reflected in the magnificent, *The Wall of Death*
(1998). A repeated use of Harlequin-type figures feature in the series *On
the Road to Narragonia* (1995–1997), along with distorted dwarfish figures,
often indicating perversity or threat. A compelling use of such figures can
be seen in the painting, *Jesus Takes Up His Cross* (2002), which formed part
of the *Fourteen Stations of the Cross* series. The dwarfish trumpet player in
the background and the sinister truncated figure in the foreground add
enormous irony and pathos to the scene, bringing a sense of circus to a
most dreadful event, and emphasising the disparity between good and
evil. A similarly irreverent figure appears in *St Sebastian II* (1996) from the
Narragonia series, blowing his party hooter at the feet of the fallen saint.

The Wall Of Death (Detail)
Mixed media on panel
122 x 91.5 cm (48 x 36 in.)
1998
Private collection

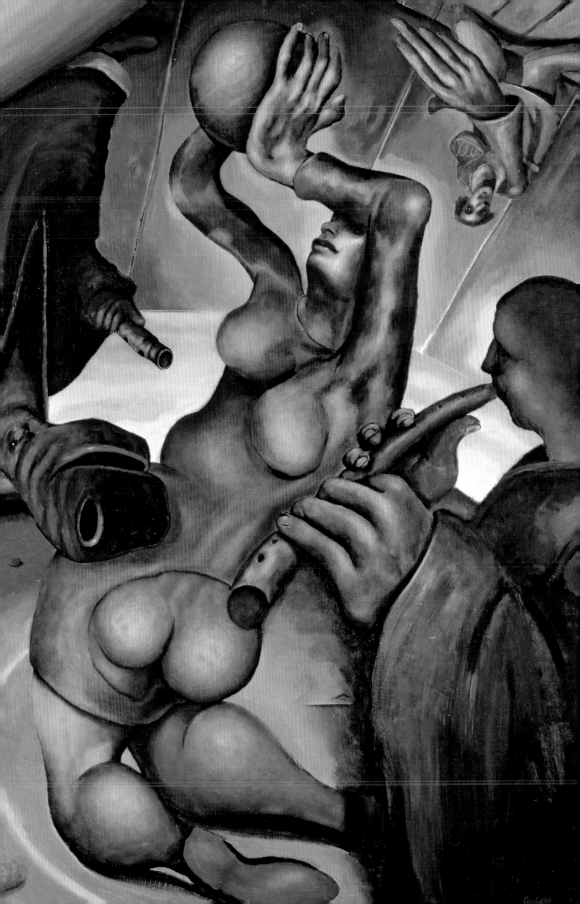

The Woburn Arms was a favoured and well-patronised pub by Gollon, who started what turned into one very long night there in the early 1980s, with his friend Keith West, from the band Tomorrow. The pair left the pub on closing and returned to the Gollon house where they retired to a room on the third floor and set about consuming large quantities of rough cut Spanish brandy. With the conversation turning to music Keith and Gollon decided to compare the Sex Pistol's version of *My Way* with Gustav Mahler's (1860–1911) *Fifth Symphony* putting both records on separate players at once and turning the volume to high. Shortly afterwards Gollon's wife Anne entered the room, asked Keith to turn the music down and inquired as to where her husband was. Keith responded, "he's on the balcony", to which Anne replied, "we don't have a balcony". Gollon, it transpired, had walked out through a window and fallen three stories to the ground, where he lay in a pool of blood, blissfully anaesthetised by the Spanish brandy. He smashed up his face in the fall, and broke both arms, which had to be put in plaster casts, rendering him effectively useless for several months. At the time he was in the middle of a portrait of Steve Howe, also from the band Tomorrow, and finally completed the painting by having his brushes strapped to the end of his cast. Shortly afterwards the Gollons moved to a bungalow ...

In 1984 a young man of Anglo-Belgian descent was introduced to Gollon through his sister-in-law, Fiona. It was an auspicious meeting that would eventually result in a most sincere and loyal friendship, which survived evolving into a business relationship. David Tregunna was, like Gollon, a young man caught up in the ideology and excitement of creative youth, with a world of ideas marching through his life. The two quickly became friends, along with Kim the young man whom Gollon had met through his dull clerical job. Long evenings of intense conversation, lubricated by red wine, led the three to declare their pressing intentions. Gollon to become a professional and full-time artist, David Tregunna to go to University to study English and French, and Kim to become a tramp. As it turned out, all three would achieve their goals with no small measure of success.

David Tregunna, who already had a keen interest in and knowledge of art, was immediately inspired by Gollon's work and began, perhaps subconsciously at first, to encourage and promote the artist. At this time, Gollon, by financial necessity, was continuing to work full time, painting only in his spare time, and becoming increasingly frustrated through these restrictive circumstances. He had so far achieved some measure of success through his portraiture, being commissioned on a fairly regular basis, but he felt unable to express himself creatively in the manner that he wished through this genre. In around 1988 he entered the London Mall Galleries competition winning a place to exhibit *The Old Couple*, a subject matter that he would return to several times over the decades, including an even more poignant image also titled *The Old Couple*, painted some years later in 1997.

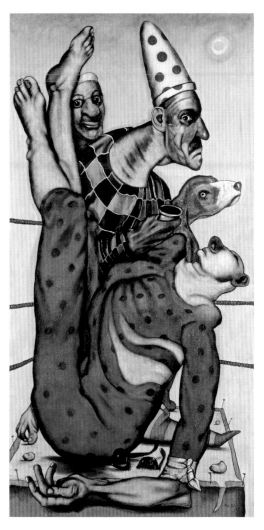

Above
The Good Samaritan
Mixed media on panel
122 x 61 cm (48 x 24 in.)
1995
Private collection

Right
The Old Couple
Mixed media on panel
183 x 61 cm (72 x 24 in.)
1997
Private collection

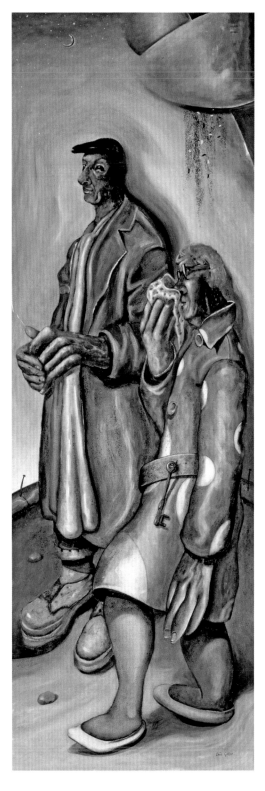

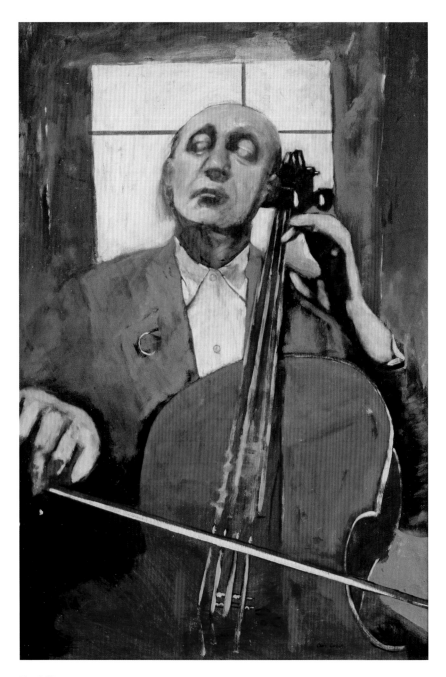

The Cellist
Mixed media on panel
91.5 x 61 cm (36 X 24 in.)
1989
Private collection

In 1989 Gollon won a place to exhibit at the Mall Galleries again, this time with the far tighter and more eloquent painting, *The Cellist.* This work, in comparison with later paintings, is still clearly Gollon in his inaugural stages, developing a style to be called his own, but it reflects a tremendous sense of human emotion, which is to a greater or lesser degree present in all his mature works. The expression of the musician is absolutely perfectly lucid and, in true Gollon style, complex and multi-layered. Here is a man aware of his own skill on the surface, yet an oblique glance of his eyes betrays a glimpse of uncertainty; simultaneously he is lost in the beauty of his music, but also inflated by the knowledge of having an audience.

In the same year, 1989, Gollon was selected as a finalist for the Spectator Prize run by Spink & Son for a humorous work titled, *Cap in Hand* (1989). It was a bold subject and one destined to cause controversy amongst the panel: the image depicts a painter (modelled on Gollon's son) standing in front of a panel of judges. Based on the success of these two exhibitions and an increase in the sales of his work, along with great moral support from his family and David Tregunna, Gollon made the decision to leave his job and paint full time. He sold his house and many of his possessions to tide him and his family over, and moved into a small flat. The following year David Tregunna went off to university in Hull, whilst continuing to market Gollon's work and to support his friend.

At Hull, David came into contact with John Osborne, Professor of American Studies at the University and editor of *Bête Noire* magazine, a thought-provoking, non-conformist literary publication from 1985–1995. David managed to persuade Osborne to publish a few reproductions of Chris's work in the magazine. Then in 1993 Gollon achieved one of his first big successes. Instigated by David, John Osborne and Jane Thomas, and organised by the then curator David Briers, Gollon was included in a two-man exhibition at the notable Ferens Gallery in Hull, which was at the time Museum Gallery of the Year. His work appeared alongside that of the portraitist Peter Edwards (b. 1955). There was an immediate media interest because David Hockney (b.1937) was also exhibiting at the gallery at the same time. The two-man show was such a public success that it was extended for several weeks and, in a real coup, was given extensive coverage on BBC North, courtesy of Joan Bakewell, whose daughter Harriet, Gollon had painted in the 1970s.

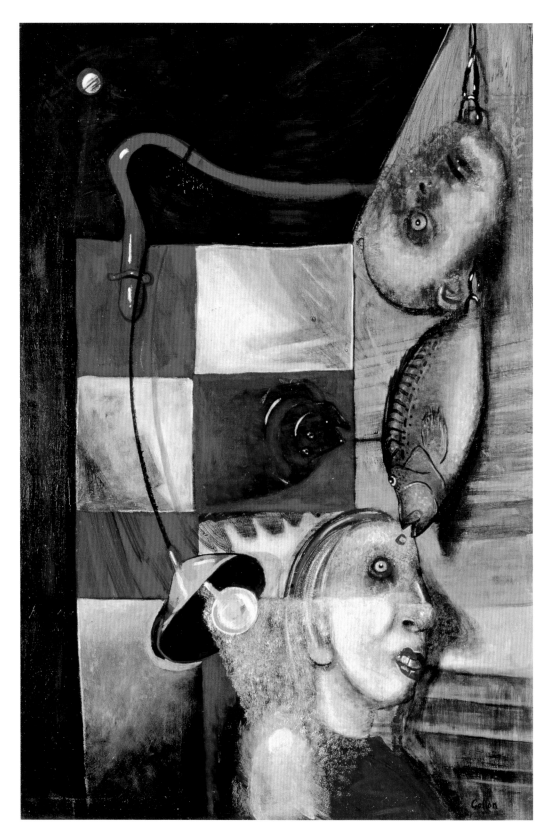

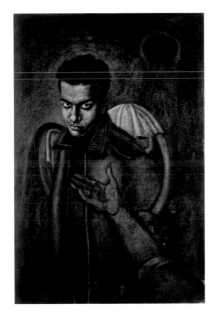

Study For Portrait Of Robin Dutt
Mixed media on panel
91.5 x 61 cm (36 x 24 in.)
1995
Private collection

The Kiss II
Mixed media on panel
91.5 x 61 cm (36 x 24 in.)
1994
Private collection

This was a turning point for Gollon, putting him firmly into the public forum and starting the Chinese whisper of his name that has steadily increased in volume over the years. Following his Ferens success he exhibited at Bretton Hall, West Yorkshire, and at the Lamont Gallery in London before his next significant media success. This occurred in 1995 at a Valentine's Day exhibition of multiple artists at Gallery K, in London, with an obvious love theme. Instead of submitting a saccharine romantic work like many of the other exhibiting artists, Gollon chose instead his surreal, humorous and outlandish painting *The Kiss II* (1994), which depicts a deathly pale woman being kissed by a dead fish that hangs from the ear of a human face mask. It is a macabre painting, which in Gollonesque fashion marries the sinister with the comedic. The work was partially inspired by the artist's pervasive fear of fish and largely by an incident that had occurred some years earlier. The artist had been walking down the street when a woman fell in front of him and lay motionless, as if dead, on the pavement. Gollon was gripped by a sudden inability to move, an immediate reaction that is not unusual. Several extended seconds later he was able to galvanise himself into action, and aid the woman, who had merely fainted (and smelt vaguely of scotch). The image of her ghastly, deathly face on the pavement was one that became ingrained in Gollon's mind and compelled him to capture the death-mask like stare of the woman in paint – in a manner not unlike that of Claude Monet (1840–1926) with his dying wife. *The Kiss II* was later used via John Osborne, editor of *Bête Noire Magazine*, by Neil Astley, editor of Bloodaxe Books on the cover of *The Triumph of the Water Witch*, a book of poems by the Romanian poet Ioana Ieronim.

The Valentine's Day exhibition was curated by Robin Dutt. He became fascinated by Gollon's compelling work and later wrote an article about the artist, which appeared in *The Independent* – the first time that Gollon had been featured in a national newspaper. This was a significant moment for the artist and he went on to paint an unusual portrait of Dutt, depicting him as a dark-angel figure.

It was around this time, during 1994 and 1995, that Gollon began work on a series of paintings that would come to mark the true beginning of his professional career. These are the *Narragonia* paintings, which would eventually reveal a maturation of Gollon's early style.

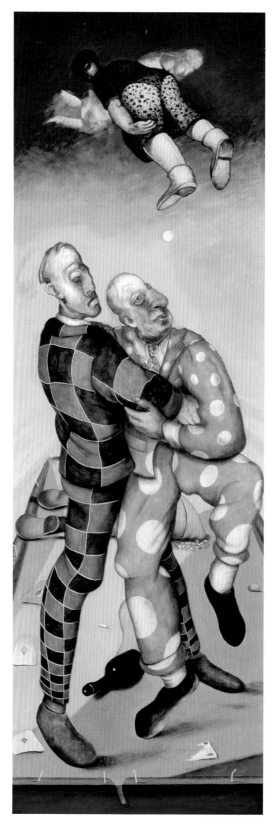

Chapter Two

THE EARLY YEARS AND NARRAGONIA

Gollon began work on his first major series, *On the Road to Narragonia*, in 1995. It was partially inspired by Hieronymus Bosch's (*c.* 1453–1516) painting, *The Ship of Fools* (*c.* 1490–1500), which was, in turn, loosely based on the fifteenth-century allegorical poem, *Das Narrenschiff* by Sebastian Brant (1457–1521). Both Bosch's painting and Brant's poem comment on the follies and vices of mankind symbolised by a ship of fools sailing towards Fool's Paradise, and reflect a condemnation of the alleged intrinsic hypocrisy of religious orders of the time. This level of criticism was not uncommon in pre-reformation fifteenth-century Europe, where religious orders were accused of all manner of vice from lewd and gluttonous behaviour to insidious moral weakness. The ship, traditionally used as a Christian symbol to transport the souls of the faithful to heaven, was parodied by Bosch, Brant and their contemporaries, hauling instead a cargo of delinquents. The use of a jester or fool, seen crouching in the rigging of Bosch's ship, had for centuries been a legitimate way of satirising the Church and society, and is a frequent inclusion in these types of work. Fools and the foolish abound in Gollon's *Narragonia* series, which does not levy such blatant criticism specifically at religious orders, but instead broaches the universal nature of inherent human absurdity and weakness.

Dance On Road To Narragonia
Mixed media on panel
183 x 61 cm (72 x 24 in.)
1995/6
Private collection

Gollon took the underlying concepts from these fifteenth-century works, and from Desiderius Erasmus's (*c.*1466–1536) *Praise of Folly* (1509), as a springboard from which his own cast of ridiculous and foolish characters emerge. They are characterised by the two hapless individuals in the painting *Dance on Road to Narragonia* (1995–1996), created early in the series. Here two sharply dressed fools dance vacuously with little joy or feeling, while behind them a figure lies with its head buried in the road; a device Gollon uses on more than one occasion to indicate denial of self-awareness. Playing cards, all aces of diamonds, litter the road symbolising the inevitability of bad luck through their uniform number. In the sky an incongruous figure, its chubby bottom revealed to represent loss of dignity, flies awkwardly towards a faintly painted angel. This is one of the first depictions of an angel by the artist, who has returned to this subject a number of times, most recently in his *Being Human* series of paintings (2009), where he explores the ideology behind angel phenomena. Gollon's angels are not always winged, nor are they specifically Christian, instead they are conceived as universal, mostly benign entities that offer only a modicum of salvation. The spectral, floating angel here in *Dance on Road to Narragonia*, lends a little hope to the painting, and Gollon's humorous depiction of the ridiculous fools prevents the work from becoming overly negative.

The gentle but dry humour and relentless irony inherent in this painting is characteristic of his work. These elements lend his paintings poignancy and allows the artist to depict subjects from the basement of human experience, whilst maintaining a balance between pathos and humour that, with rare

exception, prevents his subjects from becoming either blatantly cartoonish, or hellishly without hope. Depiction of humanity, in all its forms of weakness, strength and the diabolical, has, since the *Narragonia* series of paintings, been a fairly consistent theme throughout Gollon's work. His approach is heavily steeped in irony, with an appreciation of the ridiculousness of human situations, mostly self-induced, but with a definitive empathy. He might paint humorous and/or disadvantaged characters, but he does so without mockery, suggesting instead a genuine sincerity and understanding that encourages the viewer to identify with, and appreciate, the subject matter with sensitivity.

Around the time that ideas for the *Narragonia* paintings were in their fledgling stages, Gollon began listening to Bob Dylan's album *Highway 61*, which had been a favourite of his when he was a teenager in the late 1960s. The last song on the album *Desolation Row*, evokes a sense of movement, as if Dylan were travelling along with the song, which inspired Gollon to conceive his *Narragonia* series as a type of 'road trip' film in paint. As such the paintings have a sense of metaphysical, and to a

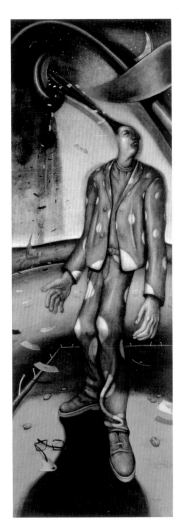

Bad Hair Day
Mixed media on panel
183 x 61 cm (72 x 24 in.)
1997
Private collection

Girl With Red Key (Detail)
Mixed media on panel
91.5 x 61 cm (36 x 24 in.)
1997
Private collection

lesser extent physical movement; they transpire and unfold across a surreal terrain, loosely following an esoteric road. Similar landscapes are revealed in different works providing continuity and suggesting, when considered as a series, the passage of characters through the unsettling and foreign place; so the protagonist in *Bad Hair Day* (1997) stands in the same place as the buxom woman in *Girl with Red Key* (1997), a place marked by the little church in the background that sits amidst a comfortless wasteland. Equally the pathetic character in *Figure with Key* (1996) huddles timorously on a spot inhabited by the ancient gods in the painting *Anubis and Charon* (1997), the horizon interrupted by crosses that teeter left and right. The implied movement, and development of ideas from painting to painting – which incidentally work in any order – reflects the artist's own evolution as he begins to define and tighten what can now be identified as the beginnings of his unique style. It is also through this series that he develops a vocabulary of imagery, symbols and even characters that recur sporadically in his subsequent works. Spinning black orbs, sometimes portals, sometimes vortexes that hang in his skies, floating playing cards inspired by a scene from Federico Fellini's film *Amarcord* (1973) where rubbish is whipped

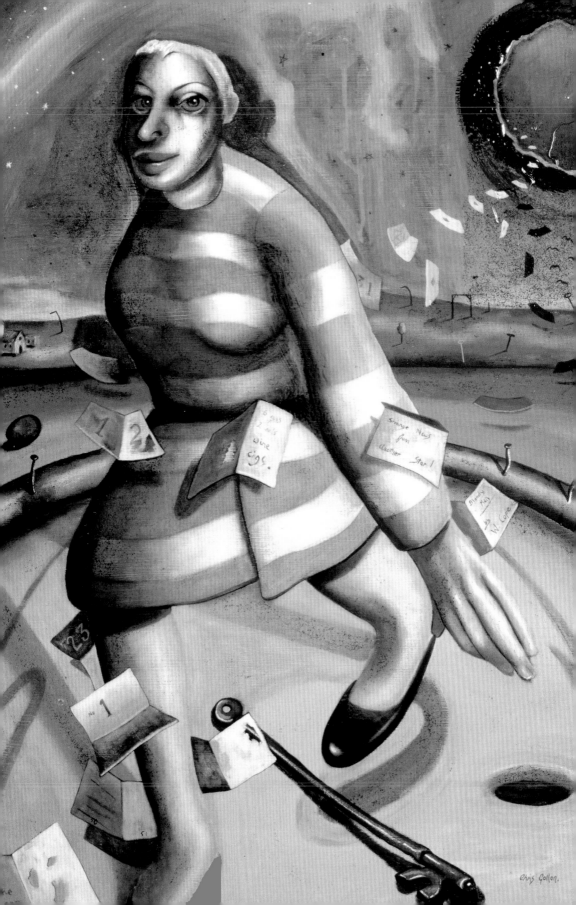

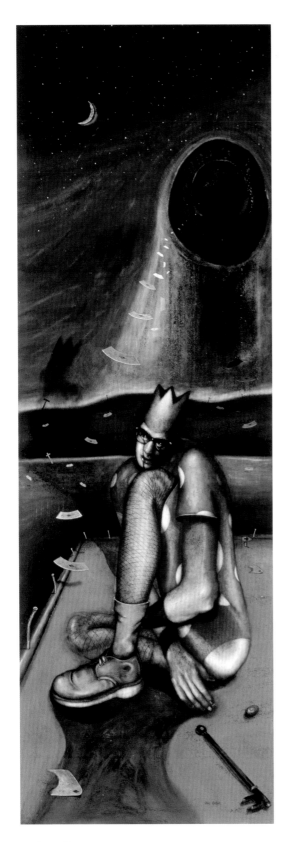

Figure With Key
Mixed media on panel
183 x 61 cm (72 x 24 in.)
1996
Private collection

Anubis And Charon
Mixed media on panel
122 x 61 cm (48 x 24 in.)
1997
Private collection

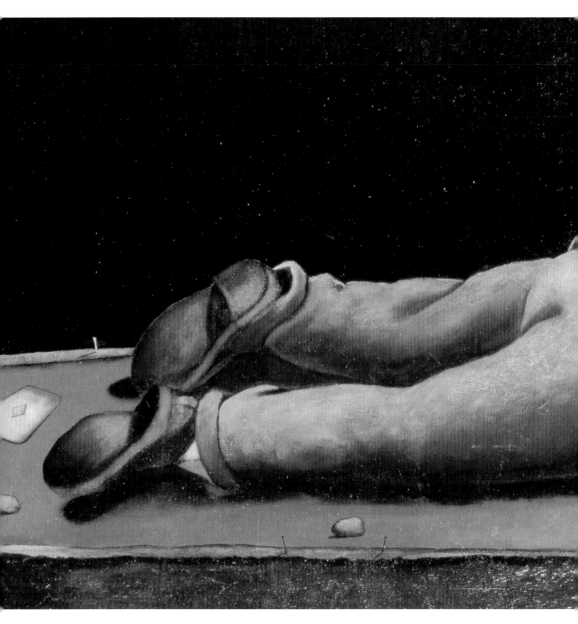

Figure On Road To Narragonia I
Mixed media on panel
122 x 61 cm (48 x 24 in.)
1995
Private collection

around in the air, discarded bottles, cigarette ends, a long, curious key, pebbles, paper party hats and outlandish dwarfs, spectacles, bent nails and a stage landscape all come to be familiar parts of Gollon's extraordinary painted world.

Although the influence of Bosch's *Ship of Fools* is evident, much of the source for the series, and the inspiration for one of its masterpieces, was the death of Gollon's close friend, Keith Downey. Downey indulged in a life of monumental excesses, particularly alcohol and cigarettes, which overtook him at just forty years old. Gollon had been friends with Downey since school, and had helplessly witnessed his decline, with his eventual death greatly affecting the artist. He painted the first of the *Narragonia* paintings, *Figure on Road to Narragonia I* (1995), a couple of years after Keith's death. In light of the circumstances surrounding the picture, it needs little explanation and is one of the more straightforward works in the series. The painting was eventually bought by the comedian Paul O'Grady. Some time after he purchased the picture O'Grady and Gollon found themselves at a charity function together. Despite buying the work, O'Grady had not met Gollon before, so the pair spent some considerable time that evening talking and drinking into the small hours. Later the same night O'Grady suffered a severe heart attack, and Gollon, on hearing the news (and feeling slightly guilty) sent him a postcard of the *Figure on Road to Narragonia I* painting with the word "Sorry" on the back.

The figure in the painting has buried his head in the road, unaccepting of his circumstances, and is surrounded by the bottles of wine and remnants of cigarettes that led to his demise. A playing card lies discarded by his feet, signifying the hand of fate, and implying that life is a gamble, while his spectacles sit uselessly on the ground, and again allude to his failure to recognise the gradual crumbling of his life. Many of the symbols in this work reappear frequently through the series, although not always suggestive of the same thing. Some of these, such as the bottles, the playing cards, cigarettes and the spectacles, are quite obvious in origin and intention, while others are more complex. One such, which is more original in concept, is Gollon's use of a fabricated stage setting on which he places his characters. The stage, which is used in many of the *Narragonia* paintings including the poignant *The King's Blessing* (1997), appears as a taut piece of cloth characterised by uneven nails holding it in place. It creates a separate world, one that hovers transcendentally beneath expansive eerie skies seen in *Welcome Home* (1996), where the stage becomes apparently the whole world, or is set into bleak, mysterious landscapes that offer little comfort characterised by *Bad Day at the Office Dear?* (1997). Periodically in his work the nails assume a greater significance, increasing in magnitude and predatory in intent. They are seen to great effect in *The Private View* (1997).

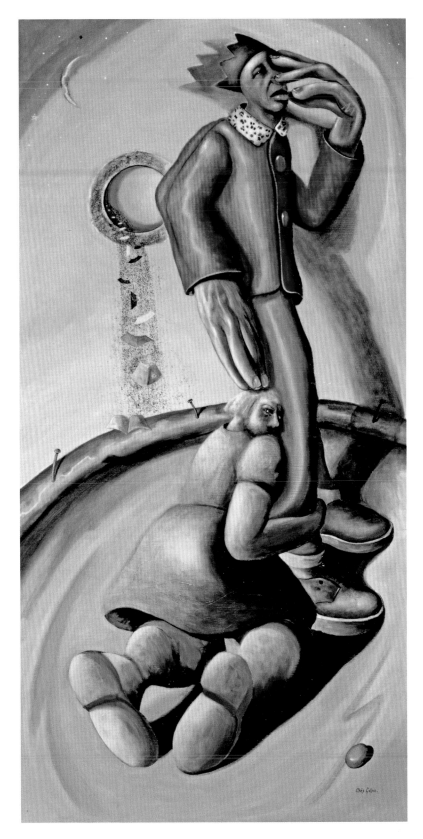

The King's Blessing
Mixed media on panel
122 x 61 cm (48 x 24 in.)
1997
Private collection

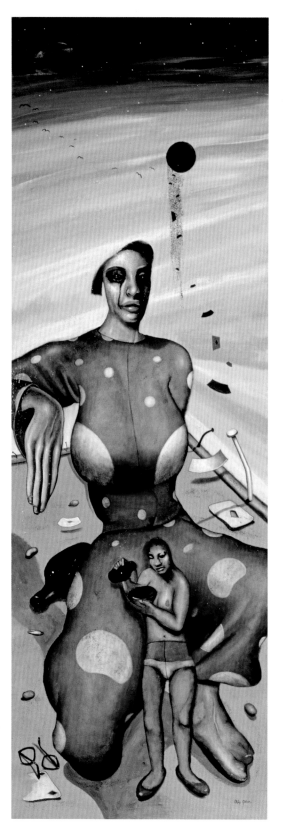

Welcome Home
Mixed media on panel
183 x 61 cm (72 x 24 in.)
1996
Private collection

Bad Day At The Office Dear?
Mixed media on panel
91.5 x 61 cm (36 x 24 in.)
1997
Private collection

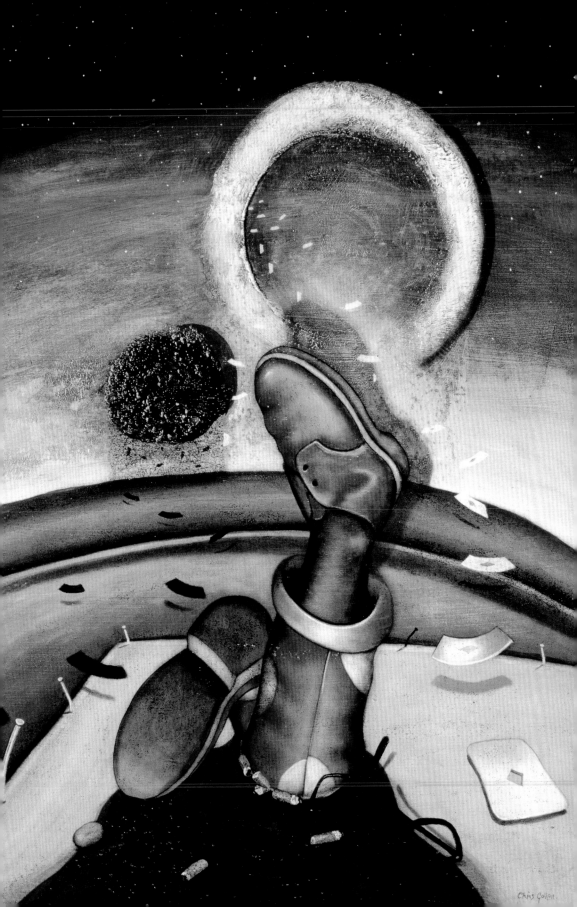

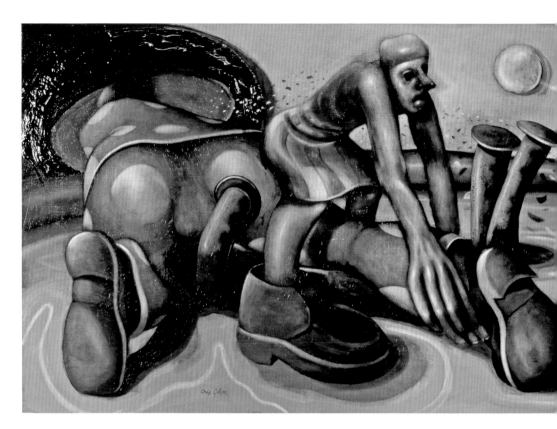

The Private View
Mixed media on panel
183 x 61 cm (72 x 24 in.)
1997
Private collection

This extraordinary work was painted towards the end of the *Narragonia*
series and is particularly powerful and ambiguous. The fallen figure, whose
head has dissolved into a swirling vortex, appears dead and is partially
diminished by a predatory nail looming over his leg, which is also held down
by an anxious woman. Towards the figures weave the pallbearers, a motley
assortment of clownish vagabond types, carrying an open coffin with little
regard for its safety. The leading pallbearer turns towards the viewer with
a raised hand in a reproachful gesture that either denies passage, or is
intended to block the view, indicating the viewer's supposed culpability for
the death of the man. The man is perhaps Gollon, or a conceptual notion
of 'the artist' or possibly even representative of art itself, which can be
eviscerated by 'the critics'. Aside from its multi-layered and complex content,
the painting is technically brilliant with the colours built up through many
thin glazes, following techniques ascribed to Titian and explained in Max
Doerner's book *The Materials of the Artist*, which lends the surface of the
painting a vibrant, luminous quality.

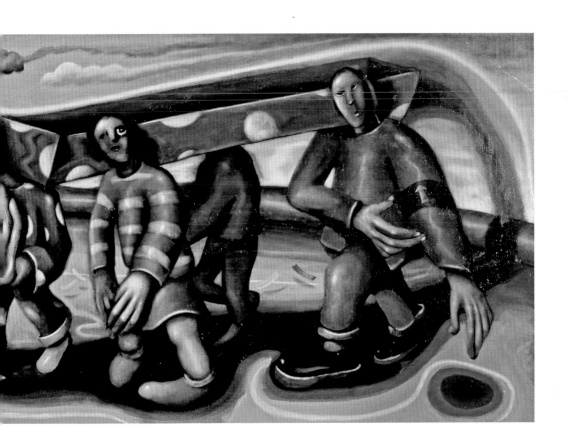

Gollon's use of nails, seen in *The Private View* and others, and a stage setting can again be traced back to the death of Keith Downey. Downey's burial was the first that Gollon had been to, and was an ostentatious affair, not without humour inadvertently supplied by the vicar who referred to Keith as Trevor throughout the entire service. It was the internment however that struck Gollon, particularly the synthetic grass surrounding the grave that had been folded back over the freshly turned earth, and held in place with large irregular nails. This mental image remained with the artist later evolving into his use of stage settings.

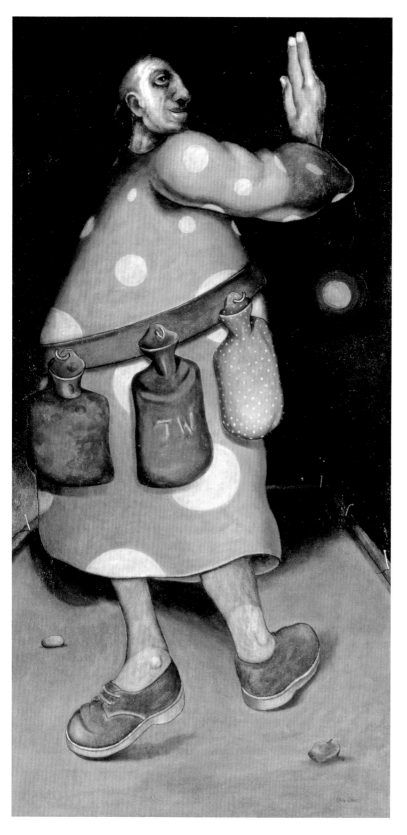

Figure On Road To Narragonia II
Mixed media on panel
122 x 61 cm (48 x 24 in.)
1995
Private collection

The absurd nature of the characters that populate the *Narragonia* paintings is heightened by their comical and clown-like clothing. Spotted garments such as the robe in *Figure on the Road to Narragonia II* (1995) feature largely, and can be seen again in *Prayer for a Return to a Previous Life* (1996) and the disturbing *The High Priest* (1996). The source for these green-and-white spotted clothes can be traced back to Gollon's school days and to an unfortunate friend whose eccentric father typically undertook the school run wearing a green-and-white spotted dressing gown, secured with a belt from which hung a hot-water bottle. Just such a character dominates the painting *Figure on the Road to Narragonia II*, but with an added Gollon twist the figure is impossibly, ludicrously formed. There is no sense of front or back, he appears to look one way, but his legs face the other, or perhaps his arms are back-to-front, and his heavy pendulous belly opposes the rest of his body. His gesture is one of praying, but his death-mask-like face registers no understanding of what he is praying for. He is the ultimate fool and, perhaps on account of his supposedly benign ridiculousness, he levies a little sympathy, but nothing is as it first seems in the work, which adds an element of tension.

A figure with similar outward appearance, though this time more physically correct, appears in *The High Priest* and the triptych *St Sebastian II* (1996), both of which have an obvious loose religious connection. Gollon's high priest is an inversion of the truth and as far from saintliness as possible. He appears more as a brutish thug than a man of God. He kneels with a shifty expression in his green-and-white robe, complete with water bottle. He also has a key, another recurrent piece of Gollonesque imagery. His head turns towards the viewer, eyes masked behind lurid spectacles, his lips obscenely thick and rubbery, set above a sharply protruding Adam's apple. He has raised his hands in a parody of religious gesture, yet instead of offering up prayer he is desperately waiting to receive something, and has an attitude of glutinous desire. Playing cards dealing his fate fall softly from a portal in the sky to lie abandoned at his feet, each card the same. In the background a figure attempts to straighten the bent nails that secure the tenuous platform world on which they exist, intimating humans' innate desire to unravel and destroy. Gollon has used a distortion of scale in the figures, which heightens the surrealism of the piece. A tiny man in the foreground with great long arms and huge hands smokes a cigarette, an apparently random addition, while next to him a larger and faceless girl reaches her hands towards the high priest, without knowing why she is doing it; her only directive being the tiny arrow pinned to her dress.

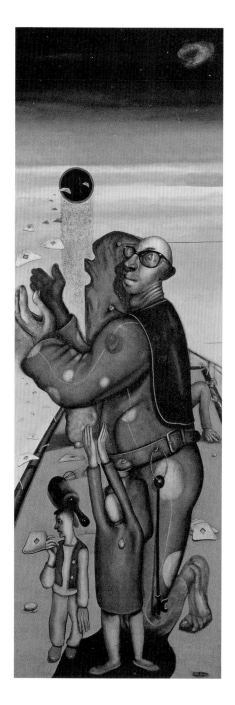

The High Priest
Mixed media on panel
183 x 61 cm (72 x 24 in.)
1996
Private collection

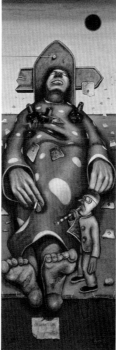

St Sebastian II Triptych

The Devotee I
St Sebastian II
The Devotee II

Mixed media on panel
35.5 x 30.5 cm (14 x 12 in.)
183 x 61 cm (72 x 24 in.)
35.5 x 30.5 cm (14 x 12 in.)
1996
Private collection

This complex painting is ambiguous in meaning, and like many Gollon works is open to a number of possible interpretations. It could feasibly be an attack on religion, implying hypocrisy and corruption within the religious orders, and so fit neatly with Bosch's *Ship of Fools*. In light of Gollon's general ideology it is more likely that the painting is a comment on humankind in general, on the conceit and greed of people, represented here by the high priest who has no affiliation with priesthood and is a self-appointed figure of authority. It further implies, through the unreasoning supplication of the faceless girl, the implicit danger, and power of corrupt leadership.

The triptych of *St Sebastian II* presents a rather different aspect of a supposedly religious figure, and is a striking display of Gollon's technical skills as a painter. The central panel, which depicts the dead saint with tremendous foreshortening, recalls Andrea Mantegna's (*c.* 1431–1506) *Dead Christ* (*c.* 1480). It is a truly masterful piece of work. The figure wears what has become a characteristic Gollon garment: a long, spotted robe. He is squeezed into the pictorial space, his head jammed against a make-shift headstone, more road sign than gravestone, and his great, rough feet, project out of the picture towards the viewer. His feet, with their yellowed, thickened nails and sticking plasters are back-to-front, implying his legs must be crossed underneath his robe, or are they? In Gollon fashion the artist has left it rather ambiguous, encouraging the viewer to really look at the painting, rather than simply to see it. The saint's hands are large and coarse: one grasps a dead cigarette, the other curls in pain and reflects the grimace of agony on his face.

Over the course of Gollon's career hands have become increasingly important. In his later paintings in particular he uses them as expressive tools, reflecting emotion and thoughts, especially in figurative works that are faceless or have semi-obscured facial features. Gollon's treatment of St Sebastian's hands is an early example of the artist beginning to explore the effects of distorting hands, enlarging them, giving them their own identity and allowing them to become important commentators on the rest of the painting. Here the hand holding the cigarette symbolises the sins of man, while the other, curled in pain, alludes to the outcome of those sins. The upper body of the saint is pierced with bottles, a fairly obvious metaphor for the collective 'sins of man', while buried sideways in the torso can just be seen a heart, taking the form of a macabre cookie cutter. At his feet is a peculiar little man, blowing a party hooter with no joy, his hands reduced to mere suggestions, like paper cut-outs. From inside his jacket pokes a £10 note, indicating perhaps that he is open to bribery, or possibly alluding to his role as a modern day Charon, the ferryman of the Underworld in Greek mythology, who was paid a coin to transport newly deceased souls from the land of the living across the river Styx to the world of the dead.

In the sky hangs a morbid black orb, which is neither sun nor moon, and is repeated (possibly suggesting the Trinity) in the two side panels of the triptych. Each of these side panels incorporates a head of a devotee, but both devotees have their eyes shut, indicating closed minds and a failure to recognise truth. A final point of particular interest in this work is the taut wire that stretches from St Sebastian's headstone, horizontally out of the picture frame. It raises the questions of what is it attached to and what is its purpose? These questions are left to the individual to work out, although compositionally it reflects an obvious structural integrity, balancing the weight of the black orb to the right of the picture. When studying the paintings as a complete series, however, it becomes apparent that this wire in fact stretches into the painting *The High Priest*, its other end nailed to the headstone in the background. Since these works were not originally intended to be viewed as a sequential series, this small detail can be attributed to Gollon's own sense of humour, and is a reflection of the artist playing with his pictures for his own entertainment. These two works are also the only two of the series that have a specific, albeit loosely, religious subject matter.

Strong women, seen in *Girl with Red Key* for example, feature in this series of paintings that primarily depicts spiritually weak men, although in fairness some of the characters like that in *Figure with Key* are androgynous in appearance and therefore representative of more general human conditions. *Figure with Key* depicts a pathetic, crouched figure set against a dark expansive sky and desolate landscape, the horizon punctured by small crosses. The figure is wearing a paper crown, a prop Gollon uses quite often including in *New Shoes for the King* (1996–1997) and *The King's Blessing* (1997). *New Shoes for the King* is an important work and was the first the artist exhibited alongside major public artists such as Maggi Hambling (b.1945) and Peter Howson (b.1958). The painting was created for the *Shadow of Life* exhibition at the Islington Art Fair (the curating was chaired by Dr Judith Collins, Assistant Keeper of the Modern Collection, Tate Gallery).

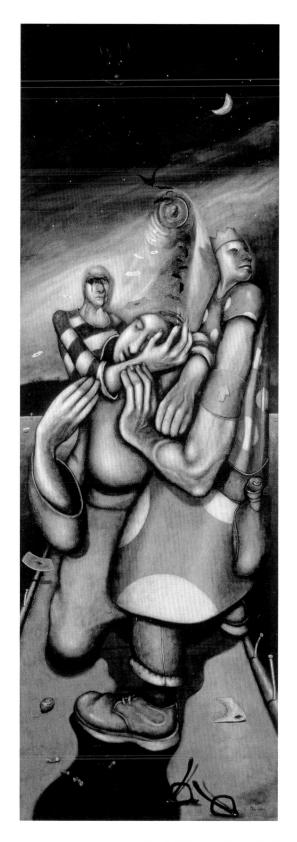

New Shoes For The King
Mixed media on panel
183 x 61 cm (72 x 24 in.)
1996/7
Private collection

With typical Gollon irony, the artist chose to depict a figure with its life ebbing away, being comforted by a burglar and a man obsessed with his own importance, the self-appointed king wearing his paper hat.

In the aforementioned three paintings the paper hat symbolises falsity, represented by a self-appointed king, who is not of course a king at all. *Figure with Key*, reflects the possible outcome of such bombastic behaviour, when superficiality peels away and reveals the small, tiny "self" inherent in pompous individuals. Here the character is caught in the despair of its own making. A key lies within its reach, but it is unable to help itself and makes no attempt to reach for it. Gollon uses keys with some frequency in this series of paintings, although the symbolism differs within each image. Here the key represents knowledge and self-awareness: by using the key the figure would be able to redeem itself, but it chooses not to.

The *Girl with Red Key* could not feel more different from this work. The focus of this painting is a striding girl, who sweeps across the canvas with a great sense of positive movement. Black streaks of mascara run from one eye suggesting she has been crying, but her demeanour is one of fortitude, of powering through a difficult situation. Behind her a trail of playing cards fall, with some intimated force, from an orb in the sky, turning into mysterious folded pieces of paper as they near the girl. At her feet lies a red key, slightly bent, and a little further away is a hole in the ground, possibly a keyhole. Unlike *Figure with Key*, where the character ignores the key and therefore denies self-awareness, here the girl has used it already and is on the path to enlightenment. The meaning of the work is fairly ambiguous, but it can plausibly be rationalised as a commentary about taking on life as it comes, about bravery and rising to an occasion. Alternatively, and if considering the works within the context of the title of the *Narragonia* series, it could be seen rather more bleakly, since it can be conjectured that the key is meaningless as the characters are inhabiting Fool's Paradise, where nothing is real, there are no doors (conceptual or otherwise) and no locks and therefore any key is defunct.

A similarly strident female figure is seen in *Entrance to Narragonia* (1996), although she too is again a slight contradiction, with her strong body language at odds with her mascara-streaked cheeks. The figure leans forward towards the front of the canvas in a beckoning manner, inviting the viewer to enter Narragonia, but she offers a far-from-welcoming reception. She is the gatekeeper in essence, the doorman to Fool's Paradise, but little behind her alludes to a land of plenty; the landscape is instead small, surreal and desolate. Seemingly there is not much on offer in this Narragonia with any anticipation of pleasure severely marginalised. The desolation of the place is emphasised by a stark and dead tree in the background, under whose comfortless branches is a faceless and foolish figure mincing on tiny feet, and reiterating the invitation to enter. This is an early example of Gollon using a faceless figure, which is a technique that he returns to time and again through his career, and to the present, evolving the concept of expression and identity despite the lack of facial features. This concept is not yet formulated here in this small figure, but already the artist has established its

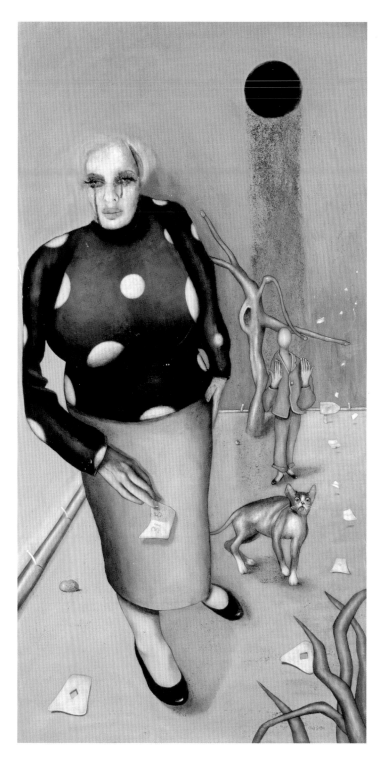

Entrance To Narragonia
Mixred media on panel
122 x 61 cm (48 x 24 in.)
1996
Private collection

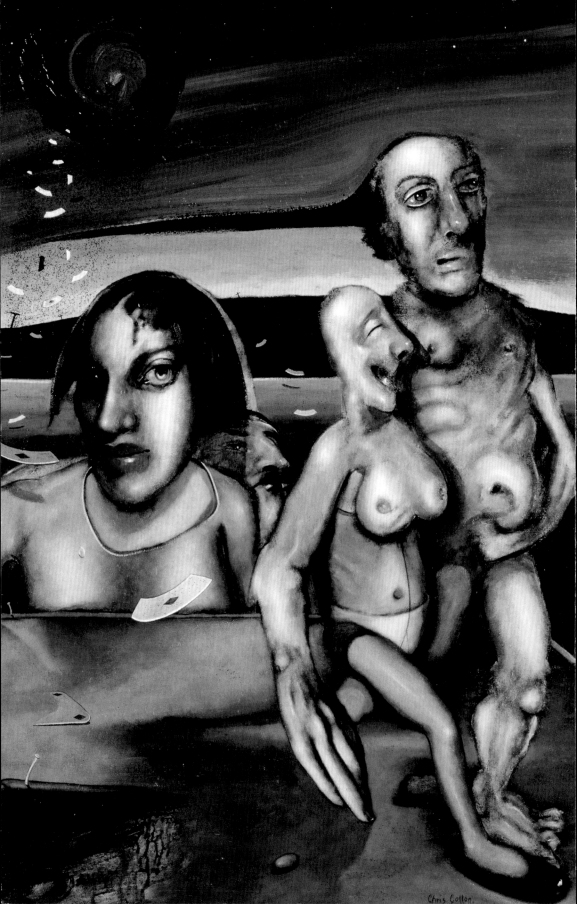

Chris Cotton.

inherent foolishness despite a lack of expression. Balancing the morbidity of the tree is a rather predatory green plant in the foreground, which hints perhaps at some form of life. This peculiar plant form is one that recurs in Gollon's work and can be seen in some of his still life and landscape paintings. It has no direct botanical source but is loosely based on territorial plants that are all but encroaching on Gollon's studio space in Surrey.

Despite the overwhelming negative aspect of this work the woman herself is rather attractive in a perverse sort of way. Her face is particularly delicately painted, and although her body is distorted and her eyes blackened, she has the appearance of once being a beauty. Flashes of beauty appear relatively frequently in Gollon's figurative work, and often on figures that are otherwise compromised. This is particularly well illustrated in *An Evening Walk* (1997), a painting that displays both enormous, unpalatable ugliness and profound beauty. It is a particularly difficult work to come to terms with, which is precisely the point of the painting, and underlines Gollon's starkly honest approach. He wants the viewer to question their reaction to the abject ugliness of the figures, to question the line between sympathy and revulsion, and to understand the temporal, frail nature of beauty that decays with each passing day. It is in a sense a last judgement piece, but there is no God to judge, instead the viewer is intimated as judge and jury of human destiny, which is both arguably more frightening and more applicable to modern society. With destiny and fate in mind, it is interesting to note that although the work contains the playing cards, which are characteristic of this series, it is the only work in the series to contain a card bearing anything other than an ace. Buried in the earth at the front of the picture is a card with two diamonds visible on it, while many of the other cards are completely blank. The suggestion here, based on consideration of the other paintings in the series, is that in this instance fate remains undecided.

The work is split into two juxtaposed worlds, one of which transpires on his characteristic stage setting in the foreground, the other unfolding behind this and occupying the middle and background of the pictorial space. Two grotesque and hideously ugly figures emerge from an open grave in the first world. Both figures are grossly distorted, but the woman appears oblivious to her state and is happy and cackling. Her male companion wears a less cheerful demeanour. Both figures are evolving into something else, their physical form melting to form matter of a different sort, perhaps referencing the gradual decay and changes of the body after death. The man's hair has merged into the dark line of sky in the background, joining the two worlds and emphasising the sense of organic attachment between body and earth; they have risen up from the grave and are melting into the landscape.

Rising up behind these two figures, and occupying the second world is a strikingly beautiful girl who stares towards the viewer with a mixture of pain and anxiety. Barely visible behind her hovers the half formed face of a man, which again emerges from the landscape, with no real context. Proportions and scale are vastly distorted in the work to increase the unsettling and surreal nature of the scene. Gollon's intention with this highly complex painting is to address human instinct and reaction when faced with

something outwardly "abnormal". The work was loosely inspired by two separate occasions in the artist's life, the first of which occurred in boyhood. As a young boy Gollon and his friend Keith Downey had climbed over the perimeter wall of a local psychiatric institution as a dare, and clambered onto a pile of old boxes to peer through the small, high windows of the building. They were unprepared for the sight they saw, a room full of severely disabled patients, many of whom had horrifying facial and head deformities. It was a scene that neither child had expected, if indeed they had given it any thought, and it was one that remained with the pair for many years to come. As an adult, Gollon was greatly affected by the voyeuristic nature of his boyhood discovery, and the adolescent compulsion, later deeply regretted, to stare in sick fascination.

The second passage of Gollon's life to inspire this painting, and one that effectively balances out the boyish prank, revolved around his daughter, Alice. A couple of years before he began on the *Narragonia* paintings Gollon's daughter became ill and spent a great deal of time in hospital. During his visits to see her the artist would go outside to have a cigarette, where he was joined by any number of patients for a smoke, many of whom had facial disfigurations or were wearing metal cage-like contraptions over their heads as part of their physical therapy. The patients were, like the cackling woman in his painting, outwardly immune to stares from passersby, while the passersby made little attempt to shield their fascination, and in some cases mockery. Gollon's daughter, represented by the beautiful girl in the painting, suffered her own share of traumas associated with her illness. This episode of illness and hospital trips has, understandably, had a profound influence on the artist despite his daughter's subsequent full recovery. In particular it has led to him drawing a very distinct line in his figurative work between a distortion of his figures and deforming them. In all respects Gollon's figures retain clear physical acuity, even when this is stretched to its furthest point through distortion such as elongating arms or increasing the size of hands. They are never depicted as specifically deformed, as in missing digits or taking their point of departure from recognisable medical conditions, which would run the risk of making them objects of voyeurism.

The artist used his family again as inspiration for the painting *Mother and Daughter* (1996), though in a more straightforward manner. The work is rather more optimistic than many of the *Narragonia* series and depicts the mother in a protective role. Her over-sized but elegant hands appear to ward off any impending trouble, while a certain nervousness in her face belies the apparent strength of her pose. The daughter leans in towards her mother, tucking her head beneath her elbow and clasping her with one arm. The shadows of the two figures join to form a single entity behind them, descriptive of their love, but neither figure is overtly joyful and both appear slightly apprehensive, which again relates back to his daughter's illness. The broken spectacles in the foreground are a characteristic piece of Gollon's imagery, probably included here to suggest 'love is blind'.

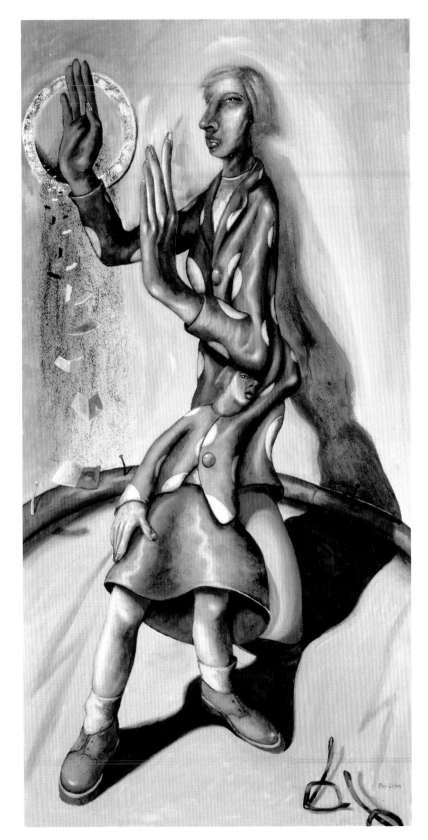

Mother And Daughter
Mixed media on panel
122 x 61 cm (48 x 24 in.)
1996
Private collection

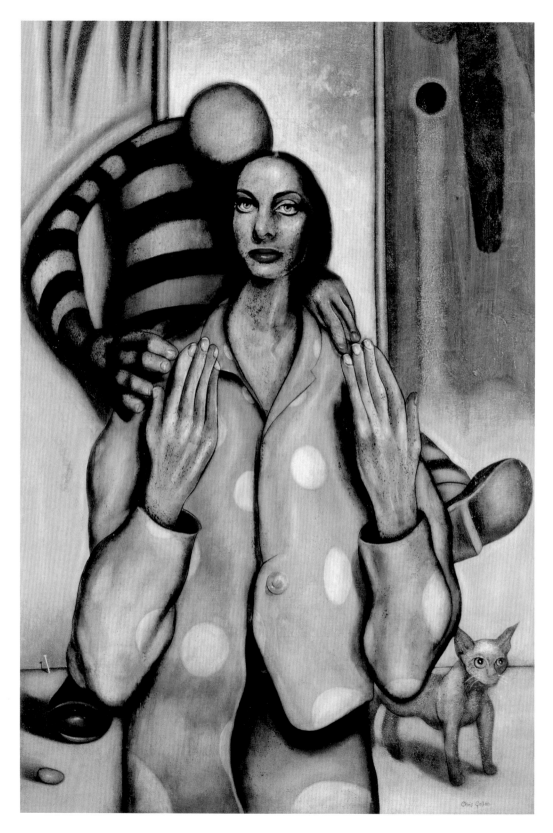

At around the same time Gollon painted *Mother and Son* and *Father and Son*, both of which refer to the artist's son Lawrence, who is now an art teacher. *Mother and Son* is a relatively common subject matter with its roots tracing back to religious imagery and those of the Virgin and Christ Child. In this painting Gollon has again used a distortion of scale to create a sense of discord, with the son being impossibly large in comparison to his mother on whose back he hangs. The oversized boy, with a blank face and wearing the striped top popularly associated with burglars, presents an unsettling image, while the mother's expression hovers delicately between nostalgia and doubt. The work was painted at a time when Lawrence was preparing to leave home, an event marked by an inevitable combination of joy and anxiety from both parties. The mother is rather beautiful with strong, elongated hands, which recall those painted by El Greco (1541–1614), who Gollon greatly admires. She is wearing a lopsided suit, the jacket of which is also seen in *Mother and Daughter*.

In these early paintings Gollon often uses distorted clothing, either jackets with impossibly long sleeves, mismatched trousers or irregular hemlines, which refer back to the artist's love of the ridiculous. The spotted jacket in this painting was one that the artist owned and had had made to order from an interesting character he had met in a local park. This was a shifty-looking Sicilian who Gollon met during the early 1990s and who introduced himself as the park keeper. Some months later, after they had developed an amicable relationship, it transpired that he was not a park keeper, but instead a tailor called Alfredo Mancini III. Not any tailor, as it turned out, but suit maker to the stars including such icons as Frank Sinatra and Dean Martin, all documented in old black-and-white photographs fading on the walls of his living room. His professional career was cut short due to an undisclosed wrangling, with some undisclosed perpetrators of Sicilian descent who had burnt down his shop and suggested he leave the area.

Gollon commissioned Alfredo (on the quiet) to make him a number of suits including the one in *Mother and Son*, and a silver-and-white one, with mother-of-pearl buttons, one arm longer than the other, and with a yellow stripe down one leg. The suit was as ridiculous as those in his paintings, although the artist did wear it on high days and holidays. Apparently the fashioning of such an ill-matched garment was deeply disturbing to the tailor/park keeper.

Gollon's love of the ridiculous allows him to paint inherently serious subjects in a manner that introduces an element of comedy, and so alleviates the weight of the subject matter without losing the fundamental meaning and intent. In many cases by introducing comedy, which is frequently done in a satirical way, the artist is able to intensify the content of the image by making it more palatable and able to be understood by a wider audience. This is seen in many of the paintings from the *Narragonia* series, and to particularly poignant effect in *Got to Give It Up* (1997). This painting was done at the end of the Narragonia series and can be considered quite transitional in terms of style between these early works and the series paintings that he subsequently moved on to. In *Got to Give It Up* he has retained the linear approach of the

Mother And Son
Mixed media on panel
122 x 61 cm (48 x 24 in.)
1996
Private collection

earlier *Narragonia* works, but there is a greater fluidity in his brushwork and the definition of the figure itself, with particularly subtle and effective use of colour to emphasise the contrast between the rotundity of the figure's form morphing into flatness as it melts into the ground.

The image is stark, simple and underlined with despair, yet is also marked with a sense of the ridiculous, heightened by the one remaining shoe. It is a subject of universal appeal that reflects despondency and frustration in equal measures, both of which are identifiable to the wider audience. Although the subject could be attributed to any number of personal issues in general terms, the driving inspiration behind the painting came again from Gollon's friend Keith Downey. The painting was conceived years previously while Gollon and Keith Downey were driving through California listening to the band Talk Talk on the stereo. Downey had recently married a wealthy American lady and moved to the "land of plenty", persuading Gollon to come over shortly afterwards to sell some paintings. Although ostensibly a working holiday, the trip quickly escalated into "one hell of a road trip", which ended when the pair, liberated on alcohol climbed over the shark netting in Ventura Bay for a kick. The coastguards were unimpressed, and the incident became something of a reality call for the artist who subsequently persuaded his friend to try and give up drinking, while he gave up smoking. The latter is a subject that Gollon has returned to several times over the years, his paintings dealing with the nicotine monster being rather more effective than his actual attempts to divorce her.

Got To Give It Up
Mixed media on panel
122 x 61 cm (48 x 24 in.)
1997
Private collection

'Gollon & his wife Anne (aged 26 and 24 respectively)' *photos by Keith West and Kim Middleton*

'Chris Gollon (c. 1972)' *photo by Kim Middleton*

'Gollon and his wife Anne at a nightclub' (c.1979)
photo by Don Mckernan

'Gollon in leather jacket' *photo by Keith Downey*

'Gollon in his early 30s (II)' *photo by Kim Middleton*

'David Tregunna around the time he and Chris Gollon first met and developing his "winning smile" ' *photo by Andy Hammond*

'Keith Downey at Fisherman's Wharf, San Francisco "in his best new blue jeans"' *(property of Marcus Downey)*

'Gollon with Keith West' (1980s) *photo by Anne Gollon*

'Gollon touring America' (1989) *photo by Keith Downey*

'Gollon touring America (Nevada Desert)' *photo by Keith Downey*

'Steve Howe of 'Yes' posing for a Gollon portrait'
photo by Chris Gollon

'Gollon happy to be on Cannery Row, California' (1989)
photo by Keith Downey

'Lawrence Gollon and friend Simon Crosthwaite posing for
'*Cap in Hand*' *photo by Chris Gollon*

'Kim Middleton leaving, never to be seen again (early 1990s)'
photo by Chris Gollon

'Gollon (mid 1990s)' *photo by Anne Gollon*

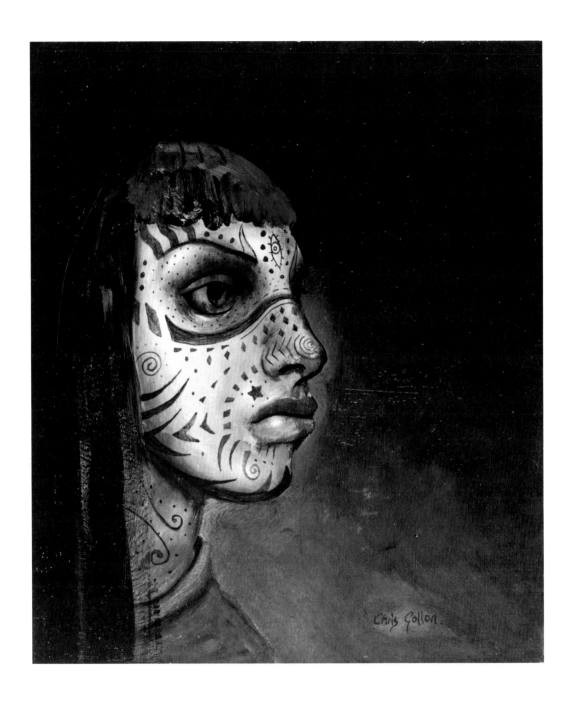

Chapter Three
THE SERIES PAINTINGS

In the early 1990s Gollon's friend the ever-flamboyant Mr Downey persuaded his wealthy girlfriend to marry him, while they were walking down Weymouth high street. He bought a suit and tie from a menswear shop and ducked into the local pub in search of a best man. His choice, and possibly the only patron of the morning, was a skinhead called Mervin whose entire face was covered in intricate tattoos. Downey, the girlfriend and Mervin duly tied the knot, with Mervin subsequently returning to his watering hole with a sausage roll and a crisp £20 note. Several years later Gollon, recalling Downey's description of Mervin painted *Best Man* (1995), which was one of the earliest of what can now be considered his series of *Heads* paintings. Two years later Gollon returned to the theme of tattooed faces and executed a number of exquisitely painted heads, including *Tattooed Woman* (1998). As with the majority of Gollon's works this painting was based on the artist's own general concept of a tattooed face, and was not taken directly from life, although there is tremendous sensitivity and realism in the depiction of the girl's pendulous and borderline-belligerent bottom lip. She has an ethereal beauty with a touching sense of inner frailty that counterbalances her more obviously defensive/aggressive nature.

Tattooed Woman
Acrylic on panel
35.5 x 30.5 cm (14 x 12 in.)
1998
Private collection

The precise and linear approach of the artist to his subject, seen to good effect in this work, is one that he retained predominantly, although not *exclusively* for some years. Just the year before *Tattooed Woman*, he painted *Portrait of Chaim Soutine* (1997), another work that can be grouped into the *Heads* series, and one marked by its thick impasto, painterly approach and richly textured surface; it could not be more different from *Tattooed Woman* in style and approach. This haunting image of the painter Chaim Soutine (1893–1943) was inspired in the first instance by the work of Amedeo Modigliani (1884–1920), whose own paintings Gollon had become acquainted with many years earlier. One of Gollon's earliest successful paintings, *The Cellist* (1989) is most obviously inspired by Modigliani's *Study for the Cellist* (1909) and to date the Italian artist has remained a barely discernible, but important, influence hovering on the peripheries of Gollon's world.

Modigliani had befriended the eccentric Russian artist Soutine after he moved to Paris in 1913, and subsequently painted him a number of times. It was after seeing Modigliani's 1915 portrait of Soutine that Gollon first became interested in the Russian painter and his extraordinary life, marked by the polarities of desperate poverty and eventual artistic success, thanks largely to the American collector Alfred C. Barnes. As a mark of his eccentricity, on selling his paintings to Barnes and earning some unaccustomed money, Soutine allegedly purchased fifty identical hats, just because he could. Unlike Gollon who paints largely *en tête*, Soutine painted only from the motive, and in quite literal terms. When attempting to paint a cover of Rembrandt's *The Slaughtered Ox* (1638), Soutine strung up a beef

carcass in his studio, the smell of decomposing flesh eventually driving his neighbours to file a police report. On researching the artist Gollon came across Soutine's *Self Portrait* (c. 1916), which further inspired Gollon's own image of the artist, an extraordinary work, unsettling and poignant in equal measure, underlined by a deep and effective use of colour. The painting depicts the artist before he has achieved success, and reflects the abject misery of his circumstances, yet there is also a suggestion of the artist's prescience of good fortune implied through his one striking and focused eye.

The series of *Heads* is perhaps more accurately described as a general theme, since it is a subject matter that Gollon has returned to regularly through his career, with no perceived notion of creating a specific series. For ease, however, the paintings are grouped together in this book. The *Heads* works are of particular interest since they have no conformity or linear timescale in style and approach, they do not necessarily relate to or reflect changes in the artist's style that are appearing in his other works at the time of painting, and they would appear most often to be construed by the artist in a different manner from that applied to his larger paintings. *Heads* as a whole offers a fascinating insight into the mind of the artist; the paintings are often whimsical and humorous, for example the many paintings of indistinct faces with enormous spectacles, and reveal the artist approaching his work in a more playful manner. Despite reflecting this playful approach they are in no way trite, and in almost all cases encapsulate a vivid emotion, a weighty idea or a complex layer of identifiable characteristics. In the painting *Ms Johnson* (2007), for example, Gollon has created a character who most people will have met at one time or other, and has done so with subtlety, effectiveness and tact. She is the formidable spinster, the pedantic maiden aunt, the classic indomitable secretary, stern, in control, prim and utterly orderly, yet Gollon captures her sensitive soul; she is full of emotion, she blushes, her lips belie a woman capable of, longing for and yet denied the joys of love. Beneath her prim exterior bubbles intensity and passion, and also acute, crippling self-consciousness. She is instantly a figure that endears herself to the viewer, the complexities of her nature and the comic aspect of such diversity treated with such sensitivity by the artist that although she is rather absurd, she is also wholly, sympathetically appreciated.

Some of the *Heads* images have clearly been painted rapidly and are the artistic equivalent of stream-of-consciousness thought. Their sketchy appearance suggests a study, yet they are not, in the most part, studies for larger works. They could be described as studies of humanity for the artist's own development. Alongside this sizeable collection of works are a number of *Heads* of a different sort, these are painted with a glassy precision and striking realism, works such as *A Pretty Girl* (2003) or *Girl Wearing a Red Hat* (2004). In some instances these works do act as preliminary studies, particularly in relation to *Dinner Dates*, a series of paintings executed in 2004. Interestingly, these realistic, portrait-like heads lack the depth and complexity found in Gollon's more painterly style and, although technically delivered, they remain a little flat.

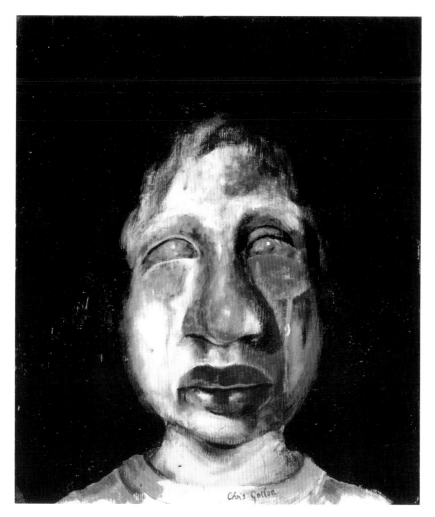

Portrait Of Chaim Soutine
Acrylic on panel
35.5 x 30.5 cm (14 x 12 in.)
1997
Private collection

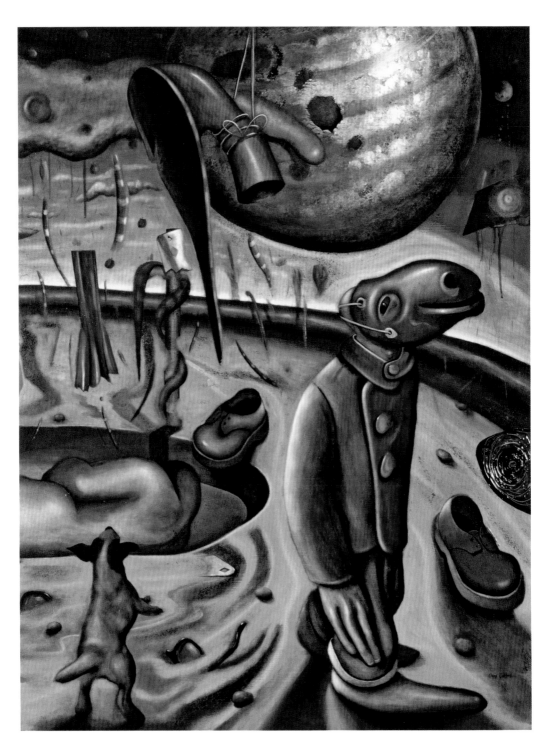

House Of Sleep
Acrylic on canvas
122 x 91.5 cm (48 x 36 in.)
1998
Private collection

In the early 1990s Gollon and his family moved to Weybridge, to a small flat overlooking Walton Bridge and the Thames, not far from the Oatlands Park Hotel where Edward Lear (1812–1888) once stayed. Lear, with his distinctive humour and brand of absurdity has unsurprisingly been a great source of amusement, and inspiration for the artist (see Chapter Four, *The Dong With A Luminous Nose* (2004)). After a studied search, in 1998 Gollon finally moved his studio out of the family's flat and to a unit on the historic Platts Eyot Island, a short walk down the towpath from his home. Platts Eyot was, particularly at that time and through the first years of the twenty-first century, an extraordinary and vibrant place and home to a number of recording studios and artists' studios. As an island, reached either by the ferry run by Barry the Bargeman, or by a footbridge, the place had developed a unique flavour and afforded a sense of other worldliness; a small kingdom peopled by musicians, artists and oddballs. One such character who combined all three was Gollon's neighbour on the island, an artist/musician/oddball affectionately known as Little Dick on account of his diminutive stature. Little Dick, who was a talented, academically trained figurative artist, rented a tiny studio next to Gollon's that housed an enormous old-fashioned safe, the kind with a great heavy door and a shiny round-handled lock. When times fell hard, Little Dick took up residence in the studio and slept in the safe, which Gollon routinely checked every morning to ensure that he had not been inadvertently locked in.

The island status of Platts Eyot was not without its drawbacks, primarily in reaching it. Gollon and David Tregunna, who was now his agent, found to their peril that walking a 1.8m x 1.2m (6ft x 4ft) canvas over the footbridge in a high wind was akin to paragliding, and detrimental to artist, agent and canvas. The ferry was generally the better option and closer to Gollon's home. Barry the Bargeman was summoned by a bell on the towpath (with a promise of never more than a 15-minute wait) and would duly glide the artist and materials across the Thames in a fittingly serene manner. It was the weekends that were to prove more difficult since Barry's substitutes were not *always* as expert or such timely bargemen as their boss, and on at least one occasion Gollon was tipped out of the boat and into the river complete with paintbrushes and packed lunch.

On one of his first trips over to the island, Gollon took the footbridge and noticed a cluster of girls surrounded by burly gentlemen drinking tea in the sunshine outside the island's café. They were, it transpired, the Spice Girls, back in their hey day, who were recording one of their albums in a unit not far from Gollon's. On the same sunny day as he walked towards his new studio, Gollon passed beneath a washing line hung with prosthetic arms and legs waving damply with fetishistic aplomb in a light wind. The combination of pop singers and prosthetic limb manufacturer would seem a fittingly bizarre backdrop for Gollon's own studio, where amongst one of the first works he painted was *House of Sleep* (1998), a heady combination of the surreal and disturbed. This work is of particular interest, and significantly although it was originally conceived as a one-off piece, Gollon would use the title of the painting some years later, in 2006, as the subject of a series of paintings.

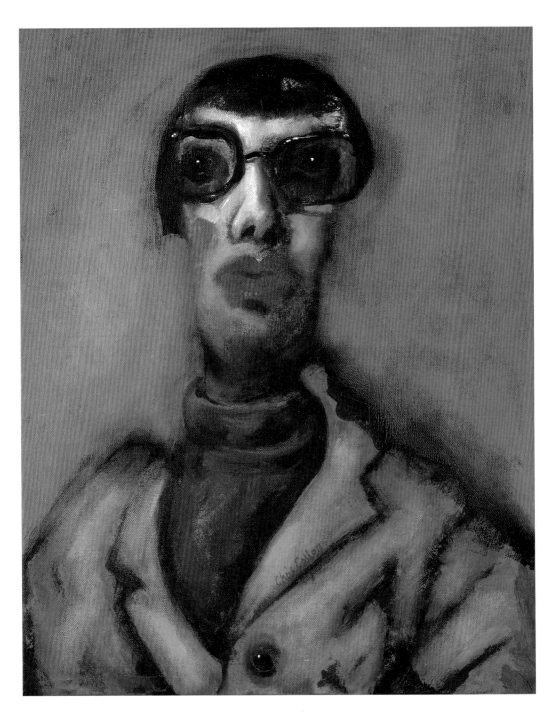

Ms Johnson
Acrylic on canvas
51 x 40.5 cm (20 x 16 in.)
2007
Private collection

The original work came about after Gollon was invited by musician Thurston Moore, of Sonic Youth fame, to submit a painting for a crossover exhibition of music and art called *Root*, which was held in 1998 at the Chisenhale Gallery, London. *Root* brought together a heady collection of artists and musicians, including Yoko Ono, David Bowie and Gavin Turk to create an exhilarating combination of music and art. Gollon's painting was based on a piece of music sent to him by Moore that, with its wind chimes and haunting notes, reminded the artist of Native American burial grounds.

The work combines reference to death and spirituality across different cultures, drawing on the influence of the Mexican muralist Diego Rivera (1886–1957) and Mexican death masks that Gollon had seen in an exhibition at the Glasgow print studios, as well as Native American influences, Greek mythology and Christian reference, reflected in the drooped cardinal's hat suspended behind the main figure. The cardinal's hat, an image that Gollon repeats in a number of works, was inspired after one of his frequent trips to the cathedral in Toledo, Spain, where the hats of dead cardinals are hung from the ceiling above their tombs, and remain there until they rot away. The title for the work references the house of the Greek god of sleep Hypnos and his son Morpheus, the god of dreams, while the curled, naked figure in the middle ground remains ambiguous, either sleeping or dead, or indeed implying a transitional existence experienced following death.

Shortly after completing *House of Sleep*, Gollon began work on his series, *In the Shadow of the Pleasure Dome* (1998–1999), which evolved as a natural progression, stylistically and metaphysically, from the former work. Other inspiration for the series came from Samuel Taylor Coleridge's (1772–1834) poem *Kubla Khan* and the Frankie Goes to Hollywood song *Welcome to the Pleasure Dome* (released in 1985), also based on Coleridge's poem. The concept of a "pleasure dome" as representative of a parallel universe, a place where anything (and nothing) can happen and all is beyond the control of normal expectations is a place tailor-made to Gollon's mode of expression. Here the absurd meets the ridiculous and shakes hands with the macabre, illustrated emphatically in the painting *Is It Time?* (1999). The work hangs delicately balanced between the sinister and the ridiculous with inherent humour tempering the concept of a deconstructing society. The title is an indication of the absurdity of the work, since it is without meaning. Gollon took the line from a children's television programme he saw many years earlier; one character turns to another and asks, "Is it time?" the second character replies, "time for what?" and the first character shrugs and says, "I don't know", therefore rendering the initial question pointless. The ridiculous theme is carried on by the bare-bottomed woman, inspired by the Spanish film maker Luis Buñuel's (1900–1983) satirical film *The Discreet Charm of the Bourgeoisie* (1972), as well as the strangely touching figure behind her, who could either be praying or about to engage in a fetishistic spanking. An upside-down character totters across floorboards in the sky watched by a leering skull, while a flute player acts as a pied piper to the lost souls in the foreground.

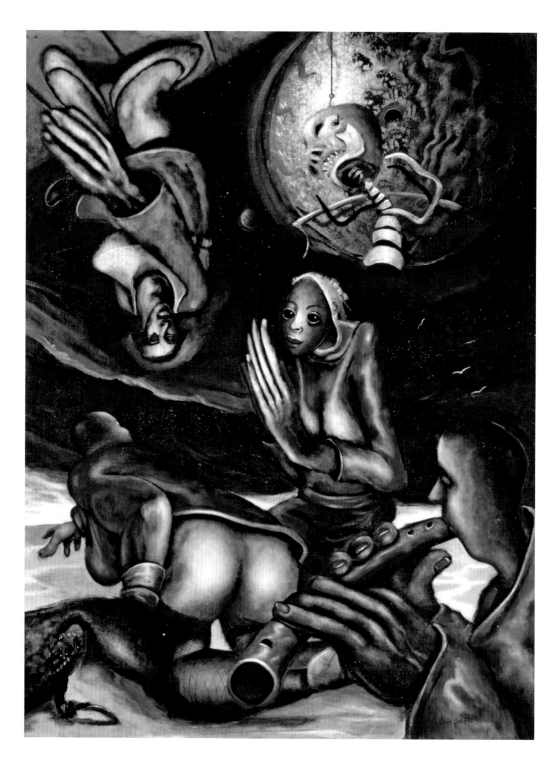

Is It Time?
Mixed media on panel
122 x 91.5 cm (48 x 36 in.)
1999
Private collection

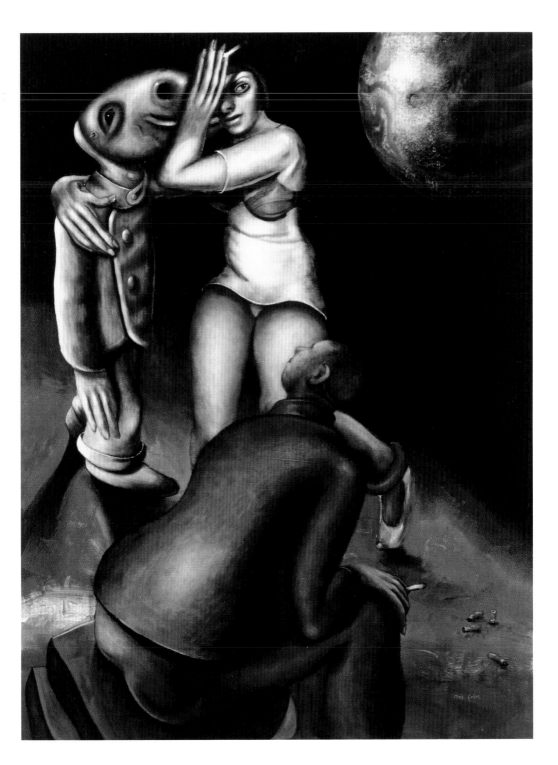

One Too Many
Mixed media on panel
122 x 91.5 cm (48 x 36 in.)
1998
Private collection

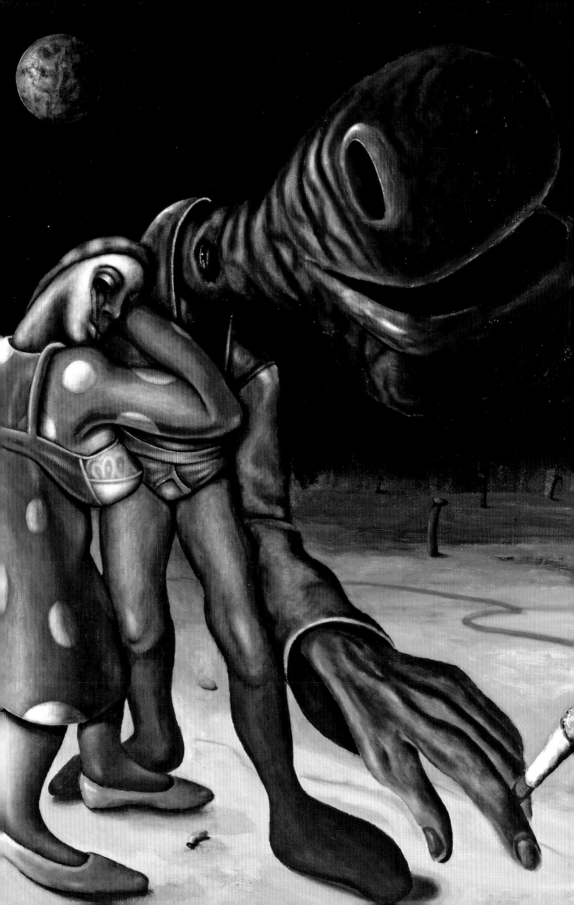

Gollon's use of an inverted figure is a device he has employed on several occasions, predominantly to imply the breakdown in natural order and the implication of human chaos, but has its visual roots in the circus, harking back to his days of frequenting Gerry Cottle's Circus when stationed at Addlestone Moor. The flute player is also a regular visitor to the Gollon canvas, and in almost all respects is a benign figure who adopts a watchful or salvationary presence. Underpinning the satirical humour in the painting is a profound statement on the degeneration of human behaviour, a statement that is lightened by the artist's implication that humanity has the ability to change this course. This is most clearly seen through the central figure as she debates her decision of either praying for or spanking the character in front of her.

One Too Many (1998) from the Pleasure Dome series is more straightforward in subject matter, but surprisingly in light of the vein of the series and this subject matter in particular, is construed with no palpable sense of threat. The scene is set in a suitably ambiguous dark, shadowy place, a recess of the Pleasure Dome, where pleasure seems mild at best. The female figure, with beautiful, elongated hands that recall the work of El Greco, is blatantly suffering from a night of excess, her skirt is hitched up and she wears her underwear on the outside of her top. The masked figure she clutches, who also appeared in House of Sleep and who is used frequently by the artist, is a benign figure; there is no sense that this girl is about to be taken advantage of. Similarly the seated figure in the foreground, who watches the couple, seems if anything, mildly curious about the two, rather than sexually implicit. Even the moon has a faint expression of kindly tolerance.

A rather more melancholic painting in the series is The Reunion (1998), though even here Gollon balances melancholia with a comedic turn, again dressing his figures with their underwear on the outside of their clothing, and grossly exaggerating the curious mask. Masks often appear in the artist's work, in varying stages of exaggeration, and are generally used to obvious effect, implying a sense of sanctity for the self-conscious to hide behind. In this painting the mask is barely separable from the figure who appears to be morphing into a vacuous monster of sorts. The female is passively happy with mascara-streaked cheeks indicating either her joy at a reunion, or her pain at the preceding separation. The artist presents two messages in the work, namely that love can be blind, the girl welcoming back her partner despite his morphosis, and also that the delicate nature of human relationships are inevitably compromised in some shape or form following a departure; nothing remains the same since spiritual evolution or devolution is an inevitability in the face of trauma.

An Evening Walk
Mixed media on panel
122 x 91.5 cm (48 x 36 in.)
1999
Private collection

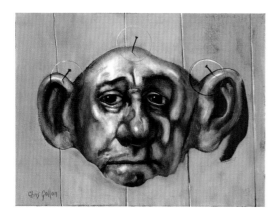

Rembrandt Lookalike XI
Acrylic on canvas
30.5 x 40.5 cm (12 x 16 in.)
2001
Private collection

One of the last paintings Gollon made in the series, *An Evening Walk* (1999), reflects a move away from the earlier *Pleasure Dome* works, and marks a natural end to the subject, leaving vice and folly, salaciousness and intemperance to their own end beneath the auspices of Pleasure. The painting is particularly lyrical and optimistic, underpinned by a sense of comfort and hope, although there is too that edge of ambiguity and absurdity that Gollon is unable to resist. Footsteps lead from the Pleasure Dome signpost towards a ladder propped against the sky, but stop before they get there indicating that the character who has made them is making a decision, whether to go on and enter the dangerously heady, velvet realms of the Pleasure Dome or to remain in their world. There is no figure present of course, which adds to the ridiculous, and raises the questions of where did it come from and where did it go? This concept was inspired by the words of one of Gollon's favourite comedians, Will Hay (1888–1949) along the lines of, "where did he come from? Where did he go? He walked the track with a sack on his back and his ear hole painted green." The words are absurd and without sense or meaning, but like many of Gollon's paintings are inherently funny and sad at the same time. Despite the missing figure there is the sense that it has, or will, make the right decision and stay in its own world, the inclusion of a rooftop being a particularly clever touch to imply domesticity, comfort and sanctity.

Gollon's series paintings are not premeditated; rather he is inspired in one particular instant to produce a painting from which he develops different concepts with a general theme. As he paints various works exploring these ideas they naturally evolve and eventually naturally come to an end. This process of working through an idea can be seen with striking clarity in his series *Rembrandt Lookalikes*, painted in 2001. The initial idea for the paintings was sparked by a private view at the Hayward Gallery, London, that Gollon and David Tregunna attended. Also present at the exhibition and for reasons unknown were, rather bizarrely, professional look-alikes of David Beckham and Tony Blair. It took Gollon and Tregunna several minutes, along with the other guests, to realise that the ill-matched duo were not the real

thing, which caused some amusement. Though an entertaining diversion it also re-ignited a formerly dormant train of thought in Gollon on the impetus behind imitation. The whole concept of look-alikes is (if done well) amusing, but why is it amusing? And what joy is there in pretending to be someone else? Originality is surely more challenging and therefore more rewarding. The same theory is obviously applied to art and in a sense underlines Gollon's particularly anti-establishment approach. For Gollon, painting in the manner of someone else is fairly absurd, but not quite as absurd as repeatedly painting the same motif in the same style (think Claude Monet's interminable *Haystacks*), which is precisely why, with perversity, he set upon a series of paintings of the same motif, that of Rembrandt's face, and began the series in a painterly manner not dissimilar to the Dutch artist. Through the series, however, Gollon gradually deconstructs the face so it becomes less and less Rembrandt, and more and more a self portrait, and clarifies his style, diminishing the textured brushstrokes, smoothing the paint surface and working towards greater linearity. The last image in the series, and one that again marked its natural end is *Rembrandt Lookalike XI*.

By this point the face has become a mask, half way between blatantly rubber yet disconcertingly still being flesh. Gollon's own likeness has started to slip away while Rembrandt's own face is a distant memory. The mask/ face is pinned to a wall, secured by three nails that Gollon has set within magnification circles. These circles provide focus and draw the eye away from the face completely, further underlining the ironic humour in the piece. The message is clear; there is little validity in imitation painting and little interest in repeating the same subject in the same manner. This attitude in part accounts for Gollon's singularity. It is not possible, or it would be incorrect to categorise him in any school or movement of art since his work does not conform to, or subscribe in technique or concept to any general group trend.

With this in mind it is important to acknowledge that Gollon has with some frequency over the years painted homage works to artists such as Max Beckmann (1884–1950), Otto Dix, El Greco, Pieter Breughel the elder (c. 1525–1569) and Hieronymus Bosch, all of whom he admires. These works are often strongly based on the other artist's work, but are manifestly Gollonesque in concept and execution and are not intended to imitate. For Gollon these paintings represent his admiration for the artist, but are also delivered with certain tongue-in-cheek humour and in his own idiosyncratic style.

Humour is again very evident in a series of paintings started in 2002, and inspired by a throwaway comment in a dark, smoke-filled nightclub. It was during a period when David Tregunna was single and living a bachelor's life to the full. Gollon and Tregunna had spent some hours in a small club in the noisy heart of London, talking to one of Gollon's collectors. Tregunna, on weaving his way to the bar, was sidetracked by a statuesque blonde, who after minimal small talk declared him a "stud muffin". Tregunna promptly imparted this to Gollon, who, with much amusement, set upon his *Stud Muffin* paintings.

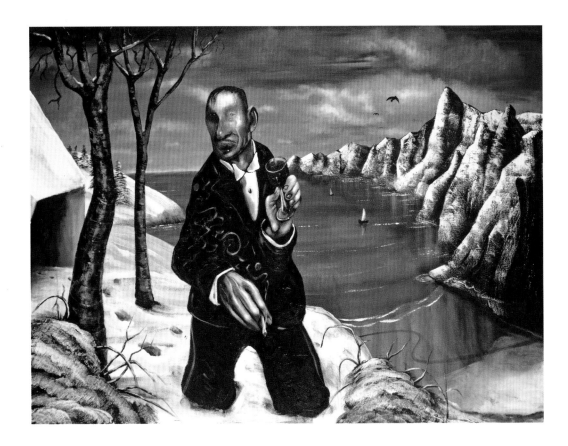

The paintings are construed in a light-hearted manner with each picture presenting a "stud muffin" of different character, from the debonair seen in *Stud Muffin I* to the gauche *Stud Muffin III* and the jaded in *The Party's Over*, which was the last work in the series. Despite the frivolous content of the paintings they are important examples of Gollon's crystal ability to present clearly identifiable characters and common human traits, and reveal the artist's developing use of haunting landscape. Each figure is set against a mysterious and sublimely beautiful landscape background that falls between the borders of the surreal and real. This is one of the first instances in the series paintings where the artist has concentrated on the landscape setting with equal intensity to his figurative subjects, and by referring to the same landscape in the different paintings also provides continuity from picture to picture. This practice of suggesting loose links between pictures based on recognisable landscape features reflects Gollon's concept of his series works as a type of road trip in paint, inspired by the songs of Bob Dylan, in particular *Desolation Row*.

Since David Tregunna was the inspiration behind the series, it is no surprise that one painting, *Stud Muffin VIII: Spring Heel Jack* (2002) was based on him. Spring Heel Jack was a character from Victorian folklore who could reputedly leap high in the air, surprise people and take advantage of them. He is a figure of shady repute whose appearance was described variously as devil-like or gentlemanly, with claws of steel, eyes of fire and breath of blue

The Party's Over
Acrylic on canvas
91.5 x 122 cm (36 x 48 in.)
2002
Private collection

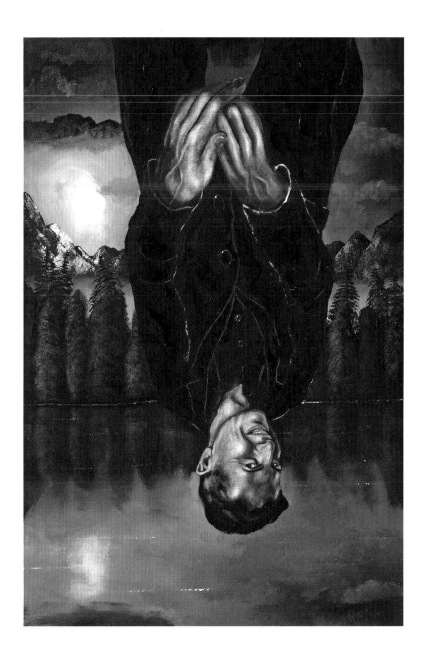

Stud Muffin VIII:
Spring Heel Jack
Acrylic on canvas
91.5 x 61 cm (36 x 24 in.)
2002
Private collection

and white flames. Gollon has taken the character of Spring Heel Jack and made him his own, creating a more benign and hapless character who can run upside down and uses his element of surprise to seduce ladies. This idea came through David who, in his youth, subscribed to, but altered the 80:20 rule when approaching women. The rule suggests you must be 80% certain of success before you make a move, and that when you do, you should make it surprising. David however, being an optimist, would invariably try a 1:99 approach, utilising a 1% chance of success as best he could, and laying on the surprise. On one occasion in Brussels, and armed with a 1% chance, he attempted to kiss a girl, who adroitly ducked sending David off balance and teetering over the back of a sofa.

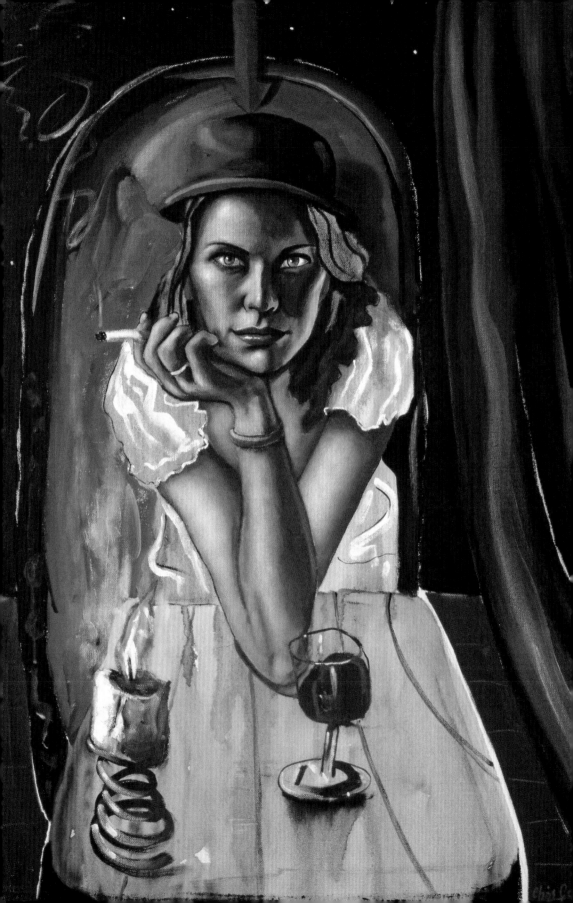

The Dining Companion III
Acrylic on canvas
91.5 x 61 cm (36 x 24 in.)
2000
Private collection

The *Stud Muffin* paintings were followed by a series called *Dinner Dates* (2001–2004), prompted by a recently divorced friend of Gollon's talking to him about the combination of fear and excitement surrounding being plunged back into the dating game. Gollon had always been a keen observer of human behaviour, but with the onset of *Dinner Dates* spent some time in restaurants and bars studying the body language of couples dating (though to his knowledge he was never reported as a stalker).

Study For Dinner Date II: The One
Acrylic on canvas
91.5 x 61 cm (36 x 24 in.)
2002
Private collection

Some years earlier Gollon had met Patte Griffith, an ex-model who was running a casting house, The Green Room, in London's Argyle Street. Gollon and Little Dick exhibited there and, over the years, became friends with Patte and several aspiring actresses and models. Patte herself has been painted frequently by Gollon, and appears in several of the *Dinner Dates* works, along with a model and former Miss Australia, called Jodie. The paintings are again quite obvious in their intention, and like the *Stud Muffins*, represent varying characters and their reactions to their date from being passionately interested as in *Study for Dinner Date II: The One* (2002) to blatant boredom. In *The Reluctant Dinner Date* (2004) an entire mountain range comes between the girl and her intolerable suitor. The works are predominantly painted in a very clear, dry and precise style and are technically virtuoso examples of characterisation, though subjectively lack depth and soul. The same cannot be said for one particular work in the series, *The Dining Companion III* (2000), which is painted with much greater feeling and expression, and as a consequence reflects Gollon's originality

to a much better degree. The figure melts out of the background, with a languid seductiveness; eyes dark and dewy, cheeks blushed by a sudden rush of blood, and lips, fiery-red, glistening with a single brilliant highlight. She is seductress and the seduced in one unit, blatantly sexually aware but also undermined by a certain uncomfortable self-consciousness. Gollon has employed his use of "highlighting boxes", or magnification areas, to create a fetishist, or voyeuristic atmosphere, and it is this that amplifies the character's sense of ill ease.

In 2004 and after completing the *Dinner Dates* paintings, Gollon became interested in Albert Einstein (1879–1955), triggered by the planned festivities for the forthcoming centenary of the publication of Einstein's theory of special relativity in 2005. His interest in the charismatic scientist, who when asked why he had not written his ideas down, replied that he had had only two, and was capable of remembering those, eventually led to a series of paintings, and an important large work now in a public collection. Gollon first began a number of portrait-like paintings, focusing on Einstein's face, which in typical Gollon fashion he gradually began to deconstruct. One of the earliest works titled simply *Einstein* (2004) reveals the man in perhaps his most accurate form, and shows Gollon's early use of arrows, or cursors, used here to emphasise Einstein's face. Gollon has, since this time, used arrows fairly regularly in his works, particularly in his monumental religious series, the *Fourteen Stations of the Cross* (2000–2009). Gollon changes the intent of these arrows from painting to painting, so they might serve to emphasise or highlight (much as his use of magnifying circles), be used as a deliberate diversion of attention, to create comedy, or as simple directional tools.

Following this initial painting Gollon made a number of works taking Einstein's face as his point of departure to work up further ideas such as *Einstein Lookalike I* (2004) where Gollon again addresses the art of impression with a tongue in cheek approach. Here his Einstein has adopted his own features, while with a further comedic turn, the painting *Portrait of Einstein Attempting to Resemble Another, That of Des Lynam, And Succeeding Without it Being Noticeable* (2004), is as its lengthy title suggests, a clever combination of scientist and television presenter. Further works depict Einstein in various emotional states, including two particularly touching paintings of him praying, *Einstein* and *Einstein IV* (both 2004). Towards the end of the year Gollon began work on *Einstein and the Jealous Monk* (2004) a large painting that reflects his imagination and originality to a far greater degree than the series of Einstein heads. The work was bought by the Huddersfield Art Gallery and exhibited temporarily alongside a number of Gollon's other Einstein paintings, and an Einstein bust by Sir Jacob Epstein (1880–1959). It was then moved to the museum's permanent collection and hangs alongside works by Francis Bacon (1909–92), Walter Sickert (1860–1942), L.S. Lowry (1887–1976) and Epstein.

Inspiration for the painting came from Bob Dylan's song *Desolation Row*. This song ranks among one of the artist's favourites, primarily due to the expressive and eclectic imagery that the words evoke, particularly the lines,

Einstein And The Jealous Monk
Acrylic on canvas
152 x 122 cm (60 x 48 in.)
2004
Huddersfield Art Gallery

"Einstein, disguised as Robin Hood, with his memories in a trunk, passed this way an hour ago, with his friend, a jealous monk ... you would not think to look at him, but he was famous long ago, for playing the electric violin, on Desolation Row." Gollon's intense and continuing study of humanity and the human condition is presented even here, in a work outwardly humorous. There is a riveting and divergent sense of randomness and logic in the painting, the two dichotic forces that collide within the greater spectrum, where suddenly, and presented as such, the ridiculous concept of Einstein playing an electric violin and being friends with a jealous monk seems entirely plausible. Though gently humorous, the painting is underpinned by melancholy. The figures collapse inwards their core strength crumbling despite the implied solidity of the monk's frame, and both seem frail in spirit. A heavy, brilliant sky of shot-yellow and sharp light adds to the unease, compounding the surrealism of the scene, which features a characteristic Gollon landscape in the background. This landscape reappears in differing forms through many of his works, lending continuity and familiarity to otherwise disparate paintings.

Study For Don Quixote Deciding
Upon His Course Of Knight Errantr
Acrylic on canvas
91.5 x 61 cm (36 x 24 in.)
2004
Private collection

Gollon turned again to his emotive yellow sky when painting the first study
in a short series of works based on Miguel de Cervantes (1547–1616) literary
masterpiece *Don Quixote* (1605–1615). This first work, *Study for Don Quixote
Deciding Upon his Course of Knight Errantry* (2004) was completed in study
form only, an unusual occurrence for the artist who rarely undertakes
studies. As it turned out he painted two studies, the second being *Study
for Sancho Panza* (2005), for the series as well as one finished work, *Her
Royal and Sovereign Highness Dulcinea Del Toboso* (2005), before moving
on to a new subject. To date this is the only series of paintings that has not
undergone Gollon's characteristic process of natural development from
start to finish, being hampered in part by commitments to his monumental
religious commission *Fourteen Stations of the Cross*. The most arresting

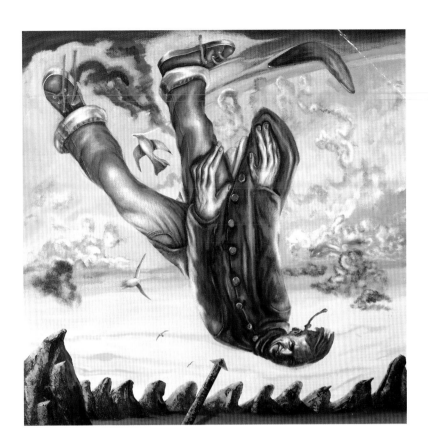

Study For Sancho Panza
Acrylic on canvas
102 x 102 cm (40 x 40 in.)
2005
Private collection

detail to be taken from these three paintings is Gollon's treatment of Don Quixote's hands in *Study for Don Quixote Deciding Upon his Course of Knight Errantry*. They are rendered particularly beautifully, combining the elongated gracefulness seen in El Greco's work with Gollon's own quirky exaggeration. In sharp contrast to the hands is the precisely drawn face of Don Quixote beneath whose coolly audacious exterior hovers the shadow of a self-portrait.

Gollon used David Tregunna as his model for the figure of Sancho Panza in *Study for Sancho Panza*, somewhat to Tregunna's annoyance, and has for comic reasons kept to himself, painted Tregunna upside down on several occasions. Possibly there is just cause in this instance since the painting refers to an episode in the story when Don Quixote refuses to pay his board and lodgings on the basis that knights errant should receive such hospitality for free. In anger the landlord and a gaggle of roughneck friends bounce Panza up into the air on a blanket, to see if any money might fall out of his pockets. Unusually for Gollon's work there is quite an element of motion in the painting, emphasised through his use of rather delicately painted, curling cloud formations, which are also atypical of his style.

Within the rhetoric of Gollon's oeuvre the *Don Quixote* paintings represent a pause, signalling a slight shift in direction for the artist's focus. Not a dramatic change of path but more a semi-colon in the body of his artistic development. Reviewing works directly prior to these, namely the *Einstein* series, it is apparent that the artist had begun to work increasingly in an

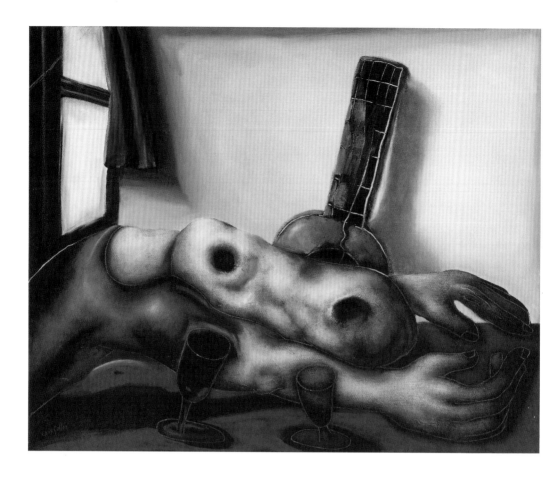

illustrative manner, which while effective for the Einstein paintings, has by the Don Quixote paintings become rather decorative and soulless. Considering the scope of the majority of Gollon's work, and the artist's innate ability to inject humanity and profound undercurrent into his paintings, it is no surprise that change was in the wind. In 2006, the same year that Gollon moved his studio from Platts Eyot to the Surrey countryside, he produced two of his most exciting series of paintings to that date, works of sensitivity and depth rendered in a newly evolving style.

The first of these series, *House of Sleep*, took its title from a painting done some years previously for Thurston Moore's *Root* exhibition. Gollon has taken the theme of gods Hypnos and Morpheus and their esoteric House of Sleep and created instead a rock-and-roll world peopled with strange ethereal characters who drift, most often with somnambulant torpor, through misty realms. Morpheus himself appears in the painting *Morning* (2006), sleeping off a night of music and drinking. Gollon's manifestation of the god of sleep is ambiguous: he appears part human, part something else, on the verge of some morphosis perhaps elicited by the onset of dawn. The scene is drenched with an unearthly light, a flood of softness that seems, in contrast to the implied party of the night before, eternally silent. Less is infinitely more moving than more in this work, with a simple splash of dazzling blue in the curtain and a breathtakingly opulent single smear of red in the wine

Morning
Acrylic on canvas
51 x 76 cm (20 x 30 in.)
2006
Private collection

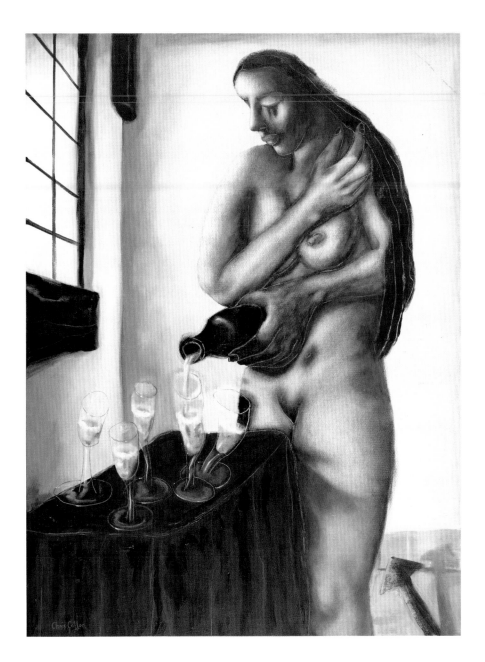

The Private View
Acrylic on canvas
102 x 76 cm (40 x 30 in.)
2006
Private collection

glass, taking the use of colour to an entirely new level of effectiveness. The same technique can be seen in the equally poignant painting, *The Private View* (2006), which is part of the same series. Here brilliant yellow fills champagne glasses, providing a striking colour source in a work otherwise markedly tonal in nature. Tonal, but within the soft tonal range, Gollon has created a spectrum of exquisite delicacy from the woman's pale, barely-blushed nipple to her translucent skin colouring, and the chilling cold white-blue light of winter beyond the window. An obvious parallel may be drawn between this painting and the works of Jan Vermeer (1632–1675) in structure certainly, and in the evocation of atmospheric light, which is not in itself a characteristic Gollon technique.

Most significant in the painting is the artist's approach to the figure, an approach discussed in detail in the next chapter. Gollon's former linearity is seen to slide away in place of greater freedom in his brushwork, symbiotically allowing him greater freedom in the configuration of his figures; so here the woman has fluidity and presence despite obvious physical distortions. She is beautiful and monumental; an icon of womanhood caught with one foot in the physical world and one in a different, ghostly place of big ideas and misplaced souls. Conversely she is also objectified, watched and uncomfortable. Gollon has again injected a little quirkiness, using the title as a pun and ensuring that any casual observer of this work is aware they have become an unwitting voyeur.

There is a similar voyeuristic flavour to the painting *If That's All There is Let's Break Out the Booze* (2006), which forms part of his series *Is That All There Is?* (2006). This series was partially inspired by the song of the same name made famous by Peggy Lee, which is outwardly profoundly depressing in spirit, and with diluted nihilism, suggests that fundamentally life is a disappointment. This is tempered however by the idea that since this is the case then it is paramount to live life to its fullest advantage. Gollon used this basic premise to work up his series, taking the song lyrics as a point of departure and creating his own resonance and ideas for the subsequent paintings. *If That's All There is Let's Break Out the Booze* relates a big story in a single frame, referencing a time of poignant reflection for a young girl in a moment of post-sexual encounter. It is a work of great soulfulness that can be representative of the theme of disappointment in general life, connecting with, and touching the audience in a universal manner. The negativity of the subject matter is countered by the exquisitely painted scene, which again reflects Gollon's tremendous use of colour. The girl's breasts are swollen and tactile, engorged and nurturing, simultaneously evoking woman as sexual entity and maternal sanctuary. Many of Gollon's paintings are laced with a subtle seductive quality that caresses the sentient core of his audience with secret finesse, but rarely are his subjects as blatantly sexualised as the contemplative girl in this painting. Her single exposed breast is both shocking and tantalisingly real, making the piece highly emotive on all fronts.

If That's All There Is Let's Break Out the Booze and Have a Ball (2006) is from the same series of works and yet could not be conceived more differently. This is Gollon revisiting his love of the ridiculous and embracing the absurd, but even here in a painting so comic and joyous, there is a tight underlying message. The painting refers, of course, back to the song performed by Peggy Lee and illustrates with obvious clarity two figures carousing with gleeful abandonment. It also refers to a conversation Gollon had with a friend concerning the apparent indignity of anyone over thirty-five years old dancing. The friend maintained that the spectacle of over thirty-five year olds dancing was embarrassing, and that people of a "certain age" should behave more appropriately. The general concept of older people enjoying themselves was further emphasised to the artist when his daughter expressed abject horror at the thought of her eighty-year-old grandmother remarrying (Fred from her whist drive). Both caused Gollon to paint a picture of an elderly couple dancing with utter flagrance, and comically nude, blatantly driving

If That's All There Is Let's Break Out The Booze
Acrylic on canvas
74 x 61 cm (29 x 24 in.)
2006
Private collection

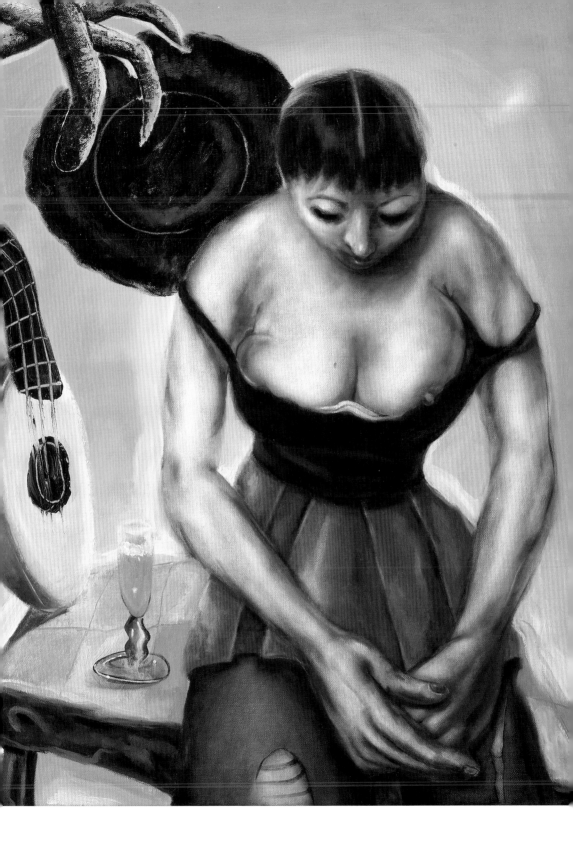

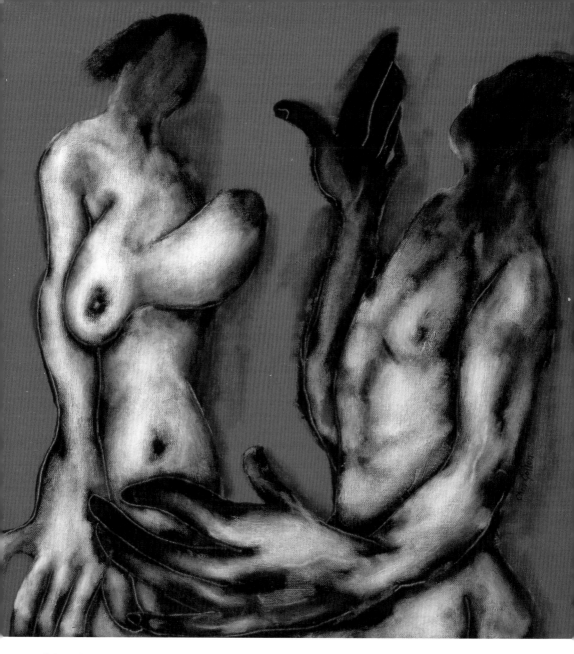

**If That's All There Is Let's Break Out
The Booze And Have A Ball**
Acrylic on canvas
61 x 61 cm (24 x 24 in.)
2006
Private collection

home his point that joy at any age is precious. There is perhaps no better expression of undiluted self-confidence and glee than the woman's breasts, which dance somewhat independently of the figure, with the passion and fervour of the work heightened through his use of brilliant, pulsating red as a backdrop.

This series of paintings marks the true beginnings of Gollon's maturing style, which continues to evolve greater form and clarity through his paintings from 2008 and 2009. Despite an overall profound development in his style, particularly at this time, the artist is capable of working in different styles simultaneously. This has already been illustrated earlier in the chapter through comparison with his *Heads* series and other works made at the same time, but becomes most apparent when the artist is working to a commission. His largest commission to date, the monumental *Fourteen Stations of the Cross*, can be considered quite separate from other works made during the ten years it took to complete the religious commission. Equally, in 2007 and at a time when his style was evolving towards abstraction, he painted the fantastically unusual *Gollon at Henley* series, based around a commissioned work, which is more similar in feel to his earlier linear manner.

The roots for this series can be traced back to 2001, to when Gollon had his studio on Platts Eyot island. As an artist working in such close proximity to the river Thames, his work came to the attention of Paul Mainds, Trustee & Chief Executive of the River & Rowing Museum, Henley-on-Thames. Mainds invited Gollon to stage a solo exhibition of his work as one of several exhibitions including John Piper (1903–92), reflecting how the Thames had affected their paintings. Gollon painted the exquisite *Big Fish Eat Little Fish* triptych for the exhibition along with a number of smaller studies, all executed with a combination of striking realism and characteristically Gollonesque quirkiness. The haunting atmospheric effects and naturalism of these works makes them particularly isolated within the artist's oeuvre, and demonstrates the extraordinary scope of his abilities. Before he commenced painting the triptych Gollon immersed himself in the river not far from his studio to study the effects of light as it filters down through the water; a quite remarkable venture considering his paranoid fear of fish. The painting was a huge success and was purchased by the museum with help from the Victoria & Albert Museum.

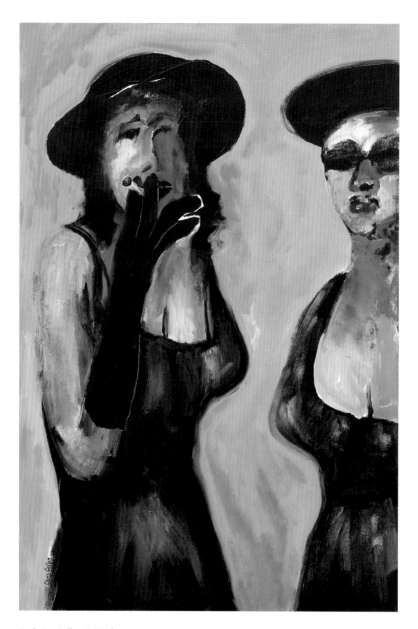

Study For Gollon At Henley:
Crowd I
Acrylic on canvas
91 x 61 cm (30 x 24 in.)
2007
Private collection

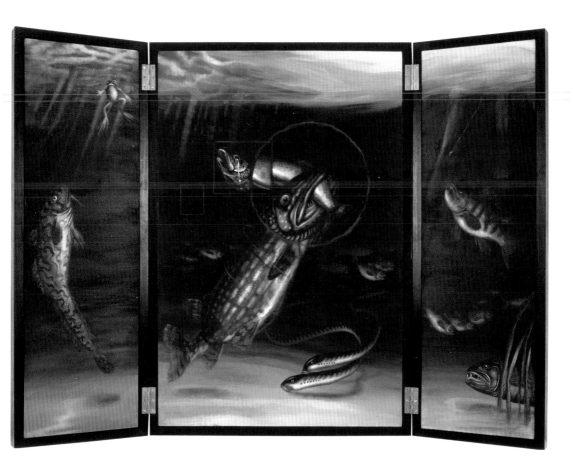

In 2006 Mainds contacted Gollon and David Tregunna again, inviting them to attend the famous Henley Royal Regatta, where they were wined and dined with the crème de la crème of the rowing fraternity. While attending a fabulous drinks party on board David Sherriff's University College (Oxford) barge, Mainds asked Gollon how, if given the choice, he would paint the Regatta. With little pause for thought Gollon replied in words to the effect that since rowing only recognises the winners and no runners-up, he would depict the losing crew, giving them their moment of acknowledgement. This concept appealed to Mainds, who subsequently commissioned Gollon to paint *Gollon at Henley*, reflecting the artist's own vision of the Regatta. In 2007 Gollon was given a cherished silver pass badge allowing him access to all areas at the Regatta to enable his research for the painting, and shortly afterwards began work. He executed a number of studies and a series of silk screen prints, characterising the pain and disappointment of losing from the rowers' perspective, as well as addressing the reactions of the crowds to the losing rowers, and eventually produced two versions of the finished painting. Of some concern to the artist, who periodically lacks self-confidence, was the knowledge that his work would be exhibited alongside Raoul Dufy's (1877–1953) painting *Regatta at Henley* (*c.* early 1930s). As it turned out when Gollon's painting was unveiled in an exhibition opened by Regatta Chairman Mike Sweeney, it was a resounding success and a testament to the strength, courage and tenacity demanded by the sport, regardless of being a winner or a loser.

Big Fish Eat Little Fish Triptych
Mixed media on canvas
91.5 x 117 cm (36 x 46 in.)
2002
*River & Rowing Museum,
Henley-on-Thames*

Overleaf
Gollon At Henley
Acrylic on canvas
91.5 x 122 cm (36 x 48 in.)
2008
*River & Rowing Museum,
Henley-on-Thames*

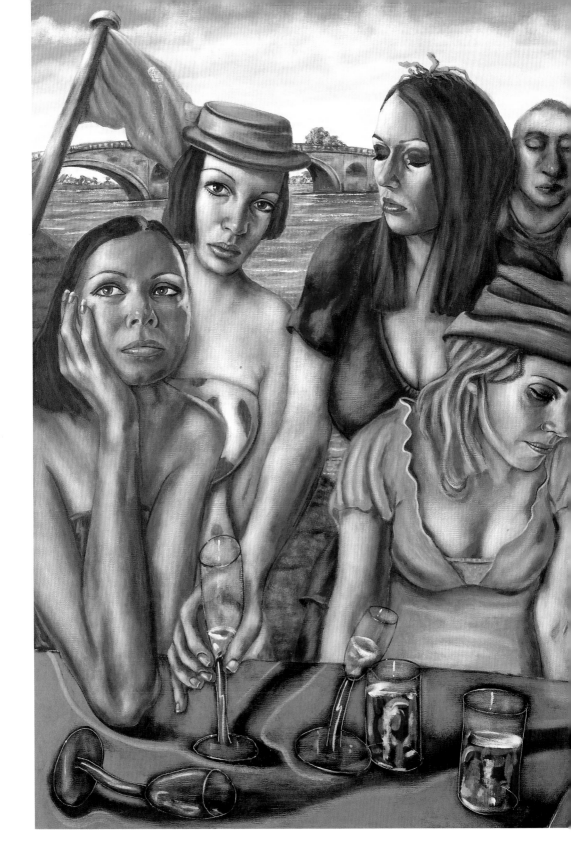

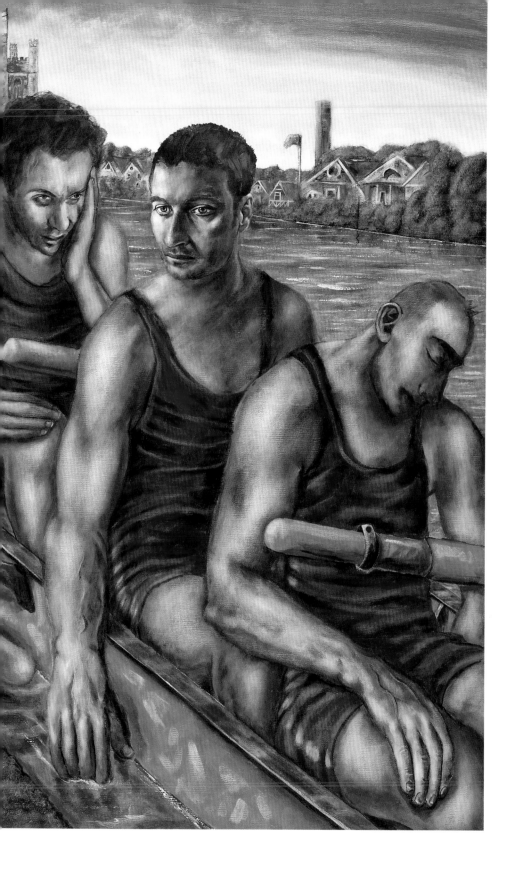

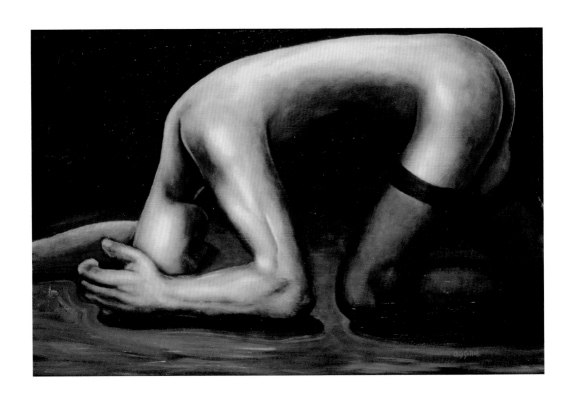

Chapter Four
FIGURATIVE PAINTINGS

Many of Gollon's figurative works have their origins in Gollon's early artistic career. When he was in his twenties, he had to spend time in hospital suffering from an affliction more commonly associated with older people. As a result he was placed on a geriatric ward, armed with nothing but his sketchpad and a sense of humour. On one side of Gollon's bed lay Reginald, a Scottish patient who repeated unendingly in a rich, burred accent, "Dear oh dear Charlie, my dinner is stone cold". This went on throughout the day and night. On Gollon's other side was Jack. For reasons unknown Jack called Gollon "Katherine"; he also responded to Reginald's words with the phrase "Please don't put black dogs in my bed". Opposite Gollon was Max a retired banker, devoid of humour or patience. One morning, after Reginald and Jack had engaged in their ridiculous conversation throughout breakfast, Max reared up, wild eyed and furious, declared he would kill them both. He hurled himself out of bed and landed on his infected foot, which promptly ruptured causing pandemonium on the ward. With the inexplicable perversity of human nature, following the incident Reginald, Jack and Max became firm friends, and Gollon sketched the three of them throughout the rest of his stay.

My Foolish Friend
Mixed media on panel
91.5 x 61 cm (36 x 24 in.)
1998
Private collection

The incident had a profound effect on Gollon, revealing to him the extraordinary range, and extremes of human emotion within a superficial and encapsulated world, that of the hospital ward, from the abjectly depressing to the sublimely humorous. The pain and suffering of his fellow inmates, and the shock for the young artist to see the possible indignities and calamity of old age at such close range, was alleviated by the overwhelming camaraderie that eventually developed between the group. More significantly still, in light of his subsequent approach to figurative work, was the realisation that very often human behaviour, particularly in forced circumstances, becomes a parody of itself, and despite the general (and anticipated) 'normal' display of control, often human nature plays out to a comic or emotional extreme. As such he consciously turned away from his very early dry realist style of the 1970s–1980s. He achieved the realisation that by exaggerating his figures, distorting them, but never deforming them and lending them subtle humour while retaining their clearly identifiable human physique, he was able to convey fundamental human emotional conditions with greater clarity. On his arrival in the hospital ward he had made two sketches, one of Reginald and one of Jack, in a passable realist manner, convincing but surprisingly dull. By the time of his release his sketches had been transformed: the figures were animated and the bitter-sweetness of the human spirit inherent in the situation was identified. Despite the continuing evolution of the artist's style, and his numerous experiments over the years, his figures have, since that hospital stay, consistently retained an essential Gollonesque element that combines quirkiness with enormous empathy for, and understanding of, humanity.

The exploration of humanity, but never a judgement of its many faces, forms the basis for the artist's work; even in his still lifes or landscapes there is an element of humanity, an organic awareness of sentient life, or the expression of big ideas pertaining to human existence. Gollon's figurative works are in essence bigger than the label "figurative" might imply, for rarely has he set out to merely paint figures – there is always a subtext at work. As such, his long and varied history of figurative painting encompasses enormous stylistic changes, and reversions, as the artist has striven to find a singular voice to express his ideas.

A striking early experiment with the human form came about in 1998 when Gollon first began to turn his attention to the nude figure. *My Foolish Friend* was inspired (many years earlier) by the band Talk Talk's song of the same name, which Gollon had listened to frequently when driving through the great and arid landscape of Nevada, heading towards Reno with his friend Keith Downey. It was to Reno that Downey had to go to finalise his numerous divorces. The song, and ultimately Downey's behaviour struck a chord with Gollon, whose painting manifests the idea that it is important for the individual to live their life in the manner they wish, but equally to be prepared for the consequences. The figure in *My Foolish Friend* is quite absurd and touchingly vulnerable, caught in the grey-green morning hours, exposed and wearing stockings, gripped with sudden, terrifying self-awareness. The monumental, almost sculptural treatment of the figure is a new departure at this point for Gollon, and is particularly effective in the context of this subject matter. Unlike his earlier paintings, here the figure is pared down and simplified to almost its purest, still recognisable form, recalling the smooth lines of Henry Moore's (1898–1986) timeless sculptures with their monolithic purity. The absence of contextual setting and lack of any imagery in the painting is unusual for Gollon's works at this time, but in this particular painting curtailment of extraneous detail makes the simple debased figure all the more poignant. Gollon returned to this simplistic treatment of his figures again in 1998 in the eerie painting, *The Sleeping Musician*, but in this work he has placed his figure back in a landscape and included characteristic early Gollon imagery such as tennis shoes and playing cards. The musician, who is also nude, remains strongly sculptural in form, but his physique has undergone greater abstraction, his hands are missing and his legs have melted into a single mass. Gollon took this approach again in 2000 in *Fall of Man*, where an elongated and distorted figure, though still fundamentally sculptural, can be seen diving down into a pool of brilliant, jewel-like turquoise. The angularity seen in the sleeping musician has been replaced with smooth fluid lines, although the figure is equally abstracted.

During the 1990s and into the early years of the new millennium, Gollon would typically move between styles during any given period, in part as he sought to clarify his mode of expression, but also it would seem out of pure amusement and experimentation. The range and diversity of his approach makes him difficult to categorise, and although within the last few years his style has gradually matured and found a more definitive voice, he is still in the habit of throwing out surprises. It is this inclusion of the unexpected and his consistent undiluted originality that greatly contributes to the fascinating

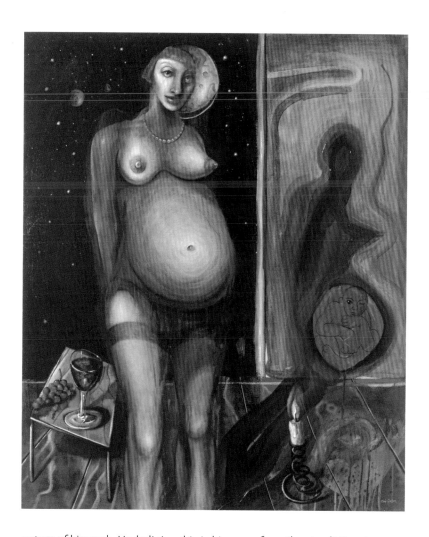

Woman
Acrylic on canvas
119.5 x 96.5 cm (47 x 38 in.)
1999
Private collection

nature of his work. Underlining this is his move from the simplistic yet profound *My Foolish Friend* to the extraordinary and complex *Woman* (1999). The painting was made for the *Maternity* exhibition at Gallery K in London, and staged to raise money for the Foetal Medicine Foundation established by Professor Kypros Nicolaides. Gollon said of the work, "I wanted to depict Woman in this work as both lover and future mother, while at the same time preserving her sense of fun and her dignity".

The image certainly combines these elements: the woman is beautiful and seductive, pregnant and nurturing, but it is also a work with an undercurrent. Gollon has painted her with fairly strong emphasis on linearity (she is not dissimilar in style to much of his *Pleasure Dome* series of the same year). He has given her a wooden, maquette-like aspect so she appears sculptural, but retains great warmth. His implication is that the woman – or Woman in general terms – tries to be everything to all people: lover, wife, mother, daughter. By accommodating everyone she is in danger of having nothing left for herself, thereby becoming reduced to a wooden model. The beautifully painted and abstracted still life with wine glass and grapes to the side of the figure subtly suggests the small and guilty – given her pregnancy – pleasure

that is entirely her own. While the winking baby, complicit perhaps in its mother's pleasure, is a characteristically humorous touch from the artist. There is however a dark note here too, which is typical of Gollon. It can be seen in the leaking amniotic fluid that drains from the shadow on the wall to pool viscously beside the candle on the floor. This can be construed either as a warning to the mother, or as an indication that the birth of her child is imminent, and is perhaps the most startling aspect of the work.

The unborn baby is drawn exquisitely, with a breathtaking purity of line and primitivism that recalls the work of Henri Matisse (1869–1954) or Pablo Picasso's (1881–1973) drawings. Gollon has subsequently returned to this striking use of line on a few rare occasions during the course of his career to date (arguably not enough) seen to best effect in a series of three etchings from 2005: *Sleeping Woman*, *Girl Praying* and *Magdalene*. These three figurative works, and that of the unborn child, demonstrate the absolute affinity the artist has for depicting the human form in pure and academic terms, although this precise depiction of the figurative is not *always* his primary objective. The artist is often more concerned, and increasingly so, with conveying a subtext or concept through his use of the figurative. In this way the specific subject, being the figure, becomes less important than the actual content, being the ideology.

The expression of 'Big Ideas', which is particularly prevalent in his paintings from 2008 onwards, does not however underpin all of Gollon's work, and it is quite clear that on occasion the artist's objective is simply to entertain his audience. Much of his work is markedly humorous, and reflects Gollon's love of the ridiculous, of irony and of the absurd. This attitude is seen to good effect in a series of paintings from 2000 based on bathers. The works followed a trip Gollon and his family made to Clearwater Beach in Florida, USA, after visiting the Salvador Dalí Museum in St Petersburg just along the coast. The day in question was searingly hot (Gollon got sun stroke) and a sting ray alert had curtailed bathers, with life guards allowing swimmers no further out than a depth of 2 feet. Due to the extreme heat, the entire occupants of the beach had moved into the shallows of the sea, with people sitting in the surf, shoulder-to-red-shoulder passing the time of day. A Florida resident seated next to Gollon – whose paranoid phobia of fish was coming to the fore – informed the artist that he need not worry about the sting ray, it was the sharks he should be fearful of, since the sharks drove the sting ray in towards the shore – but that he didn't really have to worry about the sharks because the pelicans sitting sentry-like on their posts out in the sea would alert everyone to an incoming shark, by flying away. It was a wonderfully random and nonsensical conversation which, while gripped by sunstroke and squashed ten-a-penny in the hot sea, somehow seemed perfectly logical.

Two paintings stand out from the group he painted following this trip, the right-hand panel of a triptych, *The Bathers*, and the fabulous *The Bather*. Stylistically Gollon has again used simplified, semi-sculptural forms, and created monumental figures. His use of colour is superb. In both paintings the figure combines a bluish-grey undertone that infuses it with a surreal note, with exquisite flesh-coloured highlights. The colours of the

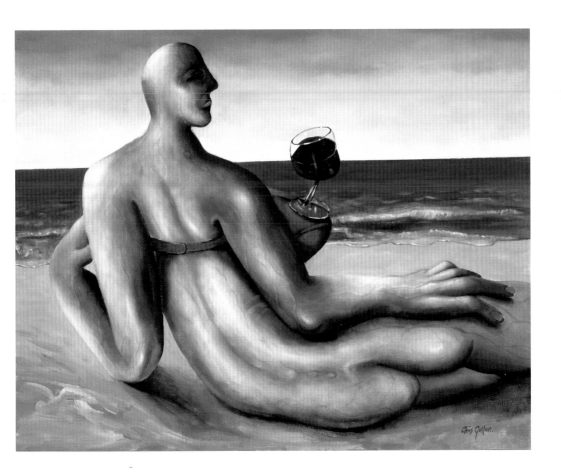

The Bather
Acrylic on canvas
72.5 x 93 cm (28.5 x 36.5 in.)
2000
Private collection

female bather in particular are extraordinarily subtle: a flash of sunburn runs comically down one buttock and across the back of her elongated arm, glowing with heat, while the marble-like effect of her upper torso is emphasised by the pure and brilliant blue of the sea in the background. With Gollonesque irony, she is missing her bikini bottom, but has her top covered up, an inversion of normal practice, and has balanced a wine glass atop her splendid breasts. Her form is exaggerated and elongated, with much attention paid to her disproportionately large hand, but despite this, and her bald head, she possesses an inexplicable beauty and a quiet, iconic grandeur that recalls Pablo Picasso's undated painting *Three Women Bathers*. Gollon's image is essentially comedic, but it is also quietly reflective.

The same cannot be said for the right-hand panel of the triptych *The Bathers*, which is pure wicked, black humour, and is a nod more to Hieronymus Bosch than Picasso. A man's legs poke up from the sea, again painted with a tremendous rich blue, and just visible is his mask-like face breaking through the surface of the water. Predatory fish surround the poor bather, who appears to be dead, killed perhaps by fear of the fish. The work is simply constructed to good effect, and again reflects the artist's skilful use of colour through the dead flesh tones of the man's legs.

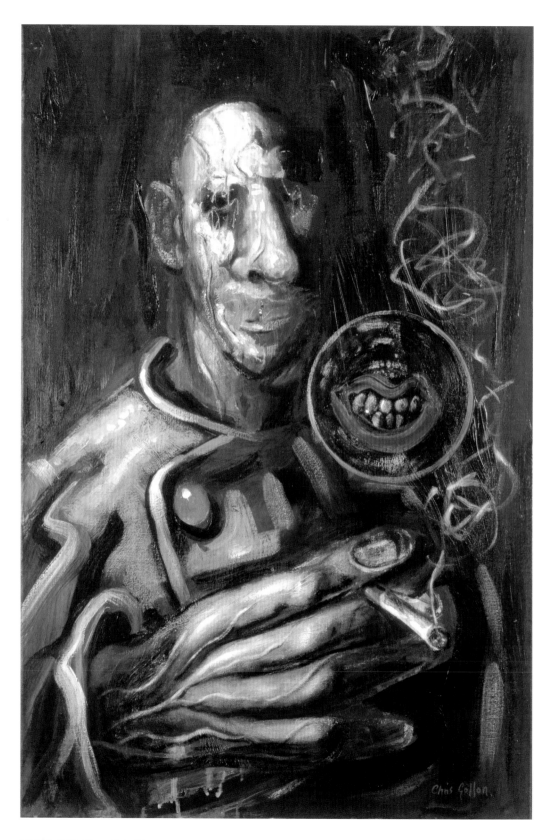

**The Bathers, Triptych I
(R/H panel)**
Acrylic on Canvas
91.5 x 74 cm (36 x 29 in.)
2000
Private collection

The Leader
Acrylic on canvas
76 x 51 cm (30 x 20 in.)
2000
Private collection

In 2000, in the same year that he created his *Bathers* paintings, Gollon set upon a completely different figurative style, approaching a group of works with greater fluidity and in a more painterly manner. These paintings are, for the most part, characterised by thick impasto, dark, rich and often tonal colouring and expressive brushwork, seen to good effect in the macabre *The Leader*. Here Gollon addresses the general nature of corruption in relation to political leadership, though he declines to make a more specific reference. The sinister and threatening nature of this particular leader is masterfully wrought; in contrast to the precisely painted hand in the foreground that clutches a smoking cigarette, his face is indistinct, eyes shadowed and mouth blurred, rendering his specific expression ambiguous, but blatantly unpleasant. The skin of his face is a spider-web of veins, his flesh, dry and paper-like. Most forceful is the inclusion of a magnification circle, which highlights a ghastly blood-red and cannibalistic mouth, which gives the image its resounding impact.

Figure Study – Homage To El Greco
Acrylic on paper
79 x 59 cm (31 x 23 in.)
2000
Private collection

Of a different nature entirely, but in a similar style is his *Figure Study – Homage to El Greco*, and *The Song and Dance Man II*, both created during the same time frame, in 2000. As mentioned, Gollon counts the work of El Greco amongst his most important influences, seen in many of his paintings, particularly in his use of elongation and distortion, which comes to form a central role in his figurative work. *Homage to El Greco* is taken almost directly from Gollon's favourite El Greco painting, *The Adoration of the Shepherds* (1612–1614), but is transformed through his unique visual language. El Greco's seventeenth-century shepherd has been replaced by a rather touching modern re-incarnation, who is more body builder than flock keeper, and prays with such intensity that he has squeezed his eyes shut with the effort. The figure's arms and hands are focal to the piece. They have lost their physical acuity in place of a sinuous grace that emphasises, rather than detracts from the action of prayer. This stance, with arms crossed in supplication is one that the artist returns to on numerous occasions from this point on in his career, making the action of prayer and the focus on hands as subject matter in its own right, not from any ardent spirituality but as a mode of expression. Hands become increasingly important to the artist, who imbues them with character and life almost separate from the figure to which they belong; they effectively come to embody the soul and are treated, for the most part, far more expressively than his faces.

The Song And Dance Man II
Acrylic on canvas
117 x 81 cm (46 x 32 in.)
2000
Private collection

This is apparent in *The Song and Dance Man II*, a whimsical painting of a stand-up act, whose face is a vacuous mask, but whose hands are altogether more animated. The painting was one of several depicting comedy club stand ups, including two versions of *The Casting Couchee* (2000), two versions of *Stand Up* (2000) and *The Funny Woman* (2000). In all, the figures are objects of mirth, inflated by their own sense of achievement, which translates of course, to no achievement at all. Underlining the paintings is a rather hollow melancholy, for despite their flippant humour they are more realistically images depicting disappointment and failure. The plastered, grinning smile of *The Song and Dance Man, II* is part humour, part desperation, his exuberance rendering the viewer uncomfortable at the prospect of the height of his fall. Gollon manages to recreate in paint the *actual* feeling of acute embarrassment and discomfort from watching a terribly bad act. The figure itself is vibrantly animated and displays a greater level of movement than is characteristically seen in Gollon's paintings.

These paintings were inspired in part by one of Charles Aznavour's songs as well as the Ettore Scola film *Le Bal* (1983), which charts several decades of history through a group of people dancing in a dance hall, but primarily through Gollon's own evenings spent in cabaret clubs. It was not so much the cabaret acts that drew Gollon, but the atmosphere in such places: the dark and, at that time, smoky interiors where smiles and half glances drift through the air. They were places of intrigue and mystery where petty human dramas and dirty little secrets unfolded over a smooth sea of over-priced cocktails. During the early years of the 2000s David Tregunna and Gollon would meet with their collectors in London's clubs, venues such as Ronnie Scott's, Gerry's Bar, The Colony Rooms, the Union Club, Teatro and Soho House, places peopled by the bon vivant, the bohemian, the fantastic and the eccentric.

At the end of 2000 Gollon painted a haunting black-and-white image, *The Shooting Star*, inspired by the Bob Dylan song, *Shooting Star* (1989). This painting sees Gollon reverting to his earlier linear style, which works well for the lyrical nature of the subject of lost love and regret. Again he has emphasised the woman's hands, yet left her face half in shadow, alluding to her slipping away from her loved one emotionally as well as physically. The figure is a curious collaboration of flat areas, seen in her dark clothing, and strongly modelled, three-dimensional flesh; as such she transforms from real to surreal with barely a breath. This is re-iterated in the treatment of her hands with the left one being rather beautifully crafted despite its oversize, while the right hand is reduced to outline only, flat, stylised and scratched into the paint layers. The artist uses this technique of scratching in quite regularly from the early 2000s onwards. Using the wrong end of his brushes he literally scratches away his motif, drawing the image through wet layers of paint. Here he has applied black over a white ground, which creates a wonderfully sharp white linear edge when scratched out.

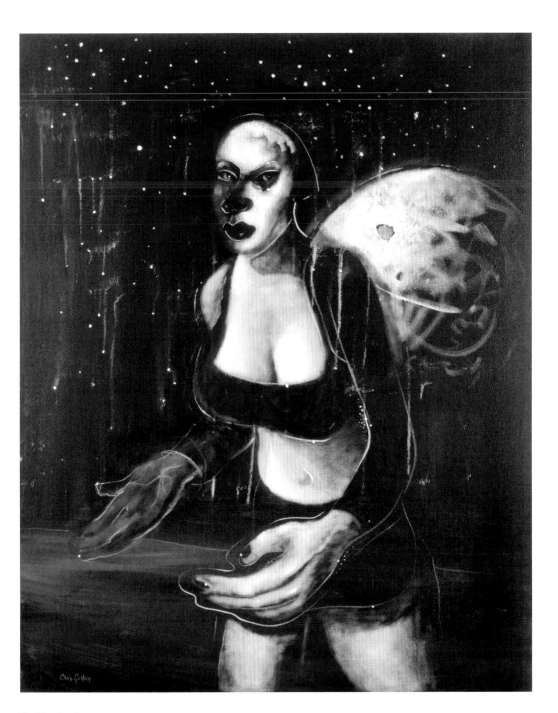

The Shooting Star
Acrylic on canvas
65 x 81 cm (25.5 x 32 in.)
2000
Private collection

Around the time of *The Shooting Star* Gollon began re-reading *Grimm's Fairy Tales*, a collection of German-based stories written by the brothers Jacob and Wilhelm Grimm, first published in 1812. The tales (particularly those of the first edition) were notable for their often grisly moralistic or macabre tone. This appealed to the artist, particularly the story of *The Fisherman and his Wife*. In this tale a poor fisherman leaves his wife at home in their shack and sets off to fish. He drops his line in the deepest water and catches a flounder who begs to be thrown back, and tells the fisherman he is really an enchanted prince. The fisherman throws the flounder back and returns to his wife empty handed. He tells her the story, and she demands he returns to the sea to find the flounder, and ask for a gift in exchange for its life. With a heavy heart the fisherman sets off and finds the fish. He asks him for a cottage to live in, and the flounder tells him to go home, since it is already done. The fisherman returns to his wife in her new cottage, but she is not satisfied, and demands he find the fish again and ask for a palace. The story continues in this vein, each time the sea changes to a more turbulent colour, the wife's demands are greater, and the fisherman more troubled. Finally she asks to be turned into God, and instead the couple are thrust back into their life of poverty. Gollon painted two works relating to this story of avarice, *The Fisherman and his Wife*, which is an unusual departure for the artist in terms of his figurative style, and *The Fisherman*, more characteristically Gollonesque.

The wife in *The Fisherman and his Wife* is a single elongated figure who occupies the centre of the canvas, while the fisherman himself is a barely-felt presence in the distance bobbing in his boat on a mirror-smooth sea. The surreal landscape with jagged mountain range, flat, reflective waters and turbulent skies of vivid colour is one that reappears in various forms in many of Gollon's paintings. This seems to be less a lack of ingenuity and more obviously an effective landscape solution for his dreamy and eccentric subject matter. It is, however, a painting all about the wife and her bitterness. Gollon has painted her as *almost* beautiful, almost, but not quite, since her beauty is tarnished by an avaricious aspect to her face, by the petulance that hangs heavy from her lips and suggests her small, bitter soul. She is tightly drawn, exquisitely painted and unusually decorative for Gollon, recalling works of the Vienna Secession such as Gustav Klimt's (1862–1918) *Judith II* (1909).

He continued this decorative approach and use of an elegantly, elongated figurative style in several works based on the fairy tale of *The Sleeping Beauty*, which he painted for the 2002 *Kiss* exhibition at Gallery K in London. Gollon chose to depict the beauty in the moments before she has been kissed, capturing her in a wistful sleep, dreaming of her release. He painted two versions of the subject and a finished study. Of the three, the study is arguably the most effective. The two finished works are horizontal in format and present the figure lying amidst a striking and surreal landscape. In one of the paintings the woman's face is beatific; in the other she has a rather deathly greyish pallor and a truculent look, which might perhaps deter a would-be suitor from kissing her. Both works depict elongated and sinuously graceful figures (in a manner that faintly recalls the nudes of the German Northern Renaissance painter Lucas Cranach the Elder (1472–1553)).

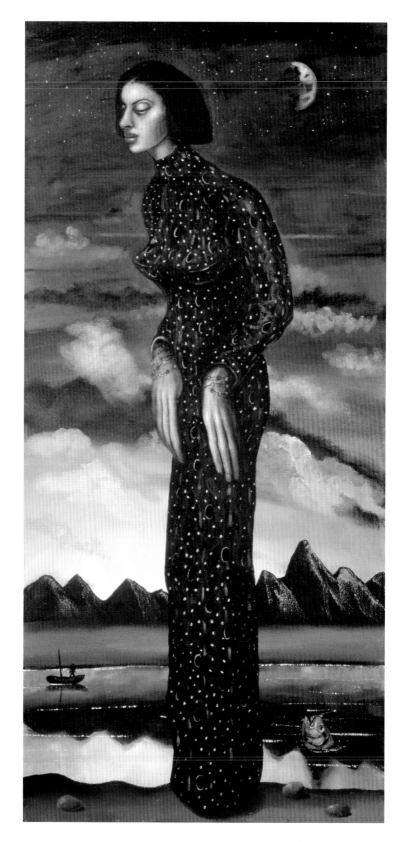

The Fisherman And His Wife
Acrylic on canvas
152 x 72 cm (60 x 28 in.)
2002
Private collection

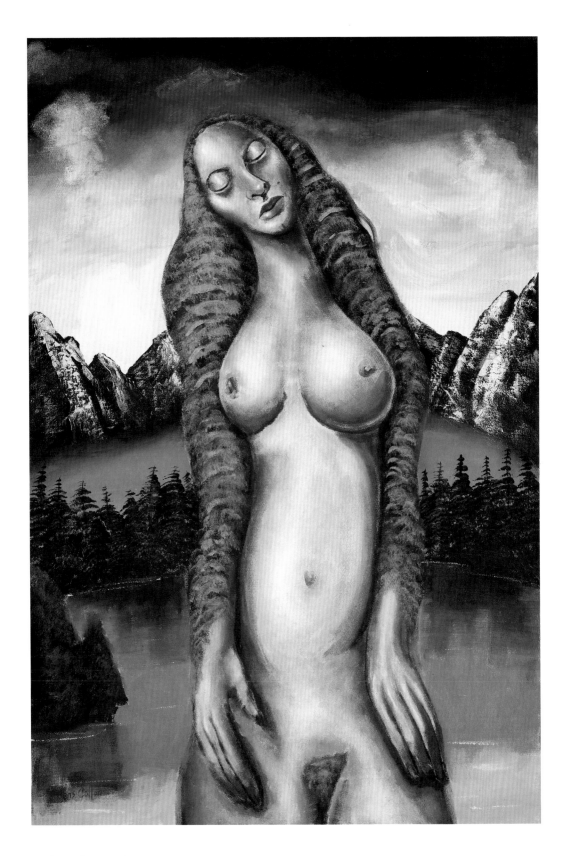

These figures slip between detailed articulation seen in the face, hair, hands and torso, and sketchy suggestiveness seen particularly in the feet. Gollon returns to this figure style several times following these works, seen to best effect in the painting *Beyond the Horizon* (2006). The discrepancy between his rendition of the woman's hands and feet is interesting since the artist has on the whole, little regard for feet and depicts them with an almost flipper-like appearance.

The study for the two *Sleeping Beauty* paintings is vertical in format with the sleeping figure hovering ethereally and dream-like before a vast, sublime landscape. This is the most lyrical of the three, and the most beautiful in terms of the figure and the structural balance of the picture. Gollon has amplified the elongation of her torso and her hands, which are particularly graceful, and truncated the figure at the top of her thigh, which gives it a slightly fetishist nuance. In terms of form, the flow and simplicity of her lines are reminiscent of Modigliani's nudes, in particular his *Nude* of 1917, and Edvard Munch's (1863–1944) *Madonna* (1894); both artists have been a longstanding influence on Gollon.

The long tresses of Gollon's sleeping beauty's hair hang down on either side over her arms; they appear to have become one with the arms, so her hands seem to grow from the ends of her hair. This lends the work a wonderfully surreal edge. Gollon does not typically paint blatantly sexualised images, and generally steers away from depicting pudenda or genitalia, although he revels in depicting female breasts. In this image (and in both the finished *Sleeping Beauty* paintings) he presents the woman frontally and has painted her with subtle eroticism, which is heightened in the study by her vertical aspect. In the two finished paintings the woman appears almost part of the landscape, as an organic aspect of a greater scene, while in the study she is displayed as very distinctly separate from her landscape. She is very obviously the focal point of the work; an icon.

Within the same general time frame as the *Sleeping Beauty* paintings with their dreamy lyricism, Gollon painted *Naked Woman* (2002), perhaps his most luridly hideous image of a nude. She is abjectly horrible, difficult even, to look at. That is precisely Gollon's point: she is the antithesis to his sleeping beauties. Representative of old age and wisdom rolled into one, she is defiant in the face of her physical deterioration, and is a declaration in universal terms of the inevitability of decay. Gollon challenges the viewer to look at, accept and understand what is a natural process to those lucky enough to live a long life – or is it still considered lucky if this is the outcome? Despite her ugliness the woman is also extraordinary. She is more than simply naked, she is stripped and flayed, ghastly-grey, with flesh mapped with knotted veins that run beneath the skin. Her bone-thin arms, sagged, pendulous breasts and haggard face inspire tremendous empathy, as she sits, somewhat humorously, on a bar stool on the brink of this world and the next. Most apparent however is the gentle pride and dignity (despite her nudity) that Gollon has managed to inject into this figure as she sits frontally – blatantly and even challengingly – her crossed arms affording decorum to a pose that could otherwise be in danger of being defiling.

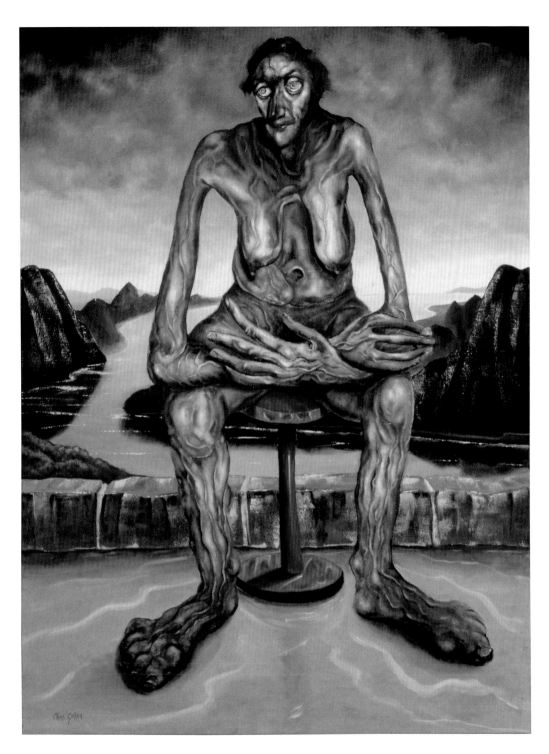

Naked Woman
Acrylic on canvas
122 x 91.5 cm (48 x 36 in.)
2002
Private collection

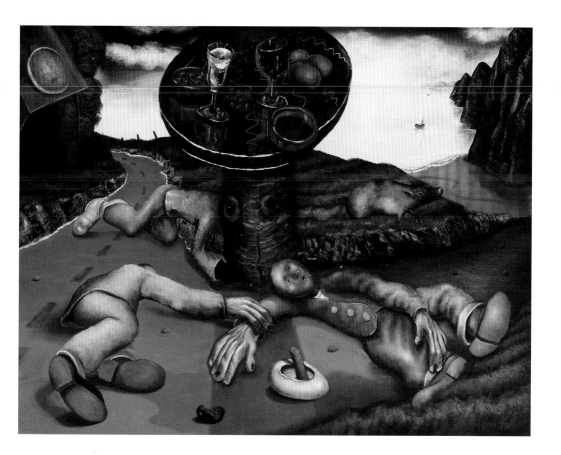

The Land Of Cockaigne
Acrylic on canvas
91.5 x 122 cm (36 x 48 in.)
2002
Private collection

After finishing *Naked Woman*, Gollon returned again to fairy tales and the stories of the Brothers Grimm. His next painting was *The Land of Cockaigne* (2002). This was, according to the original mediaeval myths and the Grimm Brothers, a mythical utopia indulgent of glutinous and carnal desires, which saw fences made of sausages, the heavens rain cheese or pies, and the rivers turn from milk to wine in the afternoons. Common rules of hierarchy and codes of conduct were inverted in this world of excess leading to the subjugated becoming powerful, and an abundance of freely dished out sexual favours. The concept of Cockaigne, which shares many similarities to Fools' Paradise and Narragonia, was created as a reaction to the oppressive poverty of peasant culture in the middle ages; it provided an imaginary Arcadia where wishes came true, but was a cautionary tale that warned the fruition of these exaggerated desires was mantled with destruction. The *Land of Cockaigne* is a subject that has been frequently addressed in the arts and literature, with Gollon's painting being a modern re-invention of Pieter Brueghel the Elder's work of the same title, dating from 1567.

In his painting Gollon has reverted to a figurative style more akin to his work during the period 1995–1997, when he was painting his monumental *On the Road to Narragonia* series: he uses a strongly linear approach, but still distorts his figures and their hands. The figures litter a beautiful and strongly Dutch landscape, severely suffering the consequences of their over indulgences. The figure in the red jacket appears to have overeaten so greatly

that even his face has bloated, diminishing his features to small pockets of discomfort. Next to him a friend, touchingly, grasps his arm, also prostrate and drawn with tremendous foreshortening. Most striking in this work, apart from the obvious humour, is Gollon's collaboration of figurative, landscape and still life, and his creation of a world part surreal and part real. The egg in the foreground, stabbed by a toast soldier and in the manner of Salvador Dalí (1904–1989), is particularly effective. This is used by the artist in a number of paintings, as is the motif of wine glasses. Once again he uses his scratching-in technique to give the glasses their form, and displays evocative use of colour in these two small touches. The clarity and sparkle of the white wine, and the richness of the red is quite remarkable given the tonal nature of the work, while the small details such as the filthy fingernails of the two main figures, and the dish on the brink of falling from the table onto the man below give the painting a greater depth.

Humour, though combined with melancholy, is also evident in his painting *The Dong with a Luminous Nose* (2004) based on the poem of the same name by Edward Lear. The illogical and often touching comedy of Lear has long been a favourite of Gollon's. When the poet and illustrator stayed at the Oatlands Park Hotel, Weybridge, (not far from Gollon's flat), he left behind one of his drawings, which still hangs there. Lear's love of the ridiculous, illustrated by poems such *The Dong with a Luminous Nose* and *The Pobble Who Has No Toes* has much in common with Gollon's own brand of humour, bringing together the absurd and the melancholic in a bitter-sweet collaboration. Gollon's painting is imbued with a sense of melancholy as the lovelorn Dong searches in vain for his missing Jumblie girl. The artist achieves this by restricting his palette to a tonal range of grey, which adds a wistful nuance to the fantastical landscape. It is the figure of the Dong, however, who causes the greatest interest, not excepting his luminous nose. His configuration is quite extraordinary and really has no logical basis – and yet it works. Gollon is able to take the human form, to distort it, change it and take away its logic, but still maintain its integrity, and make it a strongly emotive object. The Dong's hands are focal and highly expressive. They suggest tenderness despite their size. Equally the Dong's face, though only partially visible, is highly expressive. This is achieved through a simple stray lock of hair – which is already thinning – a jowl slackened through worry, fear and age, and the single glint in his small, feral eye.

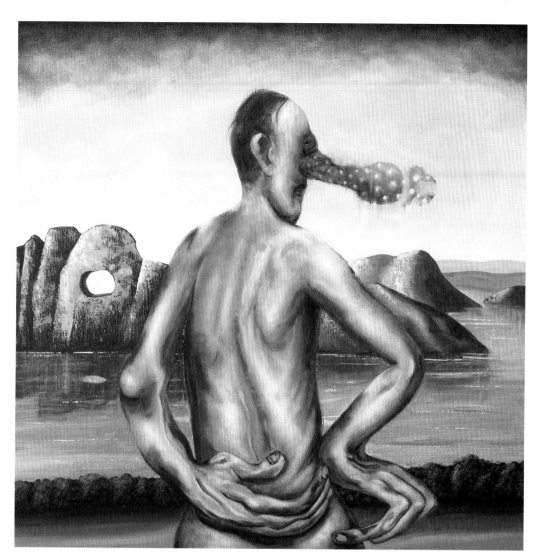

The Dong With A Luminous Nose
Acrylic on canvas
76 x 76 cm (30 x 30 in.)
2004

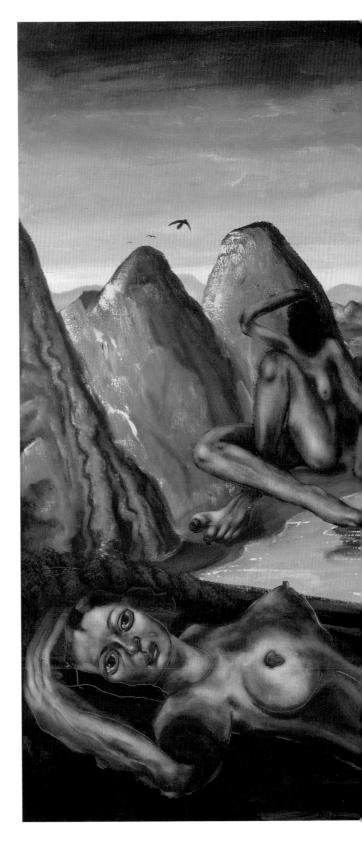

The Bathers
Acrylic on canvas
122 x 152 cm (48 x 60 in.)
2005
Private collection

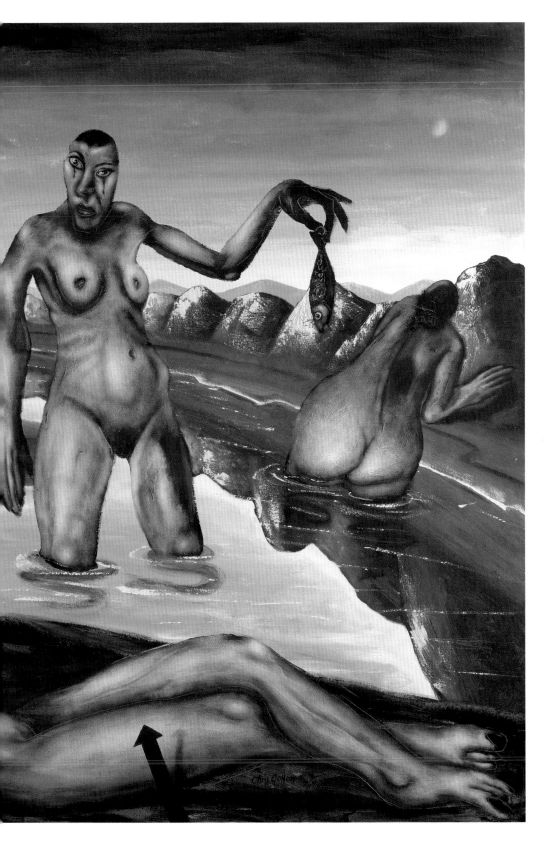

A similarly tonal work, though one of a rather different nature, is *The Bathers* (2005). A significant, monumental painting, the subject matter is based on a theme that became particularly popular with painters of the nineteenth and early twentieth centuries, including Paul Cézanne (1839–1906), Pablo Picasso and Henri Matisse, with Gollon's painting somewhat reflective in structure alone of Cézanne's *Four Bathers* (undated). During the late nineteenth century there was a marked increase in the bourgeoisie in France and the middle classes in England, which saw people having more money and greater leisure time to pursue such frivolous pastimes as bathing. This gave artists a legitimate context to paint nude figures. The subject matter is one most frequently depicted in overwhelmingly positive terms with hazy landscapes shimmering under bright Mediterranean skies. It is no great surprise then that the characteristically ironic Gollon chose to paint his bathers in singularly sinister terms, each one caught in frigid isolation, and set within a desolate and eerie land. Each figure is a loose homage to another painter: the central and most threatening woman is Gollon's nod to Otto Dix, to her left is an elongated rather graceful seated figure after Matisse, while to the right is Gollon's take on one of Auguste Renoir's (1841–1919) bathers. The mannequin-like figure with a deathly stare, in the foreground, is Gollon's own bather, and drifts in his typical manner between detailed physiognomy, and form that melts away, seen most effectively in the rendering of her feet. In most respects Gollon's grasp of the human form allows him to make great distortions and exaggerations while still retaining a true sense of fundamental matter, but this prostrate figure is rather lacking in substance. The configuration of her right arm is indistinct and poorly put together, and she is awkward in her setting. There is a marked difference between Gollon's creation of this figure and of other figures in a similar pose, such as the reclining nude in *Beyond the Horizon* (2006) and in both versions of the *Sleeping Beauty* (2002). Where his nude in *The Bathers* is uncomfortable and misaligned, the lovelorn nude in *Beyond the Horizon* is balanced and serene. Her degree of abstraction is no less, but the abstraction works in clear and poignant terms. Gollon's treatment of her hands, blackened, flattened and outlined through his scratching in technique lends them a decorative element, particularly via the contrast between their flat aesthetic and the fulsome, rotundity of her breasts.

Returning to *The Bathers*: despite the unconvincing figure in the foreground, the central, terrifying figure, who is monumentally constructed and has the monolithic presence of an ancient Goddess – though certainly a Goddess of war or death – is magnificent. The dead fish, which she holds with some delicacy may represent Christianity and other monotheistic religions, while the four women may symbolise ancient goddesses and the practice of polytheism.

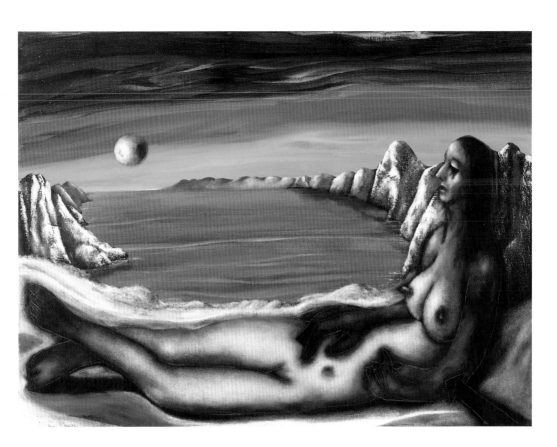

Beyond The Horizon
Acrylic on canvas
76 x 102 cm (30 x 40 in.)
2006
Private collection

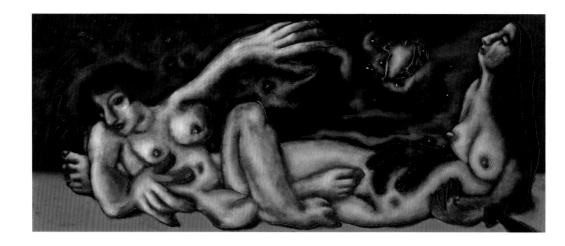

Gollon's treatment of the seated Matisse-like figure with the blanked out face is of particular relevance with regard to developments in his figurative style from 2007 onwards. The artist is beginning to diminish facial characteristics, at times simply indicating faces through the use of a dark-coloured orb. In many cases, although not seen here, he manages to evoke a sense of expression despite the absence of features.

During 2006 Gollon continued to experiment with the abstraction of figures in general and faces specifically, seen in a number of paintings that form part of his *Heads* series. Works such as *Figure with Dark Moon* and the humorous *Is That All There Is?* show faces completely blanked out, yet still manage to convey affable, slightly surprised characters. Following a trip to New York, Gollon painted the touchingly comic *Face Job and Boob Lift* (2006). The artist was moved by the number of women whose faces revealed cosmetic surgery gone wrong, women who were obviously not unattractive in the first instance. With an ironic twist the artist paints what has been abstracted in the flesh under the surgeon's hand, rather than the more characteristic other way around. It is a tragic-comedy painted with sympathy and reflective of the artist's dismay at the damage that can be done, and of the underlying emotional issues that can lead to elective surgery.

At around the same time Gollon began work on the unusual *La Colombe D'Or*, an homage to Picasso and Matisse. Once again he was experimenting with abstraction, although arguably less successfully in this work than others. The painting was inspired by one of Gollon's collectors who had recently returned from the famous La Colombe D'Or hotel in Saint Paul de Vence, France. This small, historic town with stunning views across the countryside of Provence was a fashionable destination for the avant-garde artists (and writers and actors) of the early twentieth century. These included Matisse, Marc Chagall (1887–1985), Raoul Dufy and Picasso. Many of them would dine or stay at the Le Robinson, now known as La Colombe D'Or hotel and, if short on funds, would donate a work of art to settle their bill; many of these still hang on the walls.

La Colombe D'Or
Acrylic on canvas
51 x 122 cm (20 x 48 in.)
2006

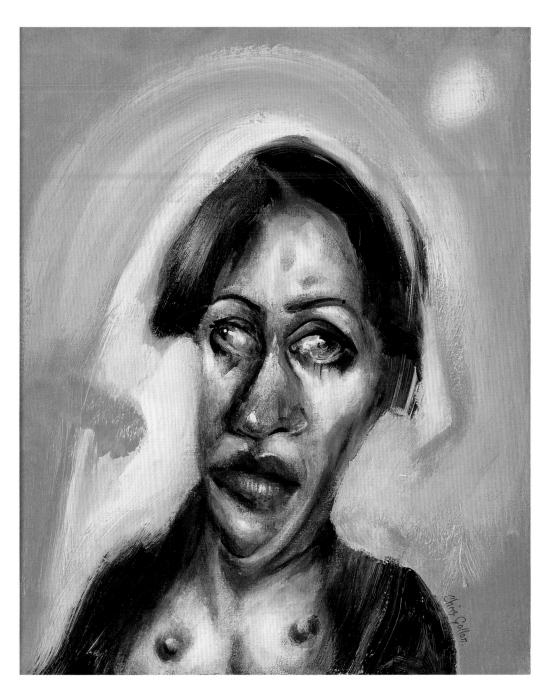

Face Job And Boob Lift
Mixed media on panel
30.5 x 25.5 cm (12 x 10 in.)
2006
Private collection

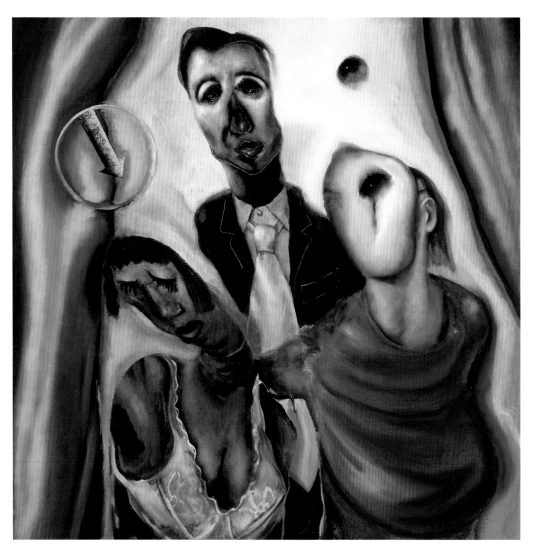

At Madame JoJo's
Acrylic on canvas
81 x 81 cm (32 x 32 in.)
2006
Private collection

As part of the ongoing evolution of his style, Gollon experimented in this work with a collaboration of Picasso and Matisse, drawing on Picasso's use of colour and on Matisse's affinity for line. The figure to the right is very similar in structure to Gollon's recumbent nude in *Beyond the Horizon*, and again includes his use of black, blurred hands in a decorative fashion. Here, however, the distortion of the figure is less successful, the line and flow of her form lack clarity, and she appears to collapse inwards. The figure on the left is conceived with greater drama and distortion, but both figures are rather hollow in concept. Unusually for Gollon, they have no real purpose and little to say. This work is indicative of a conscious stylistic move in one direction. Subsequently Gollon recognised its lack of success and moved on in a new direction.

This new direction can be seen in the darkly humorous painting *At Madame JoJo's* (2006) inspired by nights spent by David Tregunna and Gollon at the opulent cabaret club of the same name, in London's Soho. The rich, dark interiors were home to a quirky collection of club goers and bohemians, the wild, the beautiful and the thrill seekers, particularly on nights run by the effervescent Ruby Venezuela, one of London's most charismatic compères. On one occasion, as a late night turned into the small hours, David Tregunna found himself surrounded by three gorgeous, six-feet-tall blondes. With his winning smile in place and a fresh glass of Bordeaux it appeared that he and the blondes were on a straight wicket to Narragonia, when Gollon tapped him insistently on his shoulder and broke the spell. It transpired that the heterosexual David had, quite unwittingly, been charming three transvestites. After much foot shuffling and with a flaming face, the situation was dissolved. Gollon commented that David had learned the valuable lesson of always checking the size of someone's Adam's apple before engaging in frivolities.

In the painting Gollon alludes to the hidden self and the act of charade: the masked figure appears very feminine, but conversely the mask is masculine. An eye hangs above her head, suggestive of a voyeur standing behind the curtains looking through, while the other female figure in the foreground, wearing her underwear, appears to be missing an arm completely, and is painted in a very two-dimensional manner, contrasting to the rotundity of the masked figure. The man is similarly distorted, skewed and flattened but with an exceptionally expressive face. The figures are clearly representational: the cad, the aggrieved (has she been taken advantage of?) and the masked figure who is hiding her true self. The latter stands apart from the other two as the most real in terms of flesh and form. With a sense of irony, Gollon has depicted her as the most realistic, but has hidden her behind a flattened and surreal mask.

Aspects of this painting recall an earlier work, *At the Salon (After Otto Dix)*, painted in 2002. It is a reworking of Dix's *Le Salon* (1927). Gollon's work depicts a group of ageing and care-worn prostitutes sitting waiting for clients at a table. He has used masks here too, one full mask, and a half mask on the figure in the foreground, Her facial features have been drastically diminished, while her scrawny hand offers a contrastingly fleshy breast to

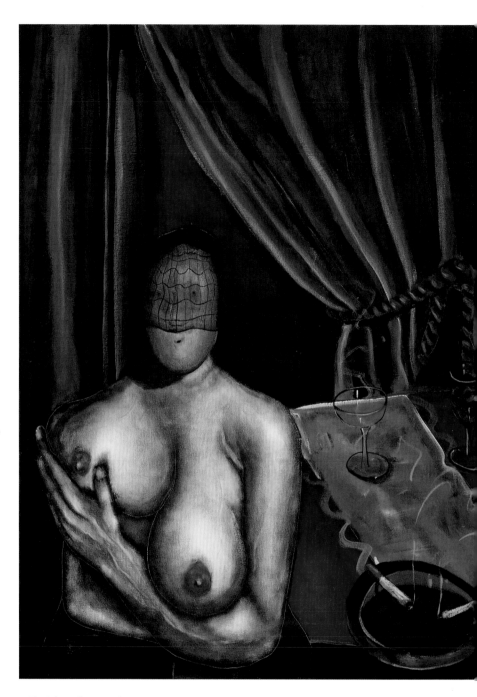

At The Salon (After Otto Dix)
Acrylic on canvas
81 x 152 cm (32 x 60 in.)
2002
Private collection

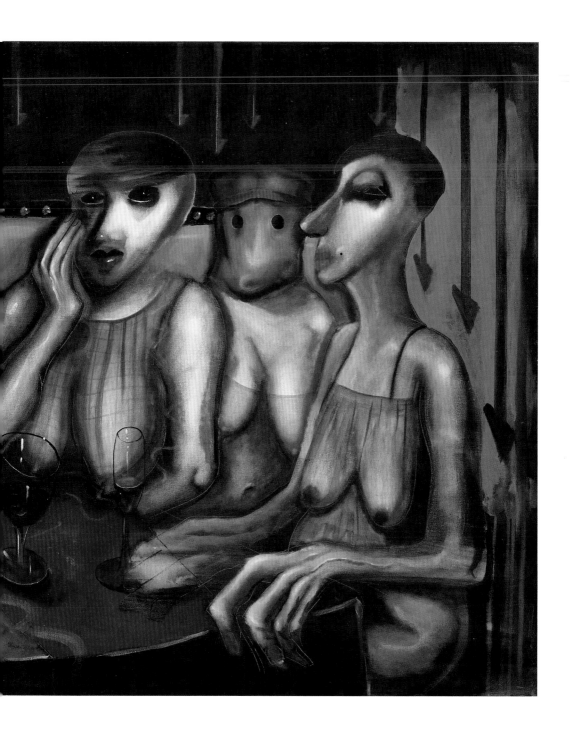

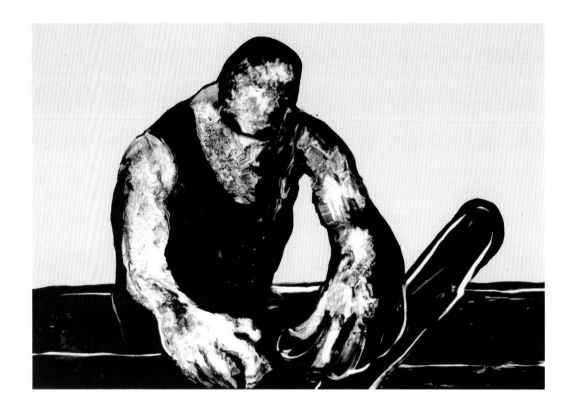

the viewer. The three women to the right present a parody of the three wise
monkeys who "see no evil, hear no evil, speak no evil". The nearest figure
has no ears, the one in the middle is masked and has no apparent mouth,
while the furthest one touches her eye. Gollon has used the stage setting
with curtain that is seen in *At Madame JoJo's*; it suggests a voyeuristic slant,
perhaps someone lurking in the shadows beyond with salacious intent. In
the earlier work the artist included an arrow, it is barely visible, poking out
from behind the curtain, making an obvious sexual allusion.

Both paintings combine humour and sadness with equal measure; they are
paintings about disappointment, regret, ageing; about the consequences
of human behaviour and hiding behind an image, but these weighty
suggestions are alleviated through Gollon's use of humour. As he continues
with his figurative work, his artistic objective gains more clarity, and it
becomes apparent that his primary concern is the understanding and
expression of the substance of human, what transpires inside, rather than
the expression of human substance, being the physicality of structure. By
distorting the frame to its limits he is better able to express the intensity
of emotion below the surface, which is seen to great effect in his series of
paintings about the Royal Henley Regatta (2007).

Of the works in this series, one in particular stands out as the sheer
embodiment of that feeling of losing the race, *Henley Regatta silk screen I*.
A single monumental figure with vastly exaggerated forearms and hands sits
hunched over his oar. His face is virtually without features, yet Gollon has

Henley Regatta Silk Screen I
Silk screen print, edition of 20
53 x 70.5 cm (21 x 27.75 in.)
2007

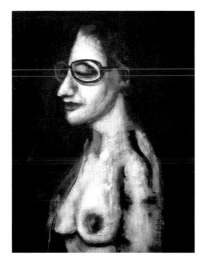
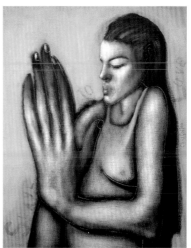

managed to create a sense of utter, nullifying despair and exhaustion. Much of 2007 was taken up by this large series of works, which by their nature and as commissioned pieces, were executed in a more conventional manner than his paintings of 2006, such as the beautiful and uncharacteristically lyrical *Slave to Love*, still exhibiting figurative distortion seen in the girl's hands or the haunting *Portrait of a Woman*. The latter work is particularly touching and, although not painted as such, could be considered a companion piece to *Ms Johnson* (2007). Here she is the librarian stripped bare, the woman beneath the stern exterior, eyes closed against the indignity of her nakedness, yet despite her embarrassment, she is touched by a certain, elusive beauty.

Alongside these quietly emotive figurative works the artist turned to still life and landscape painting. He concentrated on these two genres for much of 2007. This decision made his 2008 figurative work debut all the more startling. At the beginning of the year Gollon suddenly began to find coherence and a more singular voice in the depiction of his figurative works bringing the nude and his cerebral subtexts to the canvas with shocking clarity.

Chapter Five

STILL LIFE AND LANDSCAPE PAINTINGS

Much as Gollon's work defies stylistic categorisation, it also frequently challenges traditional concepts of genre. This is particularly evident in his work to 2008, where essentially figurative pieces such as *The Bather* (2000) or *The Reunion* (1998), for example, have a monolithic simplicity and stillness that evoke a sense of still life painting. Conversely, many of the artist's still life works convey a heightened sense of animation, of perceptible drama and emotional consequences more familiarly seen in figurative works (see *Pittura Metafisica* (2007)). The boundaries of genre are similarly blurred in the artist's approach to, and use of, landscape painting, which can incorporate strong elements of still life and implied drama, seen to good effect in *Landscape with Flowers and Broken Guitar* (2007), as well as figurative content. To such extent that works like *Beyond the Horizon* (2006) rest between figurative and landscape genres with the figure conceived as an organic extension of its sublime landscape setting. Gollon's unique redefinition of painting genres to suit his own end is achieved with striking simplicity through his application of a consistent and unifying ideology. This singular approach, which underpins all his work is based on his perception of emotive forces in all aspects of his world. As such the artist sees individual identities and dramas in inanimate objects such as pots, wine glasses or musical instruments; while organic components, foliage and flowers become predatory or mincing under his hand, and landscapes ache with melancholy; hills breath distrust, and surreal, vibrant skies dream of another planet (see *Landscape with Mountains* (2004)).

Still Life After De Chirico
Mixed media on panel
35.5 x 30.5 cm (14 X 12 in.)
1997
Private collection

Issues of identity and humanity are the life blood at the heart of Gollon's work, investing the traditional art forms, portraiture, still life, landscape and religious subject matter with a definitive and at times unsettling edge. This is seen to startling effect in one of his first still lifes, *Still Life After De Chirico* (1997). This work was painted at the same time the artist was working on his first defining series, *On the Road to Narragonia*, and incorporates a number of elements seen in the Narragonia paintings, including his use of a surreal stage-like setting, a gaping vortex and a playing card. Occupying centre stage is a trio of peppers that appear to resiliently face an impending crisis. Their shadows loom against the sky heightening the surreal nature of the work in a familiar Gollonesque manner, and one seen in a number of paintings from that time, including *Figure with Key* (1996) and *Anubis and Charon* (1997). The overriding impression with this still life is that the artist has simply exchanged any potential figurative element with vegetables, which is in itself wryly amusing. The early work of Italian-Greek artist Giorgio de Chirico (1888–1978), named in the still life, was of some considerable influence on Gollon, primarily de Chirico's projection of *pittura metafisica*, or metaphysical painting, which brought together random commonplace objects often interacting in dreamlike settings. These works, which paved the way for Surrealism, have at their core similar underlying emotive forces and visionary integrity, which is seen with great clarity and objectivity in Gollon's work.

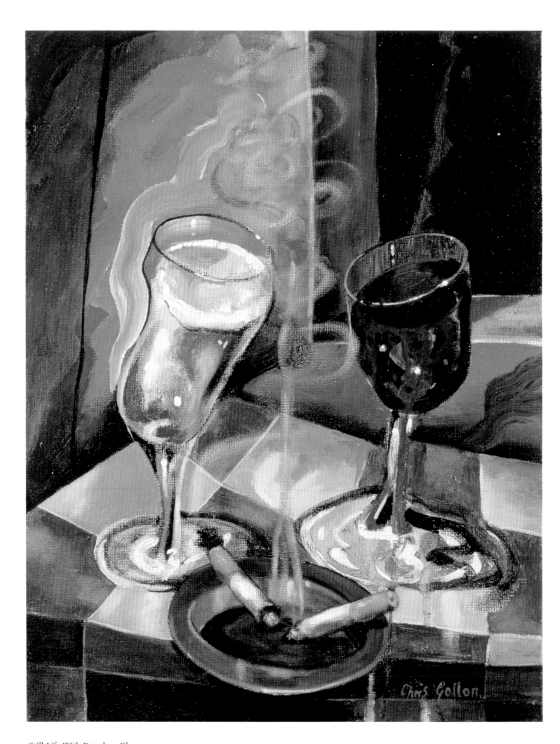

Still Life With Drunken Glasses
Mixed media on canvas
35.5 x 30.5 cm (14 x 12 in.)
1998
Private collection

There are four themes that recur with frequency in Gollon's still lifes: wine glasses, cheese, musical instruments and pots, and of these he has returned to wine glasses most often. *Still Life with Drunken Glasses* (1998) is a wonderfully humorous and richly coloured work that suggest the relationship of two drunks. Unlike his figurative works, which are predominantly static, here his glasses wobble with the swaying, deliberated grandeur of the infinitely sozzled. The feminine white wine glass leans towards the masculine red alluringly, while the red is barely able to stand, the base of the glass spreading across the tabletop in an effort to maintain its posture. The inclusion of two smoking cigarettes alludes to the sense of an illicit or salacious affair, while the smoke rings curl together to form a single plume with an obvious sexual reference.

In this painting Gollon has moved away from the surreal, dream-like settings of works from the previous year and has placed his wine glasses in a familiar, domestic situation using a tabletop and adjacent window, an arrangement he turned to repeatedly in his early still life paintings. All is not as straightforward as it seems here, however, since Gollon has abstracted the perspective, given the tabletop an alarming warp and balanced the ash tray on the edge of the table to the point of falling. This implied impending disaster wryly reflects the probable collapse of the alcohol-fuelled tryst transpiring behind it.

Gollon experimented a number of times with placing objects on the edge of a table and using sharp foreshortening, seen again in *Still Life* (1999), and influenced in this respect by the work of Spanish artists Juan Sanchez Cotán (1560–1627) and Luis Egidio Melendez (1716–1780). Gollon spent some time in Madrid during the 1990s where he was greatly affected by the work of Spanish artists, in particular Cotán, Melendez, El Greco and Francisco Goya (1746–1828), and often made the short journey to Toledo to visit the magnificent Gothic Cathedral. Having already made the decision to experiment with still life painting, he then studied the history of the genre (primarily in Southern Europe). He became familiar with Cotán and Melendez's work, as well as paintings by Francisco de Zurbarán (1598–1664) who was nicknamed "the Spanish Caravaggio" because of his simple, dramatic compositions, naturalistic handling and strong use of *chiaroscuro*.

Cotán was one of the first artists in Europe to paint independent still life works, and was instrumental in elevating the genre from one of artistry and decoration to fine art. Through Cotán's clever and stark compositions he was able to inject greater depth into the genre, producing works of a contemplative aspect with implied subtexts and imbuing simple foodstuffs with a sense of profound drama. This sense of drama is inherent in Gollon's still lifes, which are also almost always depicted either at night, or in some unidentifiable, mysterious twilight zone such as that seen in *Still Life*. This scene of brightly coloured marblesque grapes with wine glass, knife and cheese, unfolds beneath a brilliant red night sky laden with jewel-like satellites and a sliver of silver moon.

The following year, also the start of the new millennium, heralded a turning point for Gollon, and one that was precipitated through a major commission. He was asked to create fourteen monumental religious works to illustrate the *Fourteen Stations of the Cross*. This necessitated the artist having to devise a consistent landscape setting for the fourteen events that made up the subject, and for the first time he began to experiment with pure landscape painting. Landscape was quite a departure for the artist, whose work is marked by a far-reaching exploration of the driving forces of humanity and by his idiosyncratic humour. He managed, however, in the majority of cases, to bring these factors to his quirky, surreal scenes. Over the course of several years they began to develop a unique and recognisable mode of expression.

The very first work he painted in this genre was a total departure, in technical terms, from his characteristic style to that date. He approached the work *Figure on the Seashore* (2000) in a painterly manner, almost Impressionistically, with rapid, tangible brush strokes wrought with immense freedom. It is apparent that the artist did not over-think the painting, but simply painted it, quickly and from the heart, which gives it an enormous sense of atmosphere. It is one of the few paintings that the artist has kept for himself and it now hangs in his family home. It is surprising that, given its success in aesthetic and atmospheric terms, he never returned to this style for his landscapes, although this is possibly a reflection of the ongoing religious commission, which dictated a rather different approach and setting.

Figure on the Seashore depicts a tiny figure in an immense and stormy landscape, and addresses the relative insignificance of humans versus the elements. It is a haunting and melancholy work alleviated by a single slice of light that infiltrates the horizon and crawls across the clouds, hinting at a better dawn. The melancholy might perhaps have been inspired by the sizeable hangover Gollon had when he painted the work, though this explanation rather dampens any romantic inflection. It was painted while the artist and David Tregunna were in Aberdeen, in January 2000, where Gollon was undertaking a series of monotypes. The pair were staying in a hotel on the shore and enjoying the Scottish hospitality of heart-warming whisky, which was not their customary tipple. As the evening stretched on they decided that, quite oblivious to the gale-force storm raging outside, it would be beneficial to the creative soul to take a stroll along the seashore and embrace the raging waves. Gollon recounts that the following morning, with aching head and sandy feet, he remembered never having felt quite so small as he stood before the monstrous, black waves, lashed with stinging rain, and staring into the face of infinity. He felt small, but exhilarated, and somehow temporarily at least, immensely free, released from the fetters of daily existence. The painting was further inspired by Casper David Friedrich's (1774–1840) *Monk by the Sea* (1809).

The same year Gollon painted a series of eerie, surreal landscapes including *Landscape with Obelisk* and *Landscape with Obelisk II*, which are rendered in a more characteristically Gollonesque style with a precise use of line and large, flat areas of colour. As with much of his work, humour is quietly evident in the aforementioned paintings where the radiant, monolithic and

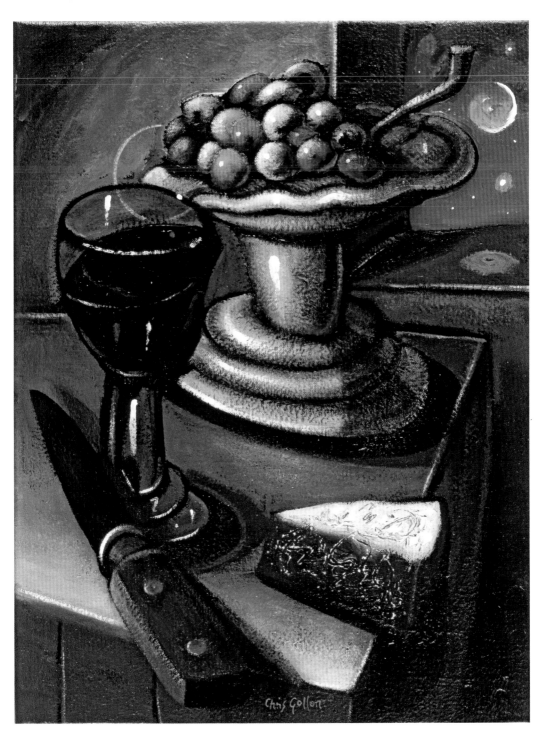

Still Life
Mixed media on canvas
91.5 x 61 cm (36 x 24 in.)
1999
Private collection

Figure On The Seashore
Acrylic on canvas
91.5 x 74 cm (36 x 29 in.)
2000
Private collection

Landscape With Obelisk
Acrylic on canvas
25.5 x 35.5 cm (10 x 14 in.)
2000
Private collection

faintly spiritual structure is both plausibly ancient memorial and a hulking cheese. There is a strong symbolist and surreal feel to these, and later landscape works, which take elements of naturalism as their starting point, as in the clouds in *Landscape with Obelisk*, but are essentially imagined and abstracted. In most cases Gollon's landscapes transpire within a mysterious atmosphere that is neither night nor day nor of this world. Or else they are set at night, as in *Landscape with Obelisk* and his reflective *Nocturne* (2004). His use of what can best be described as a twilight zone, or a period of space and time known only to the artist, is one that extends across much of his work including his figurative paintings and his still lifes. These times – evening, twilight, darkness and other Gollon states – are windows of intrigue for the artist, when the mundane world has packed up for the day and the night animals come out to prowl. Similarly, and this accounts for the lack of landscape work up to this point in his career, Gollon has always been more interested in city life, in dark alleys, in secret doors hiding secret lives of the debauched and misaligned, and in the heavy pulse of human traffic.

Ironically, it was a small slice of city life that inspired two landscape paintings in 2002, *Landscape with Fish I* and *Landscape with Fish II*; both reflect a haunting, ghostly place with a flat, reflective lake surrounded by conical hills. These are some of the earliest landscape paintings in which Gollon established consistent, recognisable features that he went on to develop as the setting for his religious works, most notably the peculiar hill formation and use of mirror-flat water. The idea for these two works came after a short

Nocturne
Acrylic on canvas
51 x 51 cm (20 x 20 in.)
2004
Private collection

trip to New York. The artist took his family away for a much-needed long-weekend break to the iconic American city, and one evening found himself wandering through the bustling community of China Town in the lower east side of Manhattan. There, amid the traditional Chinese food markets, Gollon saw a fishmonger with a large bucket of fish barely covered with water, gasping dry, hollow air, and just clinging to life. The artist, despite his abiding fear of fish was profoundly moved by their plight, and painted these two landscape pictures of fish escaping and heading, en masse, back towards the waters of their birth. In the first version the fish, rather comically, glance nervously behind them, fearful of their escape being foiled, but the sense is that they will make it to the lake. The second version is rather darker, the fish eyes boggle with a deathly stare and the crumbled, sketchy paint application gives the illusion that they are already on the point of decay, and have lost the battle.

By 2004 Gollon had established a unifying and distinctive visual language in his landscape paintings, which would eventually provide continuity through the fourteen monumental religious works. During the course of the year he painted a number of landscapes, which reflect his interest in pre-Renaissance and Renaissance art with his small, conical and distinctive hills recalling those seen in the backgrounds of paintings by artists such as Giotto di Bondone (*c.* 1266–1337), Giovanni Bellini (*c.* 1430–1516) and Leonardo da Vinci (1452–1519). Another significant influence on his development in this genre is the work of Pieter Brueghel the Elder, with particular respect

Landscape With Fish I
Acrylic on canvas
40.5 x 51 cm (16 x 20 in.)
2002
Private collection

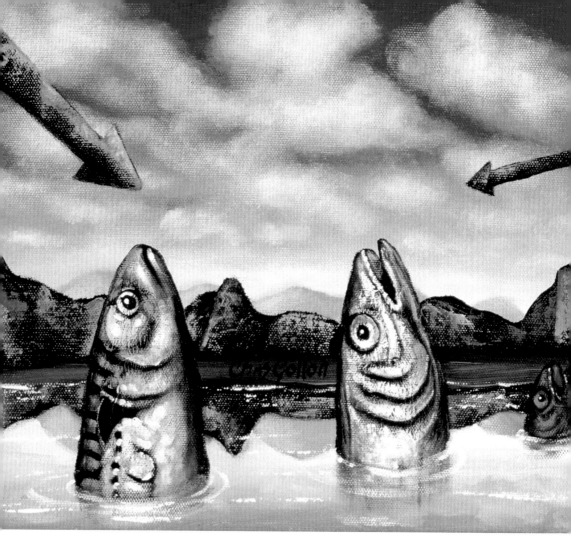

Fish In A Landscape
Acrylic on canvas
25.5 x 35.5 cm (10 x 14 in.)
2004
Private collection

Landscape With Mountains
Acrylic on canvas
76 x 51 cm (30 x 20 in.)
2004

to his use and distortion of perspective, seen in Gollon's painting *Fish in a Landscape* (2004) where an enormously deep panorama stretches out behind a close-up study of three fish heads. Brilliant, vivid colour is also a predominant feature in the majority of Gollon's landscapes used in an Expressionist manner to evoke a profound sense of mood and atmosphere. This is particularly effective in the background of his religious works and in the paintings *Landscape with Mountains* (2004), *Somewhere in Peru* (2004) and *Nocturne* (2004).

The intense and vibrant *Landscape with Mountains*, alternatively titled, *The Way to Amarillo*, was painted after the artist heard Tony Christie's song of the same name used in the TV comedy series, *Peter Kay's Phoenix Nights*, which aired in the UK in 2002. The song, which is famously hackneyed, went on to be re-released in March 2005 in aid of Comic Relief, eventually reaching number one in the UK's pop music charts. It was a tune that, like many people, Gollon came to loathe and love in equal measure finding it incessantly irritating and infectiously catchy. He initially began the painting as a form of tongue-in-cheek cathartic healing to rid himself of the song, but as the painting progressed it became less comic and more a comment on passion and longing. The landscape has become almost purely abstract and a matter of invention, with impossibly formed mountains whose reflection is seen despite the absence of any water. It is a work of pattern and colour, but surprisingly also of movement implied through the bowed mountains and the rushing arrows. These arrows appear relatively frequently in his work during this period, particularly in his religious paintings, and are first seen in his landscape work in the aforementioned *Fish in a Landscape*

Somewhere In Peru
Acrylic on canvas
40.5 x 40.5 cm (16 x 16 in.)
2004
Private collection

(2004), where they emphasise the importance of the fish as subject matter. Gollon's use of arrows to emphasise, occasionally deliberately confuse or as simple directives can be effective in his paintings, and indeed work well in this landscape, although at times they are an unnecessary addition to his compositions and detract from the subject matter.

Although *Fish in a Landscape* is not a specific study for his religious paintings, it does appear to be linked in style and content to his religious works. The landscape background of the painting with its distinctive hills and lake can be seen in *Jesus as The Man Of Sorrows* and *Mater Dolorosa*, both painted a year earlier, in 2003. The landscape work focuses on the three silvery fish, with fish (or *Ichthys*) significantly representative of an early Christian symbol, and fish and fishermen being mentioned a number of times in the Christian Gospels. In this painting the three fish suggest a possible reference to the Trinity, although the fish also represent three stages of the physical life cycle: the fish to the left of the image is alive; the one in the middle is dead, and the third is in a state of decay and sinking back into the still waters. The fish themselves are construed much in the manner of a still life, and again the

artist crosses genres as he merges his still life and landscape work. This is seen to brilliant effect in his 2007 paintings, which move away from any connection to his religious works.

Towards the end of 2004 Gollon produced two haunting and evocative works: the richly coloured and atmospheric *Somewhere in Peru* and the ghostly *Nocturne*. *Somewhere in Peru* is a study of intense heat and breathtakingly arid air, where cloying dust battles with the serene, impenetrable waters of a looking-glass lake. Gollon has reduced his landscape elements even further in this painting moving towards greater abstraction and pattern, yet maintaining a slim acknowledgement of the natural world. This combination of abstract forms and colour, which are tethered through a basic appreciation of landscape creates an aura of mystery and lends the work a contemplative significance, while *Nocturne* is even more spiritual in concept. Despite the reference to Peru in the first painting's title, both paintings were inspired many years earlier by one of Gollon's trips to Reno, Nevada, with his friend Keith Downey. While driving along a lonely, dust-whipped road in the vast, empty interior of Nevada state Gollon and Downey made the unwise decision to camp overnight alongside the shores of a blue-green lake. It was unfortunate that they had, by chance, chosen a sacred Native-American site on which to pitch their tent. With the blanket darkness of a Nevada night drawing in, and little else for entertainment, the two men began to drink tequila. When the tequila ran out, Downey jumped in their battered old Chevrolet, deaf to Gollon's objections, and took off in pursuit of further alcohol. Some time later Gollon heard noises outside the tent and saw a gang of justifiably enraged Native Americans, armed, and making their way in his direction. The artist recounts that it was the single most frightening moment of his life, and one that brought him sudden, piercing clarity of insight. As the tribe members neared the tent, two pools of light appeared in the distance, growing gradually larger and bouncing crazily from side to side, marking the breakneck arrival of Downey and the Chevy. Downey careered to a stop and hurled himself, wild-eyed and incoherent, from the vehicle, yelled a torrent of abuse at a nearby rock and collapsed with sudden, silent finality at the edge of the lake. Such was Downey's extraordinary display that the men intent on dispatching Gollon and his tent stopped in their tracks before suddenly turning as one and disappearing with silent dignity back into the shadows of the desert.

The next morning when Gollon woke he looked through the tent flaps and saw before him the most magical, serene lake with hills behind and a perfect, mesmerising reflection of the rising sun. It was in a sense the apogee of all landscape and a single segment of time – the perfection of the new dawn – that has remained with the artist to this day. It transpired, after Gollon found Downey sleeping in the shadow of a rock, that he had left the road and spent some time driving round in circles in the desert becoming increasingly irate before, by chance apparently, arriving back at the tent. He had no recollection of Gollon's visitors at all, or of passing out by the lake, or indeed of finding his way back to the rock, though the Chevy had two flat tyres and an annihilated front axle.

Chankly Bore (After Edward Lear)
Acrylic on canvas
46 x 35.5 cm (18 x 14 in.)
2004
Private collection

Another trip to America, to the desert city of Palm Springs, California, inspired Gollon's final series of landscape works in 2004. This series comprised the paintings *Palm Springs*, *Landscape with Two Trees* and *Chankly Bore (after Edward Lear)*. All three are highly inventive and surreal in concept, they are less landscape works than still lifes of abstracted elements. *Landscape with Two Trees* is almost a portrait of landscape, and all three paintings are markedly linear and precisely drawn with large, flat areas of colour. As a trio they are defined by Gollon's use of brilliant, uplifting blue, and red-dirt-brown that speaks of the Californian sunshine and 25,000 square miles of desert. Despite their obvious Surrealism there is still a palpable sense of Palm Springs.

Gollon's commission for the *Fourteen Stations of the Cross* was also responsible for, and is closely linked to, the artist's still life paintings, which he focused on in 2004, 2006 and 2007. Ironically, while enjoying a sudden rush of media attention garnered through the announcement of the commission (in 2000), and having reached the height, at that time, of his career, Gollon found himself barely able to make ends meet. Very few people buy religious paintings, and while his loyal collectors and new admirers were enthusiastic over the works, which included a number of religious paintings separate from the commission, few sales were made. This led to Gollon turning back to still lifes, which are eminently saleable, often relatively small in scale and time-efficient for the artist in comparison to his figurative paintings. There is also an interesting historical link between religious work and still life, with early European still life painting first being produced as decorative elements to be housed in niches surrounding religious works, or being of religious content, containing religious symbolism or allegorical meaning with strong moralising overtones. It was not until the sixteenth

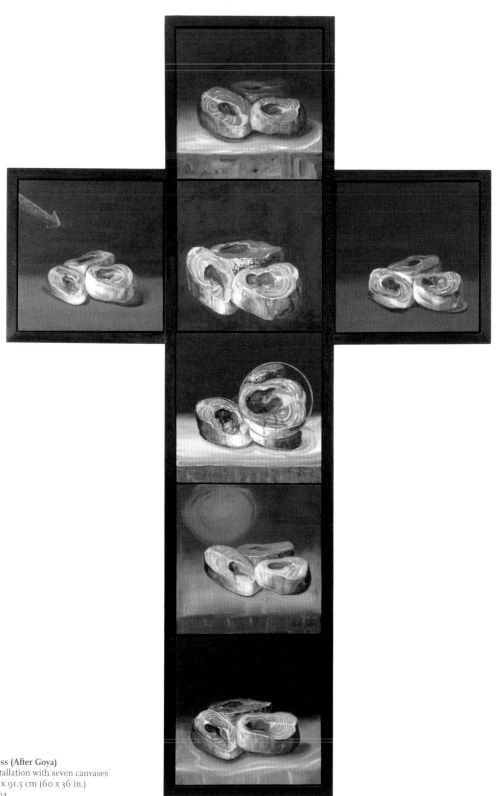

Cross (After Goya)
Installation with seven canvases
152 x 91.5 cm (60 x 36 in.)
2004

century that still lifes of secular objects, flora and fauna, began to appear. This was primarily as a result of the Renaissance in northern and southern Europe, which saw intense interest in humanism over religion and an increased interest in the natural world.

Having previously studied the work of Cotán, Melendez, Zurbarán and El Greco, in around 2001 Gollon began to explore Goya's still lifes. The Spanish master was amongst the first to remove culinary instruments and allusions towards food as essentially a consumable product. By doing so he elevated simple foodstuffs to a higher level investing them with a profundity rarely felt or seen before in such works. This concept of dead or inanimate objects being used to project fundamental emotions or messages was one that Gollon developed in his own still life paintings. One of his earliest works in this genre directly influenced by Goya was *Still Life with Salmon (After Goya)* (2001), inspired by Goya's *Still Life with Slices of Salmon* (1808–1812). Gollon's salmon steaks appear to weep with thick, sluggish blood; they are flesh that's been flayed and mutilated, and are shockingly stark. Gollon went on to explore the concept of murder and atrocity applied to the preparation of fish and meat (from artistic not moralistic grounds) and painted four more still life images of the salmon, depicting it in various states of decomposition. These were exhibited in a column formation. He returned to the subject in 2004 and painted two more salmon still lifes, then collated the seven images and displayed them in the form of a cross, creating the moving *Cross (After Goya)* (2004). To heighten the poignancy of the piece, Gollon made use of one of his magnifying circles. He positioned it on a panel indicating the rough location where the centurion's lance speared Christ's side, and included the tip of an arrow or lance on a panel diagonally opposite it, indicating the thrust of the attack.

It is clear when studying Gollon's work that many paths lead back to Toledo's magnificent Cathedral. Over the years the artist has spent a considerable amount of time in the city that El Greco made his home. The cathedral is a gothic masterpiece, and it is no surprise that both the building and Spanish art has been a consistent influence, hovering in the recesses of Gollon's fantastic, darkly humorous mind. Visiting the cathedral, which is home to works by, amongst others, El Greco and Titian, both major influences on Gollon (along with Goya), is a transcendental experience for the artist, in artistically spiritual rather than overtly religious terms, with the jostle of great art, sculpture, decaying cardinal hats and history assuaging the creative soul. When devising *Cross (After Goya)*, Gollon was inspired by the works in the cathedral, but wanted to present his painting in a different way, to make seeing the work an actual moving experience and one that would inexorably touch the viewer, which is a quality he brings to the fourteen paintings of the religious commission, as well as to the assembly of his salmon paintings.

In 2006 Gollon painted his most extraordinary and important still life work so far. *War* is a work that breathes violence and intimidation, yet it is to all intents and purposes a still life of a vase of flowers and some cherries. Once again Gollon blurred the genre of still life and landscape, a technique which he used increasingly through 2006 and 2007, seen in other works

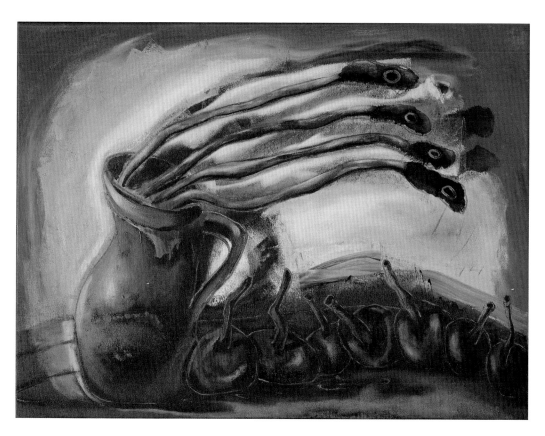

War
Acrylic on canvas
56 x 46 cm (22 x 18 in.)
2006
Private collection

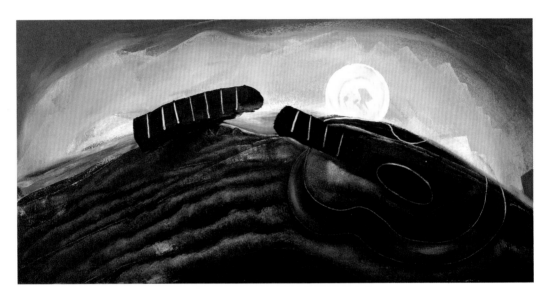

Fool On The Hill
Acrylic on canvas
50 x 99 cm (19.75 x 39 in.)
2007
Private collection

such as *Fool on the Hill* (2007) and *Landscape with Flowers and Broken Guitar* (2007), giving inanimate objects tremendous human character. *War* was painted in response to reading a number of philosophical works by the French playwright and novelist Jean Paul Sartre (1905–1980), which dealt primarily with human hostilities. Gollon was inspired to paint *War* as a pictorial reminder of the insidious violence within society. He used the colours of battle: a red ground overlaid with the blue-grey smoke of gunfire; using his scratching-in technique to produce the angry, raw-red outlines of the elements. The blatant message of the painting is that it is a hopeless battle of stacked odds and inequality with only one obvious winner. It is a painting in which any number of situations may be identified: from the brutality of war, the injustice of politics, the stranglehold of big corporations or indeed the playground bully, and as such it is universally appealing. On completing the painting the artist refused to allow David Tregunna to remove it from his studio. He insisted on it remaining in situ throughout 2007 while he completed his still lifes. It was with great reluctance that Gollon finally relinquished the work to the gallery for sale.

Of similar importance is the painting *Still Life Homage to Pittura Metafisica* (2007), which is another landmark work for Gollon and was inspired by the work of Giorgio de Chirico. This work takes the general underlying concept from *War*, but places it within a familiar social context, addressing the issue of cultural alienation in broad terms. A group of carafes and pots huddle together with introspective solidarity totally excluding the wine glass. At first the scene appears one of relative innocence, but the elements' shadows imply a different story. Acting somewhat independently from the vessels, the shadows take the scene from simple exclusion to aggressive exclusion, with the combined shadow of the group looming towards the glass, whose own shadow recoils back with fear. It is an image of almost childlike simplicity, and yet it addresses fundamental and topical issues such as racial, social, political and religious prejudice, a rather remarkable feat achieved by a still life. Shortly after finishing the work it was purchased by Professor Judith AK Howard, Head of Chemistry at Durham University and a world leader in the field of crystallography.

Following *Pittura Metafisica* and throughout 2007 Gollon continued to explore human relationships and dramas re-enacted in inanimate objects, as is demonstrated in the lyrical *Still Life with Stringed Instruments II*. The work is characterised by mellow colouring, highlighted through Gollon's use of both red and yellow grounds, which are then revealed by his scratching-in technique. He also used spray paint on this work, a technique inspired by the late work of Francis Bacon, but not one that he returned to often. In this particular instance it works to good effect and adds animation to the painting.

The beautifully coloured *Still Life with Two Glasses and Die, I* (2007) takes the theme of cavorting glasses, first addressed in his *Still Life with Drunken Glasses*, and gives it an added dimension. Here the liquid itself has escaped the glasses and is conducting its own affair, while the shadows behind, as in *Pittura Metafisica*, add great animation to the scene.

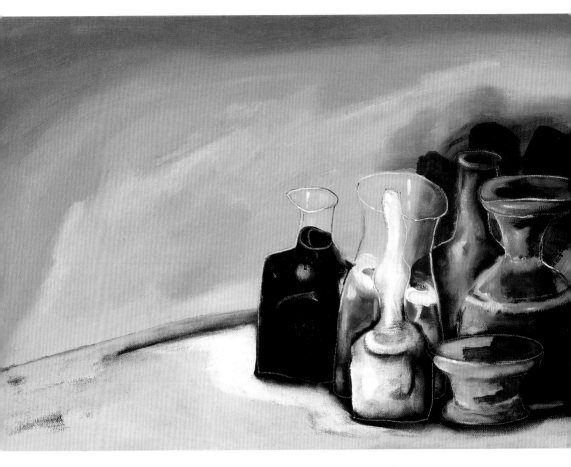

Still Life Homage To Pittura Metafisica
Acrylic on canvas
40.5 x 119.5 cm (16 x 47 in.)
2007
Private collection

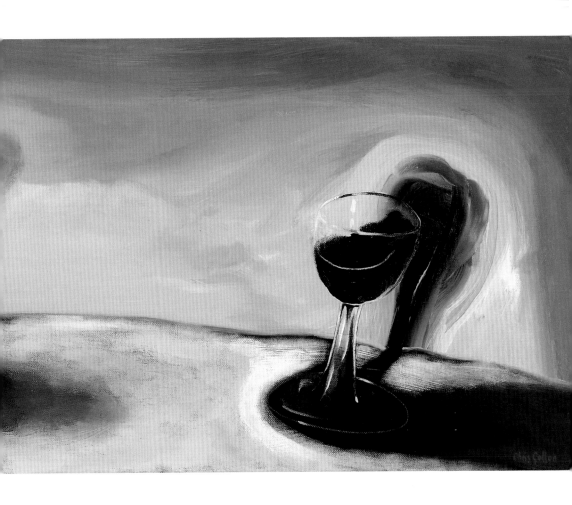

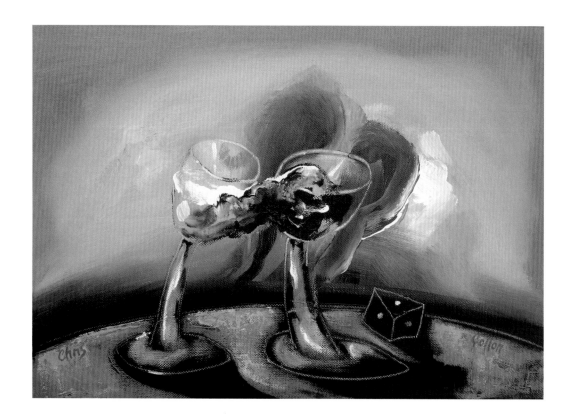

Gollon continued to experiment through 2007 with the idea of liquid leaving its intended vessel and he produced a number of works in this vein. Humour also plays an obvious role in many of these works including *Still Life with Champagne and Pot II*, which reflects the artist using an ambiguous background, possibly a stage setting for his work. His other technique, of combining a stage set with a highly stylised landscape, is seen to great effect in the quirky *Landscape with Flowers and Broken Guitar*, where predatory flowers hover with carnal intent over a broken guitar that lies in a striated landscape (also seen in *Fool on the Hill*) within a theatre-like setting. The flowers are characteristically Gollonesque, the anti-flower of the natural world, with a carnivorous countenance and peculiar, unsettling eye. The artist's inspiration for these unblinking eyes came after watching an episode of the TV programme *Nature Watch* in which a nest with two baby owls was being observed. The CCTV cameras trained on the nest showed, to the artist's consternation, the larger chick, with round, blank eyes, turn on and kill its smaller sibling when the parents had left the nest to search for food.

As 2007 drew to a close, and after further funding was secured, Gollon was able to turn his concentration again to finishing his large religious commission for the Church of St John on Bethnal Green. At the same time plans were being finalised for Gollon's trip to Durham, where he had been invited to become an artist in residence for three months, and ripples of new ideas and techniques were gathering force. These would be realised with astonishing results in his series *Early Thoughts* (2008).

Still Life With Two Glasses And Die I
Acrylic on canvas
25.5 x 35.5 cm (10 x 14 in.)
2007
Private collection

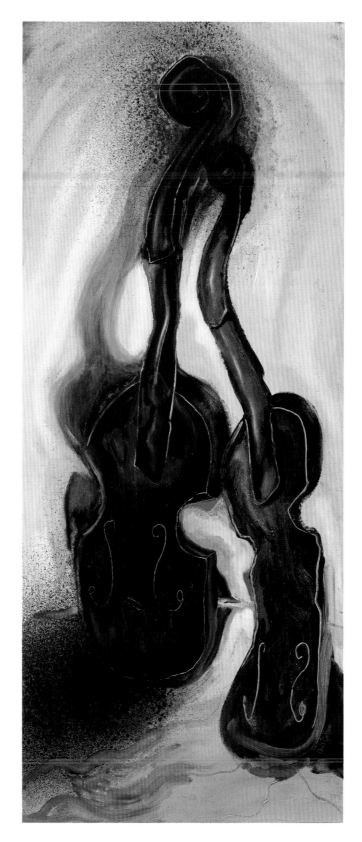

Still Life With Stringed Instruments II
Acrylic on canvas
119.5 x 50 cm (47 x 19.75 in.)
2007
Private collection

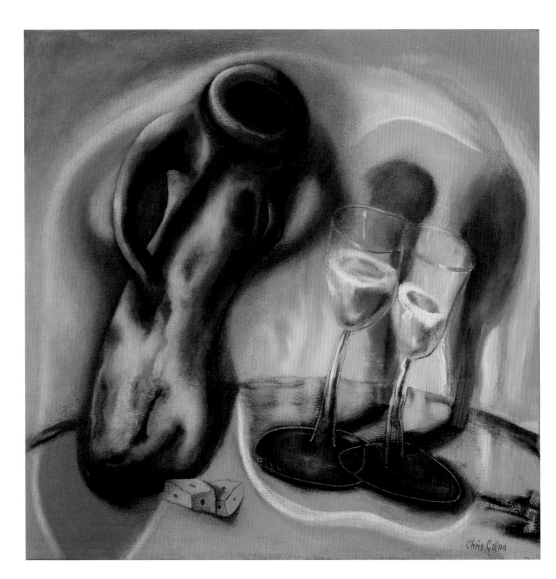

Still Life With Champagne And Pot II
Acrylic on canvas
51 x 51 cm (20 x 20 in.)
2007
Private collection

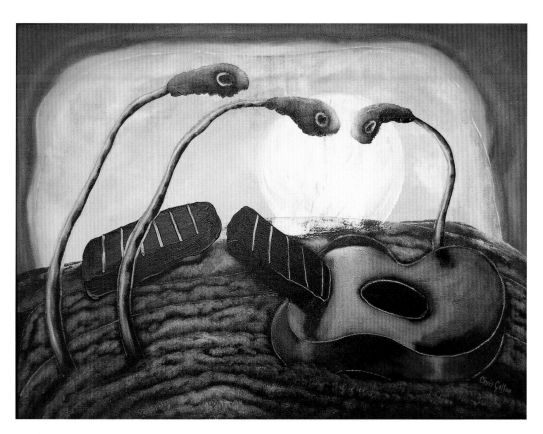

Landscape With Flowers And Broken Guitar
Acrylic on canvas
46 x 56 cm (18 x 22 in.)
2007
Private collection

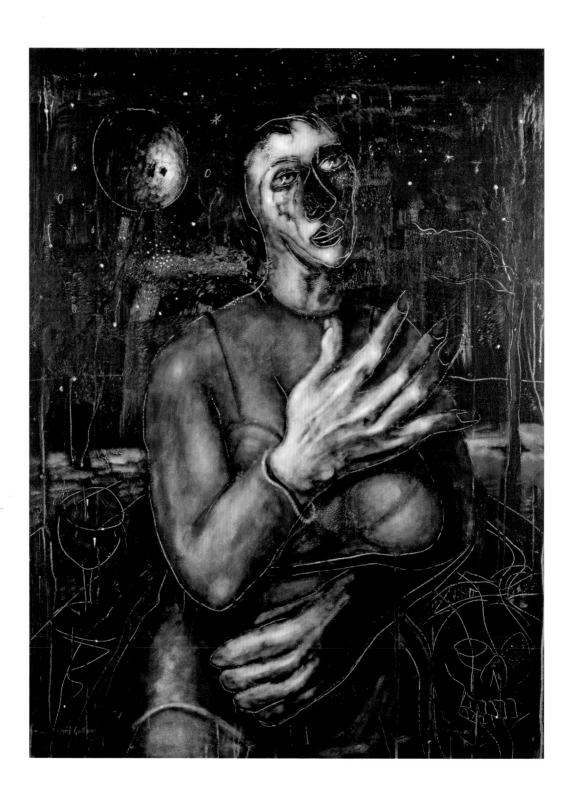

Chapter Six
THE RELIGIOUS PAINTINGS

Gollon is not considered a religious painter, nor is he a religious man, and yet in 2009 he unveiled a series of fourteen religious works, which count amongst the most important of their kind in contemporary times. The long journey that culminated in his *Fourteen Stations of the Cross*, for Sir John Soane's (1753–1837) Church of St John on Bethnal Green, began in 1999, on a dark, cold December night in a pub in the East End of London. David Tregunna was in The Approach in Bethnal Green with his friend, the master jeweller Paul Hatton, when the door swung open and two Anglican priests entered, singing Christmas carols. Hatton, on David Tregunna's behalf, jokingly offered to give them £50 if they stood on the bar and sang *Jerusalem*. What neither Hatton nor Tregunna realised was that these were no ordinary vicars: Father Brian had been the lead singer in a punk rock band and Father Alan was an occasional disc jockey. It was with great aplomb that the two men of God straddled the bar and belted out a fine rendition of *Jerusalem*, to enthusiastic applause. Since Tregunna was short on funds he asked Father Alan to come to the IAP Fine Art Gallery, just down the road from the pub, the following day and collect his £50.

The Penitent Magdalene (After Titian)
Mixed media on canvas
102 x 76 cm (40 x 30 in.)
1999
Private collection

Quite by chance, hanging in the gallery window was a painting completed by Gollon in 1999 titled *The Penitent Magdalene (After Titian)*. Although ostensibly religious in subject matter, the work was more significantly a searching reflection on human emotion, and bears little obvious religious imagery. Gollon was drawn to the specific subject matter, that of the fallen woman who seeks, and is granted, redemption – a woman whose express weakness and overriding strength is worn as a mantle – and subsequently returned to it, painting a number of penitent and pre-penitent Magdalenes such as the striking *Magdalene with Candle* (2002) and *Pre-Penitent Magdalene* (2003). Titian, whose work Gollon greatly admires, also painted this subject at least seven times including *Penitent Magdalene (c. 1555–1565)*. Titian's Magdalene paintings were intended to be contemplative devotionals and were received with great enthusiasm, lauded by his now-famous contemporary, the biographer, artist and architect Giorgio Vasari (1511–1574). In considering the paintings, however, it is clear that Titian struck a delicate balance between piety and salaciousness with his Magdalenes. They depict a woman with tear-streaked cheeks and heaving breasts either gasping with angst at her moral and spiritual crimes, or feasibly crying out with breathless ecstasy. Her beauty and attributes though covered demurely by her arm in a gesture that Gollon loosely copies were surely designed to appeal as much to the physical senses as to the spiritual soul of Renaissance man. Gollon's Magdalene, in this instance, bears no such obvious classic beauty, but she is raw and achingly honest, with artifice and aesthetics drawn aside to reveal a soul laid bare; she is in essence all that it is to be human where profligacy battles morality, and hope shadows despair.

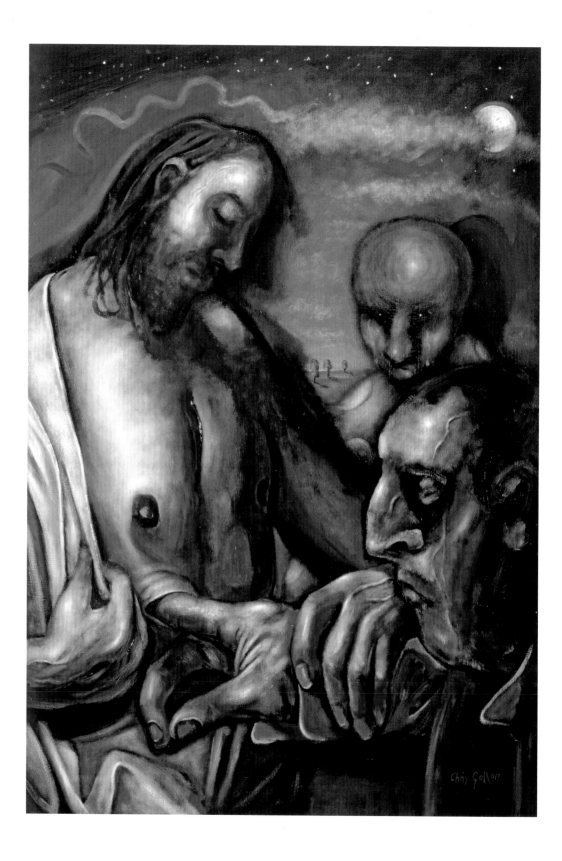

When Father Alan Green and his wife Sabine arrived at the gallery to collect their £50, both were immediately moved by this work, recognising Gollon's ability to encapsulate human emotion with rare perception. Tregunna, after handing over his money, showed the pair works from Gollon's *On the Road to Narragonia* series, which deals with human folly and vice, focusing on the absurdity of self imposed situations, and bringing irony and humour to an essentially bleak subject. Father Alan perceived that although Gollon's choice of subject matter over the years had not been religious, underlying almost all of his work were strong themes with their roots in spirituality. These themes often reflect the basic premises taught within organised Christian religions.

Several days later Father Alan requested a meeting with Gollon at which he proposed the idea of a commission to paint the fourteen stations of the cross, to hang in his parish church. Gollon was delighted to accept such a challenging commission, which over the course of the next ten years became both a labour of love and his Achilles heel, exasperated by a lack of funding. Before work could begin, Gollon, Father Alan and David Tregunna had to partake in a lengthy and delicate bureaucratic waltz to secure the support and backing of the Church for the commission.

While administrative wheels were grinding, quite by chance, Gollon was commissioned to paint two small religious works, including *Doubting Thomas (after Caravaggio)* (2000) by a private collector who had seen his paintings in a gallery owned by stalwart Gollon collector, Jon Bowles. The timing could not have been better as the artist was then able to use the two paintings to demonstrate to the Church of England his sincerity and understanding of the content of religious subject matter. *Doubting Thomas*, inspired by Caravaggio's (1571–1610) painting *The Incredulity of St Thomas* (c. 1601–1602), is an extraordinary work that is both repellent and compelling, with a striking configuration and distortion of hands in the foreground. It is Gollon taking Caravaggio's startling and controversial realism several steps further, leading the Italian master into the twenty-first century, and constructing the scene with a mixture of hyper-realism and imagination. Most significant is his juxtaposition of the profoundly moving Christ figure with the freakishly grotesque Thomas and macabre onlooker. Gollon would go on to develop further this contrast of realistically depicted figures with caricatures – in the *Stations of the Cross* paintings he uses these opposing elements to emphasise the emotive angle of the images.

In order for the Stations commission to come to fruition, it was necessary to obtain the permission of the Church, and Faculty Jurisdiction, which is a complicated process that is the Church of England's way of regulating changes to church buildings, contents and graveyards by issuing a 'faculty' or license. This also ensures the works can remain permanently in the church. To add to the complications, the church itself is a Grade I listed building. The first step was to gain approval from the parish church council, and to make sure the congregation was behind the rather controversial choice of a non-religious and non-conformist artist. Father Alan decided that the best way to do this would be to introduce the members of the parish church council to Gollon, and to show them some examples of his work.

So it was that one sunny day in June a boatload of parishioners, with Father Alan in the bows, sailed sedately down the Thames from Westminster Bridge to Gollon's studio on the island of Platts Eyot. It was a small oversight on Gollon's behalf that the studio was full of his *Stud Muffin* series of paintings, but the parishioners took this lascivious element in their stride and settled, fanned by a soft, summer breeze, on the banks of the Thames to discuss art and religion with the artist.

Any commission of such stature is naturally fraught with difficulties, but when the commission is public *and* religious there is the potential for even greater discord. With this in mind both Gollon and the parishioners had to be direct and forthright with their expectations from its inception, and it was this level of mutual honesty that contributed to the success of the paintings. From the beginning Gollon made it clear that he would need complete autonomy, in artistic terms, with the commission, although he would rely heavily on Father Alan for theological content. This required a tremendous leap of faith from the parishioners to accept that this unconventional artist, about whom they knew little, would deliver inspirational works worthy of their church, and it is testament to both Gollon and Father Alan that they were able to do so.

As the sun dipped down, the boatload of parishioners weaved its way, rather less sedately than the fashion in which it had arrived, back to Westminster Bridge. Gollon had won their full and unstinting support for the project, and had crossed the first hurdle. Next it was time to turn towards the rather more complicated and daunting prospect of gaining a faculty and winning the Church of England's approval. This eventually came down to the efforts of one man, Tom Devonshire Jones, without whom the commission would have faltered. Devonshire Jones was the editor of the *Art & Christianity Enquiry Bulletin* and a leading advisor on art to the Church of England. However, before he became involved in helping with the commission, he insisted on interviewing Gollon about his spiritual and religious beliefs, and about his intentions with the paintings. Gollon recalls it being a seriously daunting and severe interview, and one in which he was forced to address intensely personal beliefs. During the course of the four-hour session Devonshire Jones mooted he would require a series of preliminary sketches from the artist detailing the final composition of the different works. Gollon, however, who rarely produces sketches, refused since he believed that the commission would only work if it was based on a relationship of trust between the Church and the artist. Finally Devonshire Jones agreed, provided Gollon worked in close collaboration with Father Alan. At the end of the four hours Devonshire Jones cracked a smile; Gollon had passed, and had secured the support of this most esteemed man. Devonshire Jones immediately set wheels in motion approaching the Venerable Peter Delaney, Archdeacon of London to start the faculty process, and promised to fund the first two paintings through the Jerusalem Trust, and the third painting through the Christian Arts Trust. The Venerable Peter Delaney was instrumental in securing faculty for the works and became a great supporter of the project.

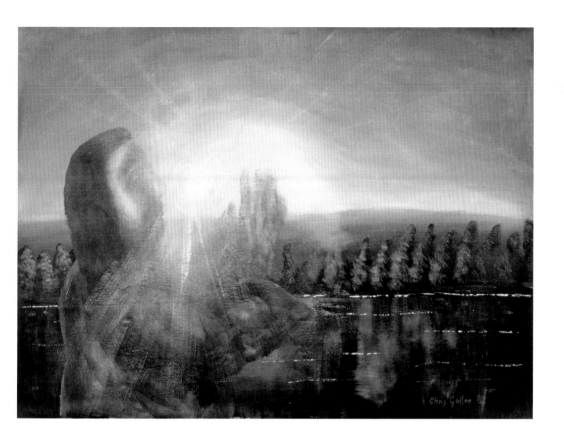

Jesus By The Sea Of Galilee
Acrylic on paper
51 x 72 cm (20 x 28 in.)
2001
Private collection

With the funding secured for the first three paintings, David Tregunna took it upon himself to find funding for the remaining works, believing this to be a relatively easy undertaking. As it turned out, the normal corporate avenues that Tregunna customarily tapped for large commissions were unable to support such overtly Christian works due to risible political correctness, and fear of upsetting religious minorities. Funding became the single biggest stumbling block with the commission, and in the end it was only through the extraordinary support of Gollon's collectors and members of the congregation, many of whom were far from wealthy, that the paintings were finally finished. To Gollon's credit, although the works have been an unprecedented critical success, financially they were an unmitigated disaster with the artist painting most of them at cost.

Before beginning work on the fourteen paintings Gollon began several small-scale religious paintings to try and develop a specific mode of expression, in particular for the depiction of Jesus. These works are not specific studies for the series, but do represent part of Gollon's working process as he prepared for the huge commission.

At the end of 2001 he painted *Jesus by the Sea of Galilee*, which incorporates elements of his familiar landscape later used in the *Stations* paintings. The work is moderately successful, though rather lacking in feeling, and reveals the artist attempting to define his concept of Jesus. As it turns out in this work he cheats, bathing Jesus' face in brilliant light, which effectively

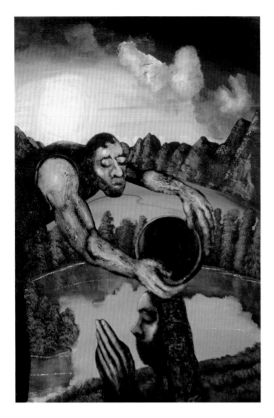

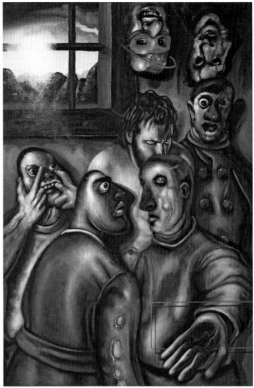

diminishes any features, and as it were the problem of depicting Jesus remains unsolved. There is a similarly unsatisfactory outcome with the depiction of Jesus in *John the Baptist Baptising Jesus* (2002). This painting has replaced the lethargy of the Galilee work with a striking dynamism: the structure is provokingly abstract with the two figures pressed into the foreground to an almost Byzantine-icon effect, and a disparate, fictional and distorted landscape behind. The hulking, ruggedness of John the Baptist's physicality emphasises with exquisite subtlety the profound tenderness of his demeanour, but again the figure of Jesus is unsatisfactory. Gollon has doused him in shadow this time, so that once again he remains indistinct and also appears rather weak, excepting the beautiful, elongation of his hands. Gollon's struggle to find a face for Jesus is clearly apparent in these early works, and it would not be until later in the year that he found his artistic voice for this commission.

The artist realised, through a process of trial and error, that to ensure consistency in the figure of Jesus through the fourteen paintings, he would need to work from a life model. This was quite a departure for the artist who characteristically works with an *en tête* approach, drawing his figures from his imagination. He then made the further, crucial decision to paint Mary mother of Jesus, Mary Magdalene, Veronica, Simon the Cyrenean, Joseph of Arimathea and Nicodemus from life models, but to depict all other characters (who were essentially the perpetrators) from his imagination. This conflict of juxtaposing strikingly realistic images with grotesques is one of

Left
John The Baptist Baptising Jesus
Acrylic on canvas
91.5 x 61 cm (36 x 24 in.)
2002
Private collection

Right
Jesus Is Condemned To Death
Acrylic on canvas
91.5 x 61 cm (36 x 24 in.)
2002
The Church Of St John On Bethnal Green, London

the fundamental keys to the series' success in aesthetic and spiritual terms. It presents a radical, non-conformist take on religious genre and reflects his manipulation of the delicate balance needed for these paintings to work as religious devotionals, and not to topple into a freakish cartoon world of insincerity. Gollon maintains this balance continuously through all fourteen paintings, producing works of polemic extremes from humour and horror, to tenderness and violence, which reach out on different levels to people of all ages and sensibilities.

The artist eventually chose to use his son Lawrence as the model for Jesus. It was a move that would cause him some distress as it meant he had to paint his son in an increasingly tortured state ending with his death. Gollon's daughter Alice became the model for Mary, Jesus' mother, Gollon's wife Anne, who is a nurse, modelled for Veronica, who tends Jesus in Station VI, and Johnny Langfield was grafted in as Simon the Cyrenean. The use of Gollon's family for the key figures was, in hindsight, a brilliant move by the non-religious artist since it lent enormous personal poignancy to the painting of such traumatic scenes. He recounts that depicting his wife and daughter as so emotionally distraught, and his son as dying was amongst the most soul-wrenching of experiences, and to this day his family is unable to look at the final station of the cross, *Jesus is Laid in the Sepulchre* (2008).

The first work for which Lawrence modelled as Jesus does not form part of the series, but was part of Gollon's working process as he defined the character and landscape. *Jesus as The Man of Sorrows* (2002) is a powerful and moving work that sets the tone for the succeeding paintings of the commission and reflects Gollon's unique idiom. It melds the real with the surreal and the imagined, with a seamless fluidity. As such the figure of Jesus moves between the achingly realistic portrayal of his emotive face, the high stylisation of his crown of thorns and thickly matted hair, and the blurred distortion of his hand, which becomes suggestive rather than objective.

Prior to finalising his visualisation of Jesus, Gollon had painted the first of the Stations, *Jesus is Condemned to Death* (2002), depicting an imaginary figure for Jesus. Although the imagined Jesus was unsuccessful, the structure of the picture and his use of hideous grotesques was clearly definitive. Gollon then had to repaint the picture retaining all pictorial elements, but replacing the lacklustre Jesus with one painted from his son. The finished version of this painting is as macabre and disturbing as the event would warrant, with grotesque parodies for guards and a mocking audience of monstrous freaks, amidst which the slight frame of Jesus is thoroughly diminished. Through the window in the background is the landscape that appeared in *Jesus by the Sea of Galilee*, and a similar burst of sunlight in the Station work obliterates part of the window frame leaving the shape of a cross, which alludes to events eventually to transpire. Most pertinent is Gollon's use of a magnification square in the foreground to highlight the guard's hand gesture, which serves to push the onlooker away. His downcast eye perhaps suggesting an awareness of, and possible shame at, the human violation occurring.

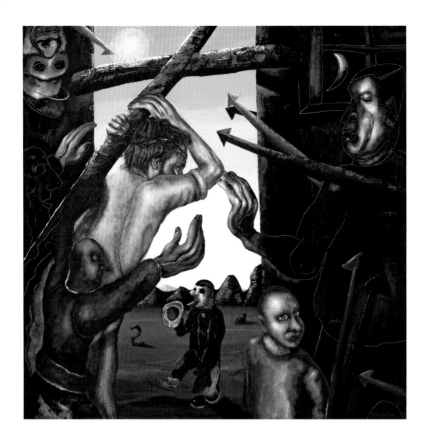

All fourteen of the paintings were conceived as site specific, with the first two, *Jesus is Condemned to Death* and *Jesus Takes Up His Cross* (2002), painted to hang in the austere, neo-classical vestibule of the church. These biblical events took place away from the public gaze, and so their positioning amidst the tall, cool columns and quiet, dark interior of the vestibule is entirely fitting. Gollon's palette for both these works is also noticeably more tonal than the remaining paintings, with a greater use of small detailing. This combined effect encourages the viewer to step up to the works and study them at a closer proximity than the remaining twelve paintings, and increases the sense of claustrophobic, evil intimacy of the events. In *Jesus Takes Up His Cross*, the figure of Jesus is seen already bowed beneath the weight of the wooden cross, and on the point of stepping across a threshold from the darkened interior out to a desolate wasteland that stretches under a vitriolic sky. Gollon provides continuity between the first and the second painting through the inclusion of the same upside-down malignant, masked figure who hangs in the corner, but the other figures have degenerated even further from those in the first painting. The guards are gone, replaced by nightmarish doppelgangers and joined by an intensely unnerving child with shining prescient eyes. Further demonic figures are hinted at and yet to emerge from the shadows, while tramping across the landscape comes an incongruous dwarf heralding the start of hell's pantomime by blowing a golden trumpet. There is a passing echo of characters from both Max Beckmann and George Grosz's (1893–1959) work in these initial manifestations of malign entities, but largely Gollon's works were

Jesus Takes Up His Cross
Acrylic on canvas
112 x 112 cm (44 x 44 in.)
2002
The Church Of St John On
Bethnal Green, London

unprecedentedly original, and have given religious painting of the twenty-first century a much-needed overhaul.

The paintings and accompanying works that comprised this commission should be viewed as an entirely separate entity within Gollon's oeuvre, and indeed they occupy a quite unique position. Once the artist had devised his visual language and use of imagery for the works, he maintained a consistency throughout, despite the lapse of nine years between the first and last painting. They also remain, stylistically, somewhat separate from other non-religious works that he undertook during this time frame, although there are some obvious natural crossovers, specifically between his landscape painting and religious work, and the recurrence of certain imagery such as his use of arrows and magnification circles. There are some exceptions to this however, with one of them being his powerful painting, *Magdalene with Candle* (2002), which although a religious subject is conceived more in the manner of his secular paintings. This work was painted at the same time as the first two Stations, and is, much like his *Penitent Magdalene* (1999), religious in title only, bearing little other relation to his religious works. *Magdalene with Candle* brings together still life and figurative painting with a religious sub text, and is quite extraordinarily beautiful. This is the Magdalene before she repents, a common prostitute, slumped across a table strewn with glasses. Rather humorously Gollon has painted a clock showing the time to be a little short of 3am, which was the time that he and David Tregunna typically spilled out of the sumptuous Teatro Club in London's vibrant Soho. Next to the woman is a lighted candle, a traditional symbol alluding to the renewal of hope. This gives the painting its quasi-religious context.

At the end of 2002, a highly productive year in terms of his religious paintings, Gollon completed the third Station, *Jesus Falls A First Time*. This is the first work to be encountered on entering the southern nave of the

Magdalene With Candle
Acrylic on canvas
51 x 76 cm (20 x 30 in.)
2002
Private collection

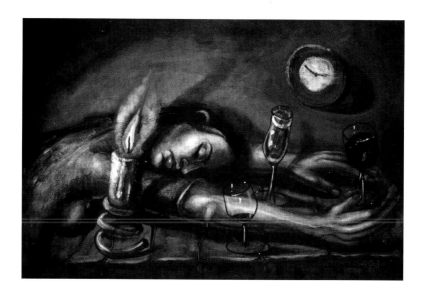

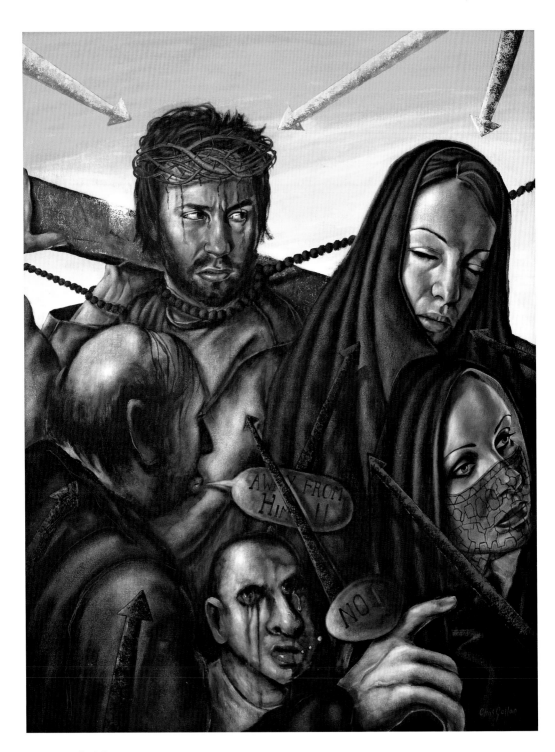

Jesus Meets His Mother
Acrylic on canvas
102 x 76 cm (40 x 30 in.)
2003
The Church Of St John On Bethnal Green, London

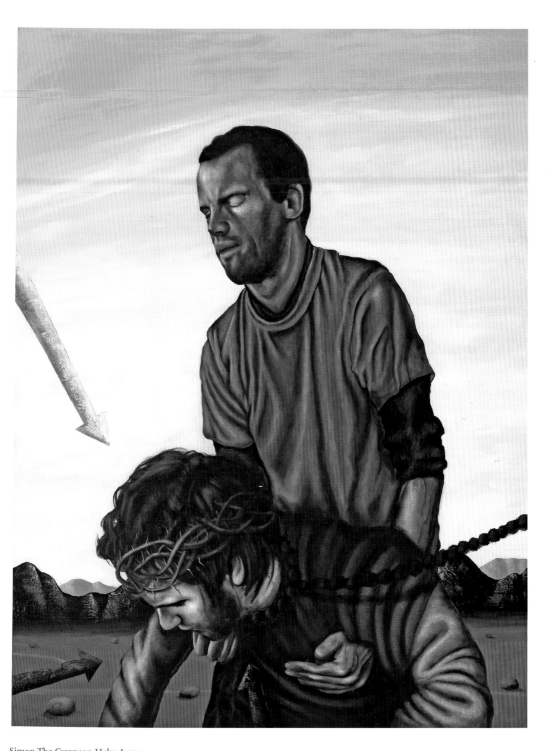

Simon The Cyrenean Helps Jesus
Acrylic on canvas
102 x 76 cm (40 x 30 in.)
2003
The Church Of St John On Bethnal Green, London

church and is also the first of the Stations to be set entirely in landscape. This, and the remaining paintings with the exception of *Jesus Dies on the Cross* (Station XII) and *Jesus is Taken Down from the Cross* (Station XIII), both painted in 2008, are characterised by a surreal and acidic-yellow sky. Gollon's unusual choice of this vibrant and unsettling sky adds to the intensity of the scenes, but was more pertinently devised by the artist as a consequence of the paintings' location. The spectacular church, considered one of the finest examples of Sir John Soane's mature style, has plain glass, rather than stained-glass windows, which allows a flood of blonde light into the interior. Gollon's searing yellow skies prevent the paintings from being washed out by the neutralising effect of such strong, natural light, and the paintings themselves, with their dramatic colouring, have almost the effect of stained glass, rendered in paint.

An important work in terms of its modern context is Station IV, *Jesus Meets His Mother* (2003), which was exhibited in St Paul's Cathedral, London in 2004 in the exhibition, *Presence: Images of Christ for the Third Millennium*, alongside works by Tracy Emin (b. 1963), Peter Howson (b.1958), Bill Viola (b. 1951), Craigie Aitchison (1926–2009) and Maggi Hambling (b.1945). Women are an important component of the Gospel stories, yet their role and traditional depiction in the arts is frequently marginalised – not so Gollon's women. The artist has, irrespective of his religious work, always painted strong women, and even those who are compromised, or caught in moments of weakness, have an inherent core strength. He brings this approach to his religious works, where women are, contrary to historic tradition, treated with equal significance. The figure of Mary in *Jesus Meets His Mother*, is placed on almost the same pictorial plane as that of Jesus and her importance to the event is further emphasised through Gollon's use of a single blue arrow above her head. Traditionally Mary is depicted as either making eye contact with her son, or as a fainting figure overcome with emotion. Here Gollon has given the scene far greater poignancy, by showing Mary looking away from her child. The enormity of her position and her inability to help him is such that she cannot bear to look at him, with her pain written with excruciating clarity across her face. Yet the two bodies are together, touching, and Mary's strength and support for Jesus is translated through this physical contact.

In front of Mary is a figure, whose great beauty provides striking contrast to the Bosch-like grotesque in the bottom corner and acts as an aesthetic clarification between good and evil. Between the two hovers the unnerving child-like figure from the second Station, *Jesus Takes Up His Cross*, who cries out in anguish against the violence. Gollon's use of speech bubbles, as seen in this work are a quirky addition and further illustrate his challenging approach to the subject matter. The composition would work equally well without them, but by their comic-book association they suggest the farcical nature of the entire event based on human depravity and injustice of the grossest kind. Significantly too, these speech bubbles and the use of macabre grotesques, which work on one level of understanding, also make the paintings more accessible on a simple level for children, giving them a far greater universal importance than many religious works have.

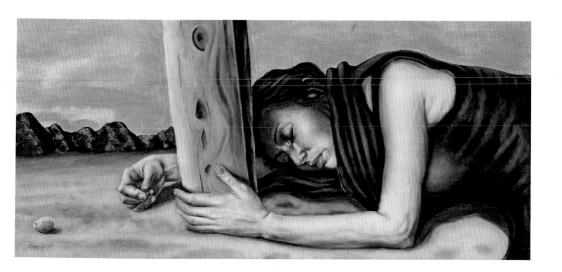

Study For The Magadalene At The Base Of The Crucifixion
Acrylic on canvas
51 x 112 cm (20 x 44 in.)
2003
Private collection

One of the problems encountered by Gollon during the painting of this series was being able to encourage the correct facial and bodily expressions from his life models. As the series progressed and the horror of the events being painted increased, Gollon's family became steadily more emotionally involved and were able to project this during their modelling. It was rather different however with the fifth Station, *Simon the Cyrenean Helps Jesus* (2003), since Johnny Langfield who was the model for Simon the Cyrenean, had not yet been involved in the harrowing process. One day in the studio Lawrence, posing for Jesus, suddenly pretended to collapse, causing his friend Johnny to rush forward with great concern and grasp him under the arms. It was the perfect gesture and Gollon was then able to paint the scene, which now ranks amongst the most moving of the fourteen works. As with the majority of the series, the modernity of Gollon's interpretation is most evident here, in the gesture of Simon, who traditionally did not have such close contact with Jesus, and with both figures clothed in garments that could as easily be from the twenty-first century as the first century. The contemporary edge that Gollon lends these scenes gives them greater profundity for the current times, giving them an immediacy that serves to increase and clarify the horror of the events for modern society.

He achieves a similar effect in two paintings related to the series, which he undertook in 2003; *Mater Dolorosa*, painted using Gollon's daughter Alice as the model, and *Study for the Magdalene at the Base of the Crucifixion*. These two works, both featuring the different Marys, reveal thoroughly modern women saturated with grief and strikingly beautiful. Gollon used the basic structure of *Study for the Magdalene at the Base of the Crucifixion* to produce an exquisite etching in 2005, and again in 2009 for his painting *Human*, which formed part of his *Being Human* series of works undertaken at Durham University.

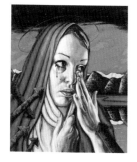

Mater Dolorosa
Acrylic on canvas
51 x 40.5 cm (20 x 16 in.)
2003
Private collection

Within the same time frame as *Mater Dolorosa* and the *Magdalene* study Gollon received a private commission to paint *The Last Supper*, which could not have been conceived more differently from his Stations paintings.

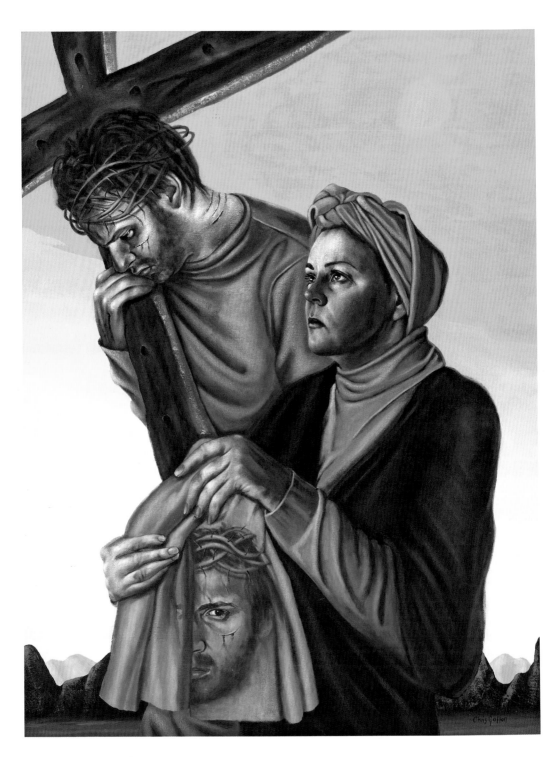

Veronica Wipes The Face Of Jesus
Acrylic on canvas
102 x 76 cm (40 x 30 in.)
2005
The Church Of St John On Bethnal Green, London

The painting is more in line stylistically with the rest of Gollon's oeuvre and reflects the artist returning to his more familiar *en tête* method of painting. It is, unsurprisingly, a rather different take on the Last Supper; not least because he has placed the figure of Jesus, seen in white, in the foreground and accompanied by a green-robed John. There is an extraordinary apathetic atmosphere in the piece, the figures so apparently lethargic that they are on the verge of an eclipsing torpor, either that or they are suffering the consequence of too much wine. It is apparent that Gollon has chosen to depict the scene before Jesus reveals one of the disciples will betray him, but has singled Judas out as a shadowy figure in the background through the use of a characteristic arrow.

Gollon returned to the Stations in 2005 when more funding had been secured, and began work on the striking painting, *Veronica Wipes the Face of Jesus*, which is the sixth Station. The biblical story behind the work relates how a woman from Jerusalem, thought to have been the wife of a high-ranking Roman official, wiped Jesus' face with her veil as he fell beneath the weight of his Cross. A full impression of his face then miraculously appeared in blood on the veil. Gollon, using his wife Anne as the model for Veronica, has depicted the scene just before Jesus falls, which is the next painting in the series. Again he has created a woman of enormous strength, whose tenacity is amplified by the physical weakness of Jesus. She looks beyond the canvas, towards a greater understanding and for some spiritual explanation of the physical violence occurring, with an unwavering loyalty and devotion. While painting the work Gollon was also considering women and their supportive, though often underplayed, role in times of conflict, most specifically the women of the First and Second World Wars. He relates that through the painting of Veronica he strove also to represent a universal concept of woman, such as those who joined the Red Cross and the Wrens, and with this in mind clothed Veronica in fairly ambiguous and timeless garb. Most compelling however, is the image of Jesus' face that Gollon has painted with striking animation on the veil in the foreground. The vibrancy of the impression on the veil contrasts greatly with the actual figure of Jesus who is bowed and barely upright. With Gollonesque irony, Jesus props himself up against his cross, the tool of his martyrdom, while the impression of his face implies the longevity of his spirit: so while the body may crumble the spirit lives on.

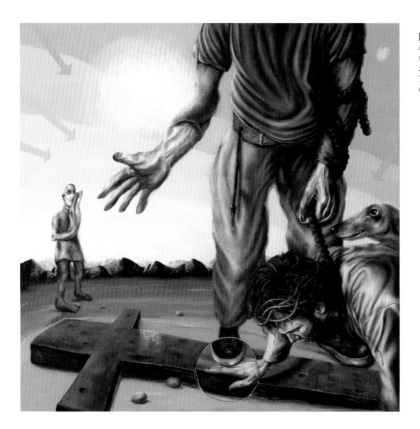

Jesus Falls A Second Time
Acyrlic on canvas
122 x 122 cm (48 x 48 in.)
2006
*The Church Of St John
On Bethnal Green, London*

The body's shortfalls are brought to the fore in the sequential work *Jesus Falls A Second Time* (Station VII), which was finished in 2006. This powerful image combines some of the best and quirkiest details of the series, from the surreal figure in the background wearing a surgical mask, implying that by this point Jesus is beyond the help of man, to the sinister hound in the foreground. The collapsing figure of Jesus is painted below the level of the dog, with obvious symbolic allusion, and Gollon has again employed the use of a magnification circle to highlight the guard's foot treading on Jesus' hand. The guard is wearing ambiguous clothing, although his baseball-booted foot propels him into contemporary times. The guard appears to be tripping over the body of Jesus, as his frame lurches forwards out of the pictorial space towards the viewer, while the sense of threat is strangely heightened by the exclusion of his face. Gollon has painted the scene to place the audience on the same ground level as the fallen Jesus creating the sensation that the viewer is as downtrodden and subjugated, with the oppressive guard looming above. It is a particularly desolate scene with Jesus alone here in his suffering, and is in complete contrast to the next Station, *Jesus Speaks to the Women of Jerusalem* (2006).

This monumental work, which counts amongst one of the largest of the series, is also perhaps one of the most challenging and important. Significantly it is the last Station in which Jesus is seen (alive) with supporters, and even more pertinent, these last supporters are strong women, conceived in very modern terms. A diminished figure of Jesus,

Jesus Speaks To The Women Of Jerusalem
Acrylic on canvas
122 x 122 cm (48 x 48 in.)
2006
*The Church Of St John
On Bethnal Green, London*

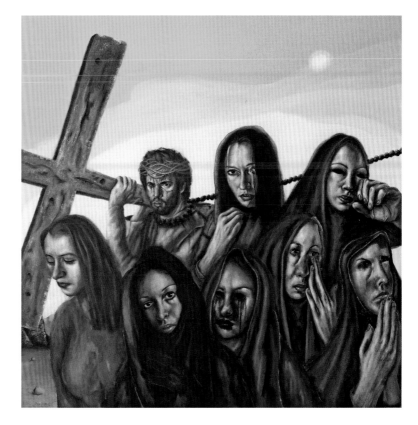

roped around the neck like a dog, is seen upright again and carrying his cross. Between the viewer and Jesus is a wall of women, the Women of Jerusalem who refused to abandon him on his journey. Traditional scriptures relate that, despite his pain, he stopped to encourage the women and offer them solace. This is inverted in Gollon's rendition of the story, where instead the women, despite their grief, present a united and solid front, offering support to their Saviour. Through the piercing look of Jesus and the expressions of the women, it can be deduced the viewer has been turned into the perpetrator with the women offering some degree of fruitless protection between the viewer and Jesus. It is unusual to see the Christ figure diminished to such an extent, and even more in the presence of women; here he is noticeably smaller in frame and is placed below the level of the Magdalene's head. This approach is typical of Gollon who challenges the onlooker to question themselves and their beliefs, to question what they see and how they perceive it, and finally to question what is fundamentally right and wrong within a broader context. The artist chose to take a controversial path, but one completely in keeping with his oeuvre as a whole. Gollon's confrontational approach to these works is clear and transparent, completely lacking in deceit, and is wrought with such finesse and sincerity that it aids contemplation, deftly sidesteps disrespect and defies being blasphemous. It is perhaps unsurprising in light of this that the painting has been placed to the left of the altar, in an area of the church that was traditionally closed to women.

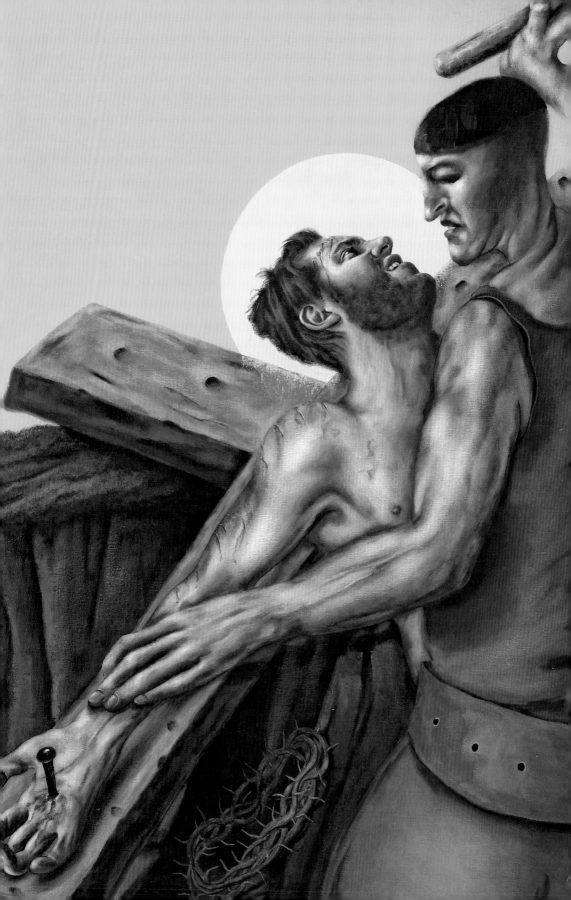

It is interesting that Gollon has chosen to depict the Magdalene next to Jesus, with Mary his mother slightly lower down in the positioning. Both Marys are beautifully painted in this work, with the Magdalene based on Patte Griffith, a Canadian former fashion model who Gollon used a number of times in his non-religious works. The beauty of these two is emphasised by the coarseness of the remaining women whose features appear to dissolve physically with increasing intensity, culminating in the woman at the centre whose face has begun to dissipate beneath the bitter, erosive path of her tears. It is fitting that this most important work in the series was funded by leading author Sara Maitland, whose novel, *Daughter of Jerusalem* won the Somerset Maugham prize in 1979.

Jesus Is Nailed To The Cross
Acrylic on canvas
102 x 76 cm (40 x 30 in.)
2007
*The Church Of St John
On Bethnal Green, London*

One of the hardest works of the series for Gollon to paint was *Jesus is Nailed to the Cross* (Station XI), being the last scene in which he painted his son as still alive. The composition of the picture is beautifully simple, condensed down to its most necessary components, and arranged with tremendous structural integrity. As with many of Gollon's works it is what he chooses to leave out that lends them such poignancy. This level of deliberation and selection is quite remarkable given that the artist rarely made preliminary sketches for these paintings. As used by the artist to great effect in previous works, here again he has juxtaposed the realistic treatment of Jesus with distortion. The guard is a mannequin of horror, growing with fluidity from a shapeless form at the bottom of the canvas and emerging as a monstrous infidel, earless and deaf to the anguish he causes, and intent only on hammering home his nails.

Throughout the paintings to this point Gollon has depicted the slow journey of an acidic sun across his dry-hot skies, marking a passage of time. In this work, the sun has dropped to rest as an iridescent and accidental halo, taking the place of Jesus' crown of thorns, which has slid from his head. This is the last painting before the eclipse, when the skies turned black during the course of Jesus' death, seen in *Jesus Dies on the Cross* (Station XII). Gollon actually painted this work last after completing Stations XIII and XIV, partly because the exact location for the work was not decided until 2008. After considerable consultation with Father Alan and with the Venerable Peter Delaney, Archdeacon of London, it was finally decided to hang the monumental painting from the upper gallery, so it faces the altar. The final position is twelve feet above the central aisle, which greatly affected the way in which the painting was conceived. It required great foreshortening of the figure to give it aesthetic logic when seen from so far below. Depicting such an iconic and revered subject as the Crucifixion in modern terms is a task of enormous proportions. At first glance it appears Gollon retained a traditional format for this work, which indeed he did drawing on masters such as Mathias Grünewald's (*c.* 1480–1528) *Crucifixion* (*c.* 1525) for inspiration. In particular the exquisitely horrific curled hand of Gollon's Jesus, taut with pain, reflects those used by Grünewald, but traditionalism stops here. Gollon's Jesus is part human, part deflated flesh, with the realism seen in his upper body, swiftly slipping into merely suggested form. His legs from the thigh down are just representations of flaccid, boneless flesh and could not contrast more with the almost icon-like depiction of Jesus' face. It is an

accurate depiction of the *instant* of death, the moment when the soul leaves the body, which collapses into something almost unrecognisable, and makes interesting comparison with the dead Jesus lying with marble solemnity in *Jesus is Laid in the Sepulchre* (2008). In this final work the body has been perfected, idealised and canonised.

Returning to his *Crucifixion*, a reflection on the transience of the human body can be intimated through the enormous structure of the cross, a monolith of evil, against which the broken body of Jesus appears even more diminished. One final detail adds further tension to the infinite pathos of the work: Gollon has painted Jesus' loincloth as if on the verge of slipping away, adding to the indignities and humiliation his body has suffered.

The final work, *Jesus is Laid in the Sepulchre*, which was painted before the *Crucifixion*, is stark and simple, understated yet immensely moving, and recalls Hans Holbein the Younger's (*c.* 1497–1543) *The Body of the Dead Christ in the Tomb* (1521). The infinite blackness of the *Crucifixion*, which Gollon created through building up multiple layers of black, has been replaced by a sulphurous sky, but the sun is notably absent. Instead, where the raw acidity of previous skies was alleviated through tonal changes, here the yellow is solid and unrelenting creating a unilaterally oppressive atmosphere. To offer a little hope and suggestive of the resurrection, the painting was placed next to the font at the back of the church. With the presence of children in mind, Gollon included a tiny golden halo around Mary's head that can only be seen from one direction. This optical illusion encourages children to walk around the font to see the halo appear and disappear, inspiring them to take an interest in the paintings.

The series was finally completed in 2008 and was exhibited temporarily at the historic Church of St John on Bethnal Green on easels, before the paintings were returned to storage to await permanent installation. It was with tremendous enthusiasm that the works were finally installed, unveiled and blessed by the Bishop of London, Richard Chartres in time for the Good Friday processional service in 2009. They have since garnered much media interest. It is one of those arbitrary turns of fate that Gollon moved from completing this serious religious undertaking to his residency amidst the world's leading scientists and thinkers at Durham University, where he embarked on an exploration of what it is to be human.

Jesus Dies On The Cross
Mixed media on panel
183 x 122 cm (72 x 48 in.)
2008
The Church Of St John On Bethnal Green, London

Overleaf
Jesus Is Laid In The Sepulchre (Detail)
Acrylic on canvas
81 x 117 cm (32 x 46 in.)
2008
The Church Of St John On Bethnal Green, London

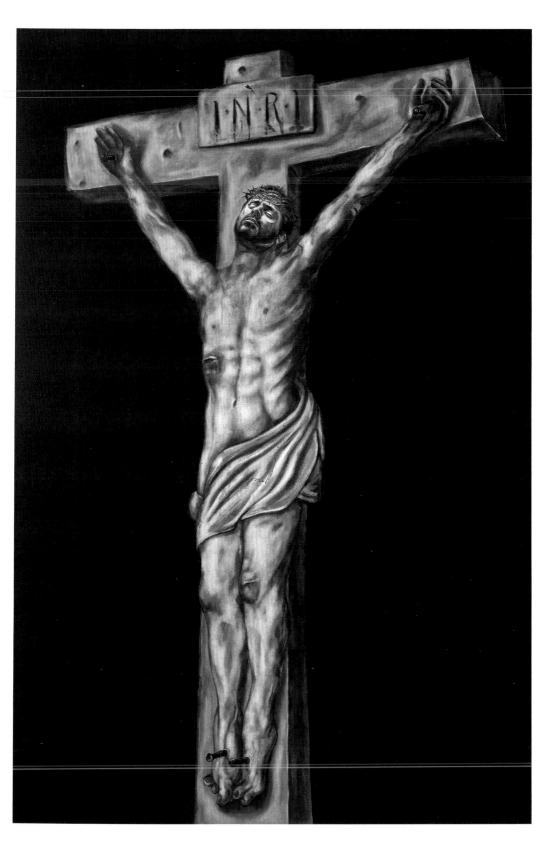

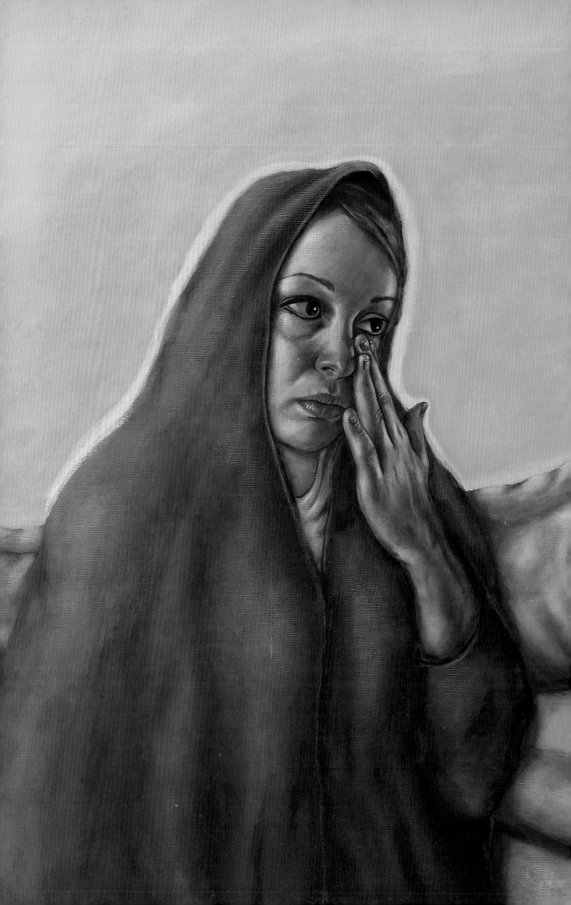

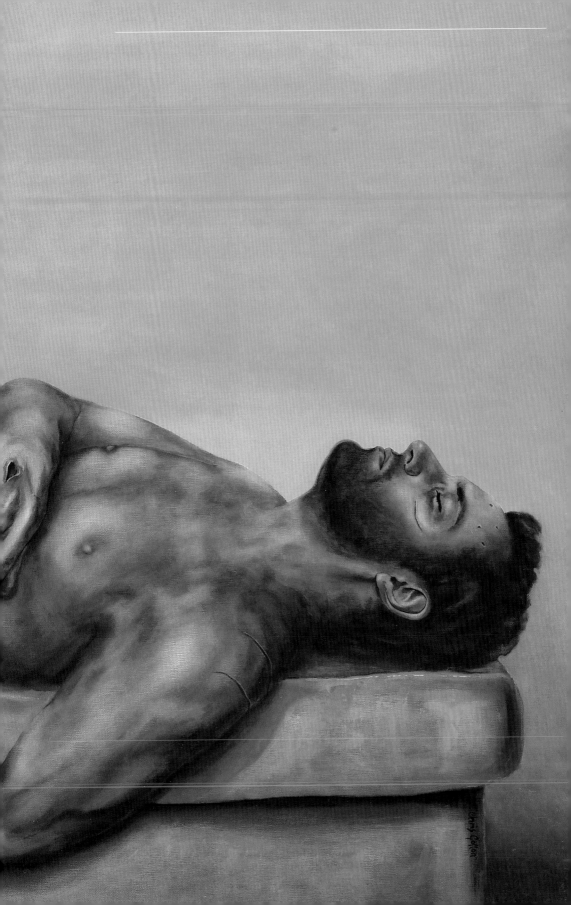

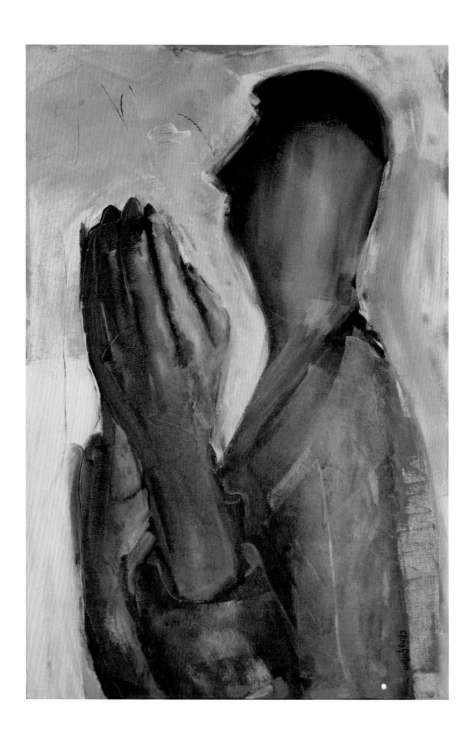

Chapter Seven
EARLY THOUGHTS AND BEING HUMAN

On a moribund morning in March 2007, a morning draped in a grey-brown London haze of damp misery and blown raw with a bellicose wind, a woman stepped through the door of the IAP Fine Art Gallery with the intention of buying a print by another artist. Hanging prominently in the gallery was Gollon's *Einstein at the Garden Party* (2005) and a number of his recent still life paintings including the striking *Still Life Homage To Pittura Metafisica*, both of which caught the woman's eye. Some time later she left the gallery with the print she went in for, and both the Einstein and the still life. It was an event that marked the inauguration of what has proved to be an extraordinarily fruitful relationship, in artistic and academic terms. The woman was the eminent scientist Professor Judith AK Howard, who is a leading crystallographer and Head of Chemistry at Durham University, and who, while attracted to the Einstein painting for obvious reasons of scientific affiliation, found the human subtext and depth in the still life particularly fascinating. It was a morning that saw the slow wheels of fate creak into torpid action.

The Gregorian Singer
Acrylic on canvas
76 x 51 cm (30 x 20 in.)
2007
St Mary's College,
Durham University

At that time, Professor Howard was in the midst of moving house, and having nowhere to store her new purchases safely, suggested hanging them on the walls of the esteemed Institute of Advanced Study (IAS), the jewel in the crown of Durham University. The loan of the paintings was intended to be temporary. *Pittura Metafisica* found its way into the office of Executive Director Ash Amin, also Professor of Geography, and *Einstein* onto the walls of the Institute's meeting room, where the Institute's scholars and Fellows congregate daily at 11.00am. Although Professor Howard is now settled in her new home, both paintings remain firmly, covetously even, ensconced in the IAS. The works, particularly the still life, made a resounding impact on the academics at the Institute and, shortly after their arrival, it was mooted by Professor Howard that Gollon should be invited to hold an exhibition there. Unbeknownst to Gollon and David Tregunna, Professor Howard and Professor Amin were already discussing the possibility of extending a Fellowship and Residency to the artist, with the reaction to his exhibition ultimately determining their decision.

On the opening night of the exhibition, held in October 2007, Gollon was engaged in conversation by a professor of music, who questioned him over his monochromatic approach to the painting, *The Gregorian Singer* (2007). To the professor, the concept of Gregorian singing was one he visualised in glorious colour, where the brilliant jostle of vivid, undiluted colour emulated the vibrancy and emotional tension of pure, unsurpassed vocals. The artist explained how he always listened to Gregorian music in the dark, heightening his sensory experience, and making his visual perception of the music one of light and dark. In his painting the figure is tonal, though not without underlying warmth, while emanating from it is tremendous, voluminous light – unearthly, spiritual and compelling – much like the sound of Gregorian

singing. The lively discourse led to a debate on the pictorial manifestation (if indeed possible) of esoteric sensory stimuli such as music. The extent of discussion generated by the paintings, and the enthusiasm of those who attended the exhibition, confirmed Professor Amin's desire to invite Gollon to become a Fellow and First Artist in Residence at the cutting edge Institute, making him the first artist to be invited into the fold of academia at the IAS.

The IAS was founded in 2006 to mark Durham University's 175th anniversary, and is housed in the magnificent Grade 1 listed Cosin's Hall, on Palace Green opposite Durham Cathedral. It was developed to promote and provoke ideas-based study of profound and elemental topics, with a different annual theme. In particular the Institute aims to encourage a cross-lateral exchange of ideas between leading figures from diverse areas of study; to break down boundaries between customarily opposing divisions such as science, religion and art, to create new channels of dialogue, and to expand understanding and reasoning on an international level. It is a hub of intellectual energy and a leading centre of academic prowess. Each year a number of gifted individuals and scholars from across the world are invited to participate in a three-month residency during which they continue with their studies, and are required to give a seminar and a public lecture. Emphasis is placed on encouraging them to share and debate their fields of expertise, with reference to the particular annual theme; it is a challenging and intellectual environment, the success of which is partly measured by the extent of collaboration and exchange between them. Understandably at first it was a daunting prospect for Gollon, a man of visual, rather than vocal accomplishment.

At the time Gollon was approached by Professor Amin, he was working exhaustively on *Fourteen Stations of the Cross*, approaching the heavy subject in his characteristically unconventional manner, bringing universal spirituality and an poignant account of the human cost to the canvas. His figures, rather than being empty paradigms of religious significance, were real, perceptible statements on humanity from the obscene to the saintly. For Professor Amin, with these in mind and the knowledge of Gollon's challenging and intuitive art, it was an obvious choice to invite the artist to join the IAS 2009 programme dedicated to the subject of *Being Human*.

Gollon began preparing for his 2009 residency in 2008, embarking on a series of paintings loosely brought together under the title of *Early Thoughts*. It was a time of reflection for the artist, and one of moving forwards, as he again developed new ideas born from the body of his past work. The artist has consistently dedicated himself to depicting humanity and the essence of what defines humans from others, being the presence or absence of soul, conscience and emotion, in all its forms, working intuitively and by instinct, rather than following a defined and considered rationale.

The Trial I
Acrylic on canvas
122 x 91.5 cm (48 x 36 in.)
2008
Private collection

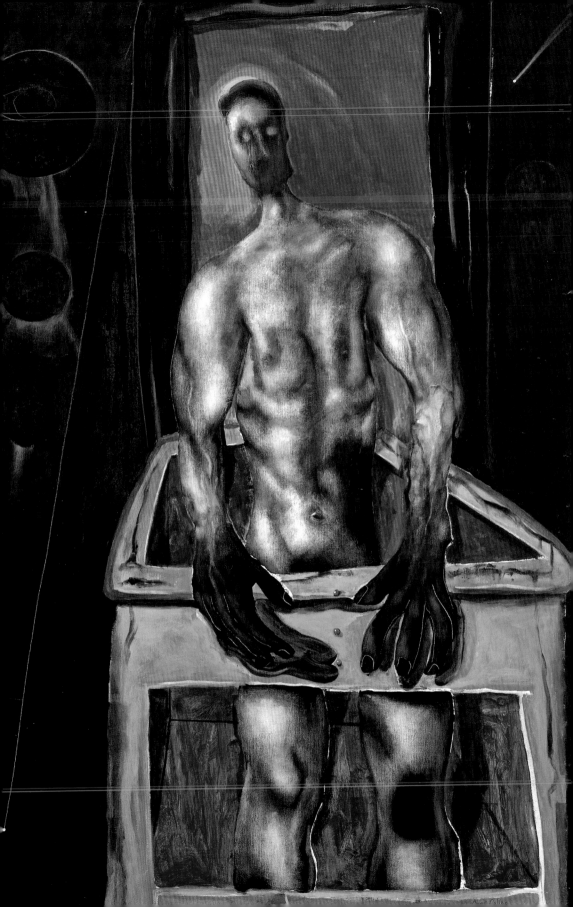

His figurative work has, through the last two decades (excluding his religious paintings, which should be considered separately) revealed a steady move towards abstraction as he has worked towards an end goal with no name; climbing the proverbial mountain to reach an unknown top shrouded in cloud. The decision however, by Gollon to begin first a new series, *Early Thoughts*, and to tackle the infinite subject of *Being Human*, suddenly provided him with a rational framework for his figurative paintings, a logical playing field for his artistic development and one into which all his past work can also be filed.

He began the *Early Thoughts* series by first putting human nature on trial, painting *The Trial I*, where man is tried, and *The Trial II*, where woman takes the stand, in quick succession. They are powerful pieces that reveal a sudden clarity in the artist's concept and evocation of the nude, particularly evident when compared with, for example, works such as *La Colombe D'Or* (2006) or *If That's All There is Then Let's Break Out the Booze And Have a Ball* (2006). The figures of the *Early Thoughts* series are a culmination of his earlier experiments, and equally a springboard for the work he went on to produce in the *Being Human* series. There are echoes of the dancing man from *If That's All There is Then Let's Break Out the Booze And Have a Ball*, resurrected in *The Trial I*, but the nude in the latter painting replaces frivolity with substance and intent. The abstraction remains paramount, the figure distorted and skewed within the bounds of reality; it remains clearly identifiable, but is also clearly secondary to the subject of the painting. The specific subject itself is the fragile concept of judgement, whether by fellow human or by the divine, implied through the trinity of spheres that appear to the figure's right. It is the act of judging and the moment of being judged, with the figure's humble and apologetic stance suggesting awareness of culpability, and remorse for the crime – is "the crime" the very act of being human? – on a universal scale. The figure has become unimportant in its physical terms; it is there to hold and convey an idea. This concept of abstracting the physical form to accentuate its capacity for holding an idea becomes central to Gollon's work with the figurative during this period, and is further defined in the *Being Human* paintings.

As part of his preparation for the residency at Durham's IAS Gollon also started to read extensively, turning again to Kenneth Clark's essential book *The Nude: A Study in Ideal Form* (1956), which indirectly influenced his next paintings, based on the god Apollo and goddess Venus. Gollon looked back to the Greek ideal of beauty represented through the nude figure, an art form ostensibly developed by the Greeks in the 5th century[1] BCE, and one discussed at length by Clark. Gollon used it as a starting point from which he developed the monumental figures seen in *Apollo* (2008) and *Venus I* (2008). These are in essence the lost gods, those gods from the ancient classical world who were swept beneath the carpet of Christendom, and yet, strangely

[1] Representations of nude figures can be dated earlier than the 5th century though their intention is unlikely to have been specifically artistic, but more aligned with symbolic associations, worship and funerary rites.

their presence remains faintly persistent. They are no longer worshipped, but are now iconically representative of their associated qualities, and have become virtual "brands": their names are applied to everything from prophylactics to nightclubs. Under Gollon's hand they are souls divided, lost to their own world and ill fitted to the present one; part divinity, part monster, part human. Gollon's creations possess a fleeting recollection of their classical roots in form, but the whole has been tormented and abstracted, leaving classical perfection a distant memory. They are, in effect, paintings of inversion, since everything here has been distorted like the world viewed through a circus mirror. The artist has depicted Apollo rising with omnipotent presence from the sea, when this was the birth pool of Venus. He is faceless, though not without expression – another of Gollon's idiosyncratic tendencies – and peers at his gargantuan hand with a childlike curiosity that seems ill at ease with his blatant, monumental, masculine form. A further slight to his classical birth are his undeniably heavy and prominent genitalia, most at odds with the traditional, polite treatment favoured by students of the classical ideal. Gollon has treated Apollo's hands, which are important to the painting, in a rather decorative, albeit monumental, manner. He used this technique frequently during this period, seen also in *The Trial I*, and to striking effect in *And In The End* (2008) and *Figures With Shooting Star* (2008). Apollo is a figure who inspires a small measure of sympathy and is irresistibly fascinating, though from a distance.

Venus too is similarly controversial and strangely compelling. Traditionally she is the benchmark of beauty and gentle eroticism, but not so in Gollon's world. Here she is massive, solid and part brutish, but also somewhat tender and possessed of a magnetising appeal, not least in the brilliant, earthy painting of her pudenda that recalls Gustave Courbet's (1819–1877) *The Origin of the World* (1866). Gollon has rejected the traditional Greek pudica-pose that maintains female modesty, and allowed her hand to slip carelessly aside making her exposure blatant, but has perversely hooded her head, lending the whole a voyeuristic and illicit edge. He returned to the subject of Venus several times during this period, most poignantly in *And in the End*, which sees the goddess slipping back into the waters she came from. The painting takes its title from *The End*, the last song on *Abbey Road*, the last album the Beatles recorded together, in 1969. It is beautifully painted. Venus' body has been distorted yet retains a sense of grace, particularly through the elongation of her arms and the delicate, decorative treatment of her hands. Gollon has blanked out her face, yet he still manages to conjure with extreme subtlety an expression of infinite melancholy.

Following pages
Venus I
Acrylic on canvas
91.5 x 61 cm (36 x 24 in.)
2008

Apollo
Acrylic on canvas
91.5 x 61 cm (36 x 24 in.)
2008
Private collection

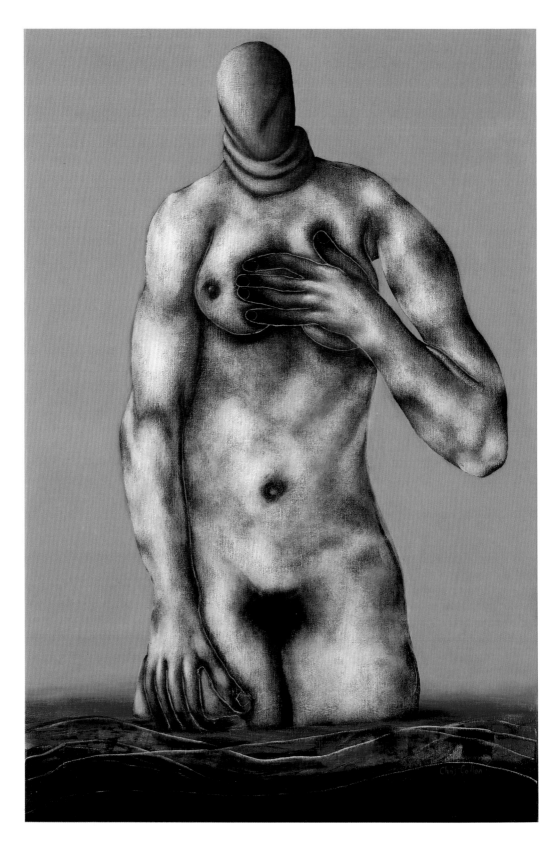

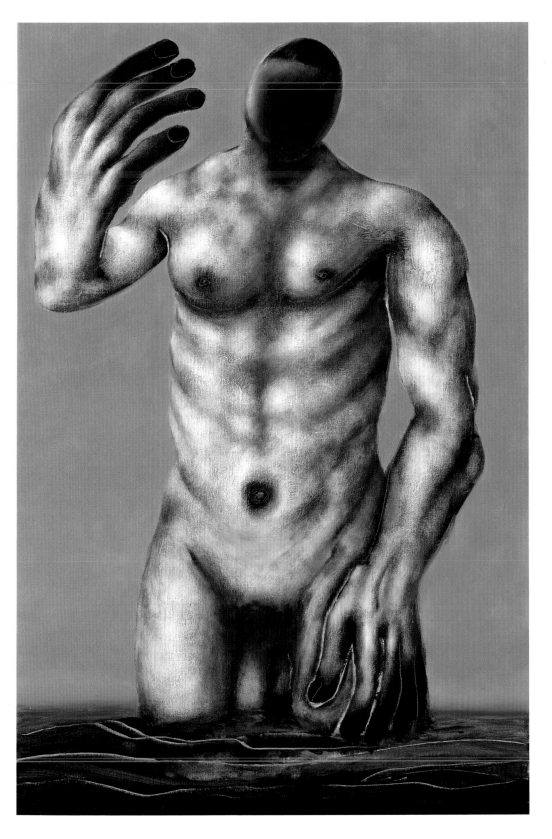

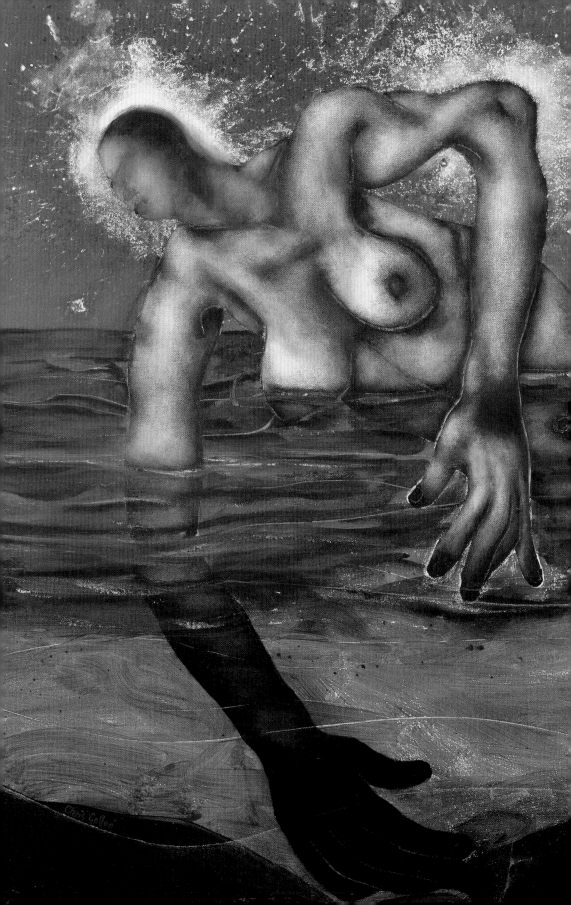

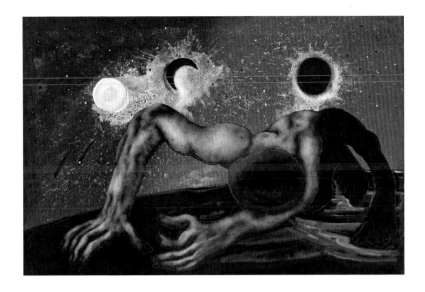

In The Beginning
Acrylic on canvas
61 x 91.5 cm (24 x 36 in.)
2008
*Institute Of Advanced Study,
Durham University*

These works and *Apollo's Last Summer* (2008), are marked by a subtle, rough sensuality and a tangible sense of human frailty. His gods are the aftermath of their own success, akin to the one-hit-wonder pop sensation; gloriously untouchable at the height of popularity, but in time vilified and left hovering on the sidelines of anonymity. Gollon has allowed them to retain a certain powerful physical presence, but beneath this they are reduced to the same pathetic anxieties and desires that fuel the human soul. This is seen to particularly good effect in the highly charged *Apollo's Last Summer* inspired by Hermann Hess's (1877–1962) book *Klingsor's Last Summer* (1919), which recounts the last days of a dying artist. Gollon's work depicts Apollo, who is no longer a god, having a final sexual encounter with a beautiful, though disinterested girl. Here no one believes in the gods anymore, not even the girl he embraces, and even his very form seems indistinct, to be slowly dissipating, losing structure and integrity as he succumbs his grip on the world of the divine for corporeal reality.

And In The End (Detail)
Acrylic on canvas
91.5 x 61 cm (36 x 24 in.)
2008
Private collection

Towards the end of 2008 Gollon moved away from the gods and goddesses of the classical world and turned instead towards science, painting the Darwinian themed *In the Beginning*, followed by a more traditional explanation of the creation myth in *Genesis*. Both paintings are extraordinarily strong in their imagery and axiom. The physical power of the figure in *In the Beginning*, as it pulls itself with blind instinct from a viscous pool of matter, is much evident and the sense of struggle is palpable. It claws its way forwards assuming its human form as it morphs from its ectoplasmic origins, while the veins in its arms run with the diluted vehement-green fluids of its birthing pool. The artist has continued his experimentation with removing facial features, but this time allows no sense of expression. This is, as yet, an empty vessel, not quite sentient and without soul, its black, blank head as infinite as the celestial orb above it.

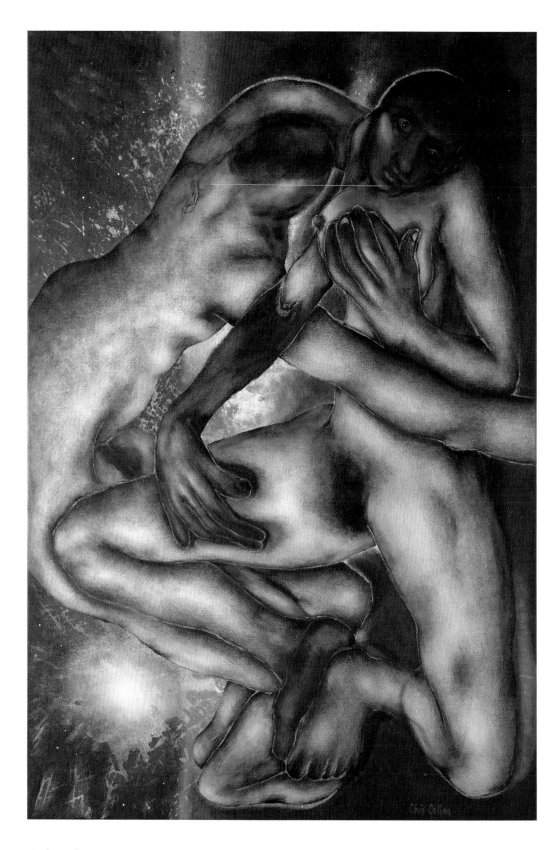

This is one of the first[2] works in the series where the artist has created a sense of moving, gaseous atmosphere. Early paintings such as *Apollo* and *Venus I* show the figures placed against simple representational settings, such as sea and sky, although these elements were painted definitively flat. They bear no real relevance to the subject matter other than providing a vague sense of setting. However, as Gollon progressed towards the end of his *Early Thoughts* paintings and later through his *Being Human* works, he increasingly placed his figures within a celestial, other-worldly atmosphere, one that has presence and vitality quite unlike his earlier paintings. The backgrounds in these works are important, removing the figurative from any vestige of the corporeal world and placing them firmly within an entirely different and volatile realm – one that swirls with ideas.

The work *Genesis* (2008), painted after *In The Beginning*, would first appear to be the artist's Christian representation of the creation myth. Here a fully grown woman, herself the bearer of life, floats curled semi-foetally in an inaurate atmosphere, part amniotic fluid, part celestial sky. With a touch of dry humour, the artist has painted her feet as strangely flipper-like. These are no fully formed human feet but rather, suggest she has evolved from something else, possibly from the blue curtain of organic substance that seeps across the canvas from one side. With characteristic subtlety the artist has quietly dispelled the Christian creation myth, without offence to those who believe.

A source of interest to the artist during this period was the work of charismatic American physicist Richard Feynman (1918–1988) who, apart from being a world leader in quantum mechanics, was also a tremendous character and a part-time artist. A wonderful story recounts how he embraced Life Drawing enthusiastically and embarked on a series of trips to strip clubs – for fieldwork and research. Feynman's book *Six Easy Pieces*, published posthumously in 1994, inspired Gollon's painting *Angels Without Wings* (2008) which ranks as one of the artist's personal favourites. Feynman used the expression "angels without wings" when describing the mystery surrounding the elliptical movement of planets, a movement which during the Renaissance, was ascribed to angels giving them a push. In Gollon's painting his wingless angels form a trio synonymous with the Three Graces of antiquity. Unusually for Gollon there is a kinetic magnetism evident in the painting, and a metronomic rhythm. The central figure in particular appears to sway from side to side as a renegade mechanism between the relative stability of her companions to left and right. The planet has shot off with implied force and speed, rushing towards the picture edge, hurled by the voluptuous figure to the right. Gollon has treated the figures with humour and delicacy, particularly evident in the facial expression of the central angel, but it is his painting of hands that is the defining feature of the work. They are effectively his means of expression. Those at the top of the painting, that barely touch (reminiscent of Michelangelo's *Creation of Adam* (*c*. 1511)), are in technical terms hardly hands at all such is their distortion, yet they rank amongst his most beautiful and telling.

2 Preceded only by *Apollo's Last Summer*, painted shortly before.

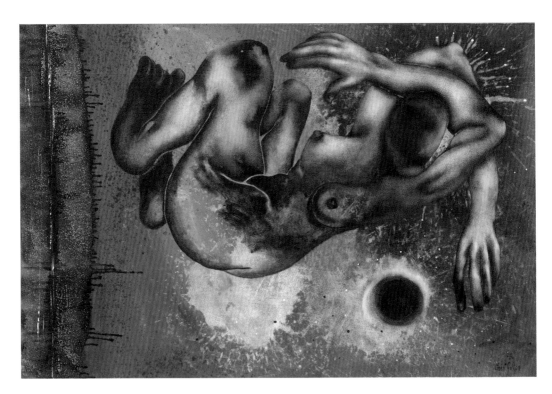

Genesis
Acrylic on canvas
91.5 x 61 cm (36 x 24 in.)
2008
Private collection

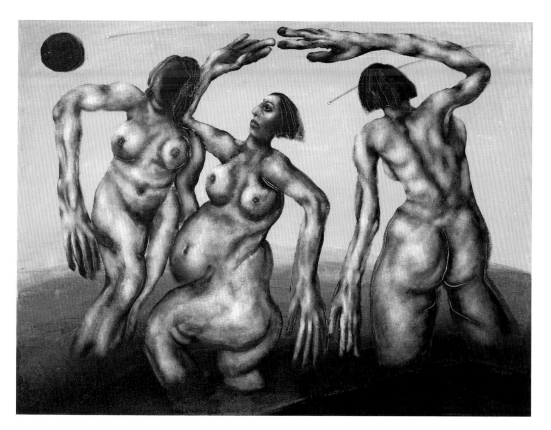

Angels Without Wings
Acrylic on canvas
91.5 x 61 cm (36 x 48 in.)
2008

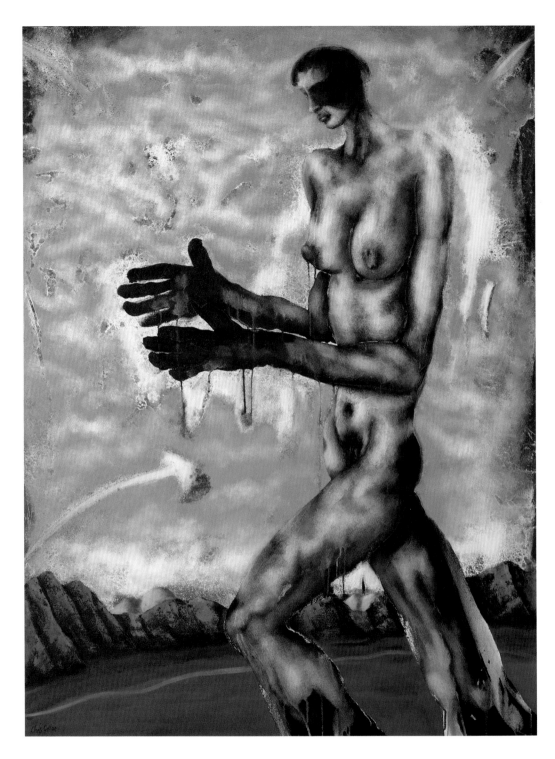

Mother (Charles Bonnet Syndrome)
Acrylic on canvas
122 x 91.5 cm (48 x 36 in.)
2008
Private collection

In terms of style and development, two important paintings from the *Early Thoughts* series are *Mother* and *Ecstasy*, both of which were painted towards the end of 2008. The two paintings represent the artist's interpretation of Charles Bonnet Syndrome, a rare condition associated with sight disorders, which had affected a close family member; they also fitted into one of the pending *Being Human* sub-topics titled Mind/Consciousness and the Well Brain. Charles Bonnet Syndrome is an extraordinary condition characterised by vivid and often increasingly disturbing visual hallucinations. All sufferers tend to share similar hallucinations one of which takes the form of a family with mother, father and children, often with musical instruments, and sometimes part tree-like. The family at first exist outside the house, but over time move indoors and can often be seen entering the room via a spiral staircase. Sufferers of the condition know that the hallucinations they see are not real, but it *can* be distressing for them, and although the family is not overtly threatening, they can be frightening. Generally the hallucinations will cease over time.

Gollon addressed the hallucinations in two ways, depicting the frightening aspect of them through *Mother*, a subject usually associated with nurturing and safety, and the musical, dream-like and ethereal nature of them in *Ecstasy*. The figure in *Mother* as she strides across the canvas morphing from tree-like to human, is omnipotent. What can be seen of her face suggests she might be rather beautiful, but her eyes are veiled and her expression daunting; Gollon has managed to invest her with tangible foreboding making the viewer loathe to have her look upon them. He ran a very real risk with the composition, choosing to place her in an almost comedic stance, something straight from a poor Frankenstein film, but gets away with it, just. His intention being to evoke a sense of childlike fear, one that is best conveyed through similarly childish means, and it is plausible. He is an artist for whom risk is a familiar and well-worn ally.

Mother's opposite is *Ecstasy*, which counts as a particularly lyrical and beautiful work, marked by its musical sense of rhythm, and harmony. The figures float weightlessly in an atmospheric soup, part human, part phantasmagorical entity, in a soft and mournful dream-like state. Both works clearly reveal the artist's continuing evolution of the nude. Here the figures have lost their weight, even the indomitable *Mother* has no dimension for this world, though she might be queen of her own. They have become, more significantly, vessels for holding an idea; the physical form, though tangible, is disseminating and the concept of their internal being taking shape. It is in effect as if the artist has peeled away the surface exterior of the nude form to reveal the esoteric matter that constitutes what lies beneath; the stuff of thoughts, souls, spirit, the self-conscious and conscience.

Although Gollon had spent much of 2008 working on *Early Thoughts*, and thinking in general terms about what it is to be human, the paintings he produced were not specifically related to the topics put forward by the IAS for their *Being Human* theme. Instead he made the choice to arrive in Durham with essentially a blank canvas. So it was one frigid morning in January 2009, that Gollon and David Tregunna chugged their way north in the ubiquitous white van full to bursting with paint supplies and tools.

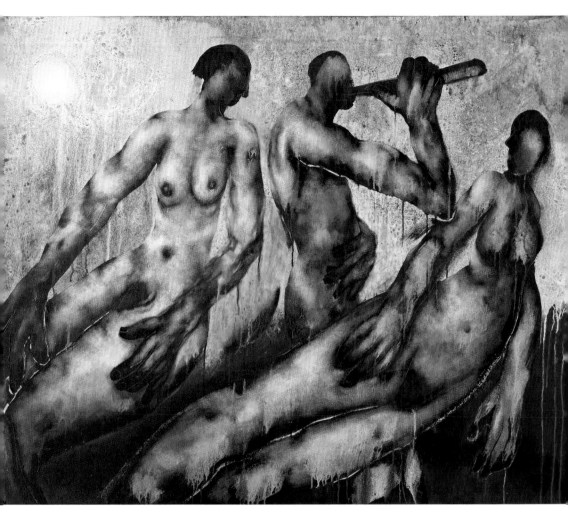

Ecstasy (Cartoon – Charles Bonnet Syndrome)
Acrylic on canvas
91.5 x 122 cm (36 x 48 in.)
2008
Private collection

David Tregunna recalls the experience of dropping Gollon off in Durham as being akin to depositing a child at school; he felt for the first time in twenty years removed from Gollon and his artistic process. For Gollon it was a day of trepidation and anticipation. Despite initial fears, once he had established his studio in the beautiful Cosin's Hall, with its view to the Cathedral and, most importantly, central heating, he felt considerably more relaxed – heating being a luxury that he is not accustomed to. For the self-taught artist who had never experienced organised further education, the opportunity to spend three months at one of the country's most respected universities was momentous. Not only would his time at Durham show him a small corner of a new world, one of academic study, of traditions and of spirited solidarity amongst the students and masters, but it also offered a vast wealth of research potential through its historic library. The library, established in 1833, is housed on Palace Green, a convenient short walk for Gollon from the IAS, and he subsequently spent much time between painting enjoying the tremendous collection of manuscripts and archives. This immediate access to knowledge, and being surrounded by some of the world's leading luminaries at Durham University, had a profound impact on the artist, and it is fair to say that this atmosphere of learning and community contributed significantly towards the clarification of the artist's own ideologies.

The theme of *Being Human*, as put forward by the IAS, was comprised of a number of sub-categories including 'Mind/Consciousness', 'Home', 'Abjection, Bare Life and De-Humanisation' and 'Crises of Personhood', but Gollon chose from the beginning to avoid these topics and to allow his paintings to be generated through discussions with the other Fellows. These discussions were specifically encouraged during a daily meeting over coffee, which brought the eclectic (and potentially explosive) mix of intellectuals together, as well as following on from their lectures and seminars. Gollon also decided to adopt an open-door policy with his studio, and encouraged (and welcomed) the other Fellows to drop by and offer comment at any time, which increased the channels of communication across the group and helped to build an atmosphere of trust. Although dropping an artist into the midst of this somewhat isolated intellectual environment was one that had potential for disaster, as it turned out Gollon became something of a lynch pin for the group; the balancing stone for a pivot laden with weighty minds. As the trust within the group was formed the exchange of ideas and dialogue flourished exponentially, and in all respects this became an incredibly successful example of the IAS's programme, and of the foresight of Executive Director Professor Ash Amin and his board.

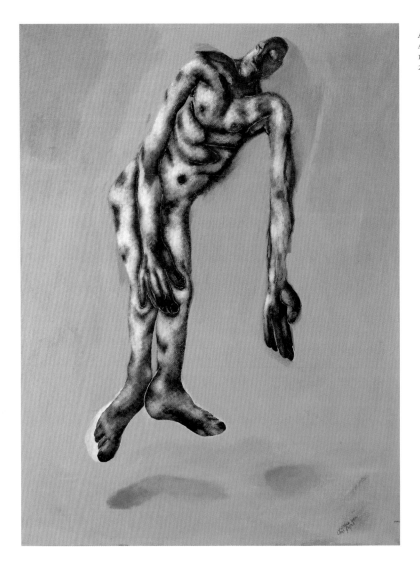

A Dream Of Switzerland
Acrylic on canvas
122 x 91.5 cm (48 x 36 in.)
2009

The first painting Gollon completed at Durham was the challenging and bold *A Dream of Switzerland*, a work that is entirely uncompromising and definitively reflective of the artist's evolving approach. The painting was sparked through a conversation about his wife's work as a nurse with one of the University's professors. The professor stated that he would rather take a trip to Switzerland, land of elective euthanasia (from the Greek word meaning "good death"), than suffer the indignities of a protracted, disease-ridden death. In Gollon's first attempt at the painting he placed his figure in a bath, but then, and following discussions with the other Fellows, removed all representational setting and devised the final version. The figure hangs awkwardly, suspended in a place that is neither heaven nor earth. Is it damned? Or has it achieved peace? Or is it in that transitory stage where the soul dissipates and the human becomes nothing at all? Gollon provides no clue here, and certainly no humour. In relation to the specific environment

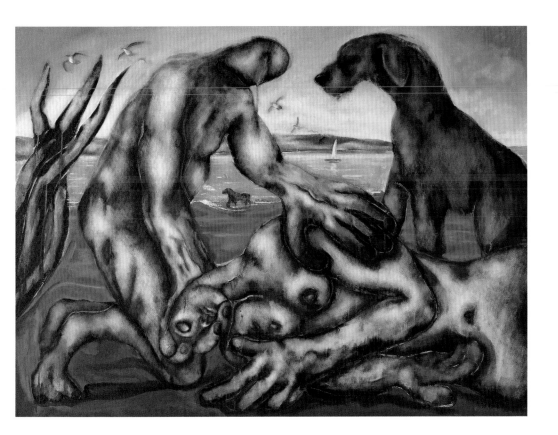

**Satyr Mourning Over
A Nypmh (After Piero Di
Cosimo)**
Acrylic on canvas
91.5 x 122 cm (36 x 48 in.)
2009
Private collection

that Gollon was working in at Durham, it was a brilliant choice of first work being controversial, utterly lacking in trite aesthetic appeal and blatantly announcing the arrival of an artist with ideas.

In contrast he painted next the most lyrical work he produced in Durham, a cover version of Piero di Cosimo's (1462–1522) *A Satyr Mourning Over a Nymph* (c. 1495). This was the only work that Gollon had started before arriving in Durham, sketching out the composition on his canvas in order to give himself something of a cushion, should inspiration be slow in coming. This explains the slightly different feel to this painting in relation to the other works he made there, which were born out of his experience of the *Being Human* theme. Of all the Durham paintings this is the only one to revert back to a clearly representational setting providing a surprisingly traditional and rather beautiful landscape background, and the inclusion of a Gollonesque plant in the foreground. Despite this retrospective approach to setting, the figures themselves are thoroughly of the moment, and are as extraordinary as they are moving. Huge, coarse and distorted, the epitome of ugly, they become nonetheless a striking expression of primitive beauty. The satyr's grief is so searing that his face melts, flesh following the path of tears and Gollon manages to make this not only believable but tangibly emotive. It is, however, his treatment of the hands in this painting that gives it such fundamental expression, primarily the contrast of such monstrously, rough

appendages evoking such tenderness. The satyr cradles the entire head of his dead nymph with exquisite care – a head that sinks with dead weight into his palm – while his other great hand rests on her shoulder. Her hands lie utterly lifeless morphing back into the organic compounds of the earth on which she rests.

Gollon's work at Durham is predominantly, and unusually, lacking in humour – the *Being Human* theme, in this context, not being predisposed in this direction – with one exception. *The Philosopher's Dream*, though essentially introspective and even touched by melancholy, is also slightly droll. The work was painted after Gollon attended a lecture by Professor Adi Ophir, an eminent philosopher and tutor of philosophy, critical theory and political theory at the Cohn Institute for the History and Philosophy of Science and Ideas at Tel Aviv University. Gollon candidly admits that he simply did not understand the lecture at all. What struck him was that although Professor Ophir's words were incomprehensible to him, they seemed to carry tremendous weight and resonance. After the lecture Gollon related to Professor Ophir the experience of listening to his words, an experience significantly exaggerated by his incomprehension, and how they had translated into a visual medium for the artist, becoming visually objective rather than subjective. Professor Ophir responded that words had become so intensely important and all consuming to him that he was at times unable to recall in his mind the appearance of his friends. Gollon took this idea and produced a headless figure in the painting, taking the professor's words one step further until the philosopher was unable to recall even his own appearance, but is surrounded by his words. It is left to the viewer to conjecture whether or not Gollon's use of ambiguous shadows around the figure were consciously intended to suggest a dove, a horned beast and several bat-like creatures, emblematic of purity, evil and winged messengers, or whether this is pure coincidence.

Gollon's unusually sombre paintings made at Durham, were in great contrast to the actual atmosphere of the University, the social side of which particularly appealed to an artist more used to spending his days in solitude. Before his arrival he expressed some concern at having to work within a regulated time frame and at being surrounded by people. As it turned out he was given free rein of the IAS, allowed to maintain his own working hours, and he found that he thrived on the human contact. During his stay he was given an apartment at St Mary's College and warmly welcomed into the fold, including their bustling social scene. It was with some surprise that in his first few weeks the artist found himself in the dining hall seated next to the Principal of the college, wearing the traditional black gown and gazing down across a sea of masked faces at the college's Venetian Ball; although both Gollon and the Principal declined to dance. Many other formal dinners at St Mary's and other colleges followed, occasions marked by their superb food and bon vivant, until Gollon formed both a great attachment to his black gown (traditional college formal wear) and started to become accustomed to such a life. It was with some regret that he departed Durham at the end of his residency and trekked back to his quiet, unheated studio.

The Philosopher's Dream
Acrylic on canvas
91.5 x 61 cm (36 x 24 in.)
2009
Private collection

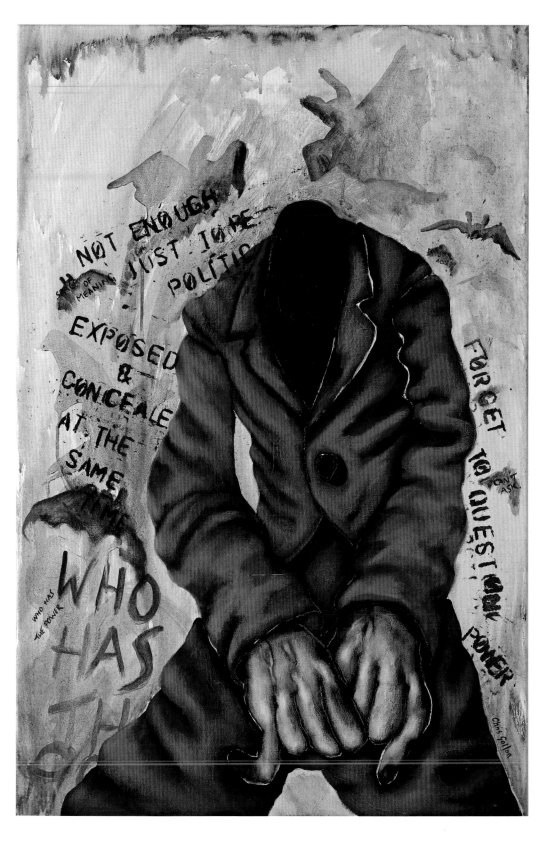

Shortly after arriving in Durham Gollon started on a series of six paintings that refer to the Chain of Being (*scala naturae*); a theoretical explanation of the universe, with first Classical, then Renaissance origins. It offered a rationale, or an ordered division of all elements based on a vertical hierarchy which, in greatly simplified terms, presents an ascending structure from insects through animals, humans and angels to god at the pinnacle. The works were again generated through discussion with the Fellows, in particular Professor Eduardo Mendieta, associate professor of philosophy at Stony Brook University, New York, who took great interest in Gollon's progress throughout his residency. Professor Mendieta found Gollon's idiosyncratic interpretation of the *scala naturae* particularly interesting, since Gollon, who knew little about the historic theory, managed to turn it on its head. The artist is sufficiently self-effacing to admit that his "re-write" of the *scala naturae* was largely intuitive rather than pre-meditated.

His account of the universe is split into *Insect*, *Almost Human*, *Human*, *Beast*, *Angels* and *Gods*. Most challenging to convention is the way in which Gollon has, through his paintings, created a circular *scala naturae*, effectively destroying the rungs of the traditional ascending ladder. In every image there is a quality that is identifiable, that threads between the paintings providing a reactive link between each to suggest progression and continuity. To label this quality "human" is to assume massive and unforgivable egocentricity, it is, rather, prescience and cognition. As such the insect strides, upright with self-awareness, bulbous eyes shining radiant with intelligence, through an apocalyptic wasteland withering beneath an exploded sky of fire, ash and matter. In *Almost Human*, a dog fawns tenderly over another who accepts such lavish attention with a haughty dignity; both creatures have disturbingly human torsos. In *Human* Gollon shows us a woman – more frequently the concept of a human in the *scala naturae* was represented by a man – exhausted and grief stricken, lying at the base of either a cross, or a tree. She occupies the same surreal landscape as that seen in *Insect*, identifiable through the range of ice-blue mountain caps, but seen here prior to its annihilation. Is she perhaps Eve, the propagator of life and equally the catalyst to death? In the following painting, *Beast*, the most horrific of the series, two figures (Cain and Abel perhaps, the spawn of Eve and the first murderer and victim in Christian historic tradition) again fill the same landscape, but it has started to unravel. The sun has gone, replaced by a charred-black orb suspended in a darkened, viscous atmosphere. Beneath this a figure, who slips from three dimensions to infinite, black two-dimension, tortures another whose arm is tied to a stump and magnified in part to reveal its surface burnt with cigarettes. The painting is hard to look at, and impossible to turn away from. One of the Fellows, Professor Abye Tasse, a world leader in international social work, was particularly moved by this painting. As a boy in the 1970s Tasse had fled war-torn Ethiopia, fearing for his life, making his way through much adversity and witness to unmitigated horror. Eventually he arrived in Paris. Later in life he interviewed child soldiers as part of his humanitarian work, asking one young child how he had felt after killing his first man. The child's response was that it was a relief, that a great burden had been lifted from his soul. Gollon's painting illustrates this wheel of violence, where the perpetrator is also a victim.

Both figures have been mutilated, physically and spiritually, the infinite blackness of their faces alluding to their crushed and hopeless souls.

Next in the chain comes *Angels*, which float with poignant melancholy across an indefinable realm. They appear to be tantalisingly close, but are untouchable, existing within their own dimension. These angels are expressly feminine; they are benign, but helpless and unable to offer much solace, which conflicts with their nurturing and maternally protective appearance. Throughout his career Gollon has frequently depicted angels in his work, and virtually without exception they are friendly, often vaguely seductive, and always utterly unable, or unwilling, to offer humans any degree of help.

Finally comes *Gods*, intentionally and challengingly plural in title. Gollon has chosen Pan as representative of all gods, fittingly here since it is from his name that the words panic and pandemonium derive, both of which are inherent in this painting. He inhabits, with a predatory and almost insect-like presence, the insect's landscape in the moments before the apocalypse, already the sky is disintegrating and the earth dividing. He is in this instant unstable, insecure, fearful and to be feared; powerful but confused. There is no sense of this divinity offering the salvation he is credited with.

Through this series the artist suggests a cyclic and evolutionary chain of being, where living elements rise, evolve, destroy and disintegrate, only to rise again. Gollon's gods, represented here by Pan are as prone to the passions of human as human is to the dark passions of "beastly" violence, suggesting a little godliness and its opposite exists within and is an extension of being human. Soberingly, while other cognitive beings might be sentient and able to express emotive forces such as love, nurturing, jealousy, fear and aggression, none other than humans inflict systematic, premeditated torture on its own kind.

The impetus for Gollon's painting of *Gods*, and also for the disturbing painting *The Night Feed*, came about after a long conversation with the eminent author Sara Maitland, during a particularly well-oiled dinner at St Chad's College, Durham. Maitland, who is a Fellow of St Chad's, recounted that when spending months in solitude while writing *A Book of Silence* (published in 2008), she underwent an extraordinary experience. At times the deafening silence, which was also reflective and nurturing, gave way to crashing, frightening noise; a visitation from the god Pan, bringing his pandemonium with him. During the same conversation she told the artist that some of the most tender moments of her life were those in the enfolding silence of night and the very early morning, as she breastfed her children.
With both these images in mind Gollon painted the nightmarish *The Night Feed*, turning a loving moment into something dark and horrifying. Here the mother is silenced by a strange bestial mask while her monstrous child rejects her breast, to feed instead on her blood with a parasitic intensity. The artist has removed the image from any sense of place to allow this awful event to unfold in a distant, surreal realm. Further, by painting a darkened edge around the scene he implies it is being viewed through a portal, becoming perhaps a warning or portentous glimpse of a future born from the widespread increase in violent society.

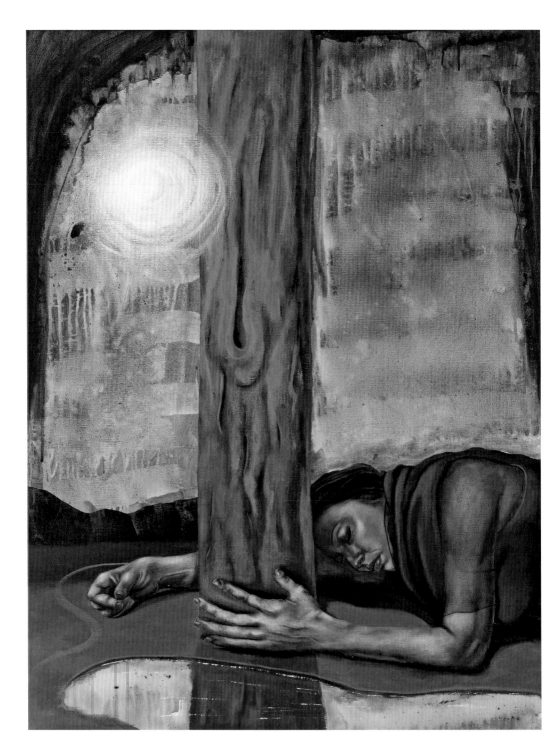

Human
Acrylic on canvas
122 x 91.5 cm (48 x 36 in.)
2009
Institute Of Advanced Study,
Durham University

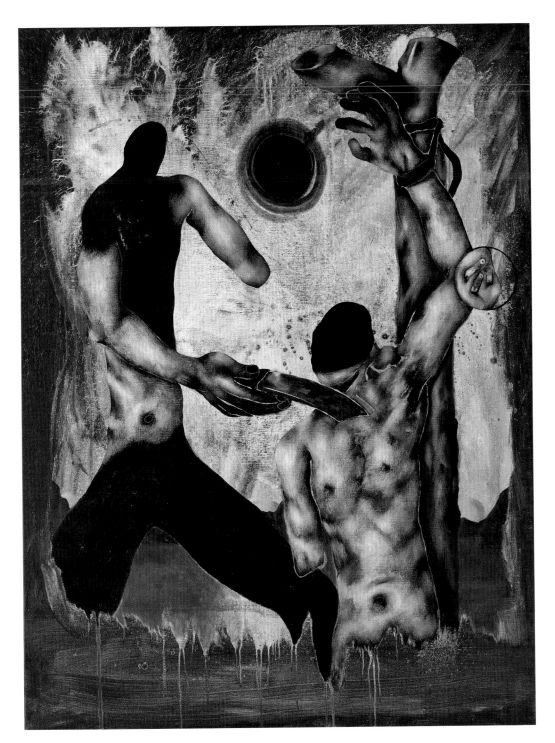

Beast
Acrylic on canvas
122 x 91.5 cm (48 x 36 in.)
2009
Private collection

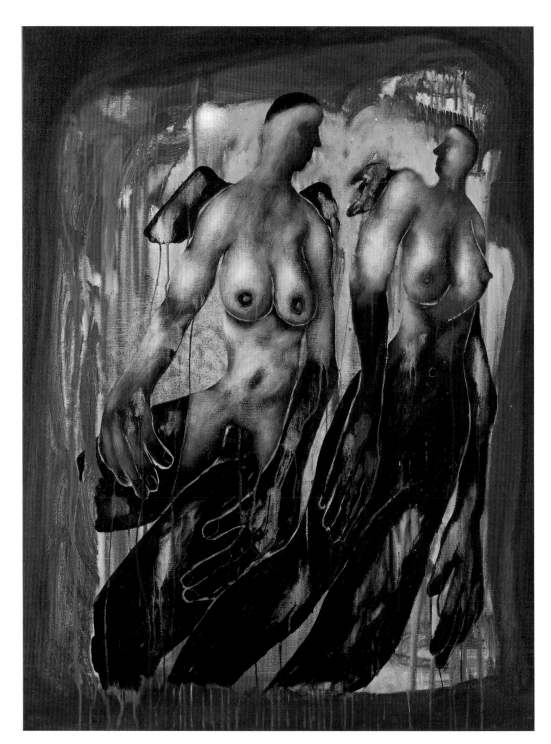

Angels
Acrylic on canvas
122 x 91.5 cm (48 x 36 in.)
2009
Private collection

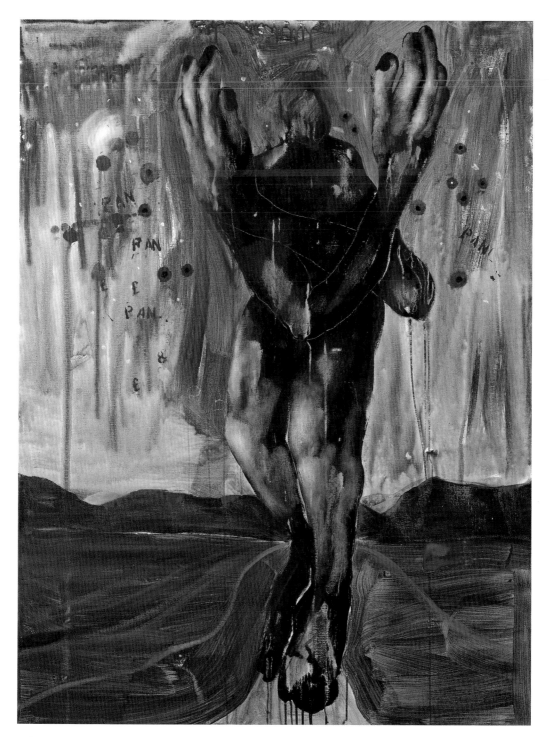

Gods
Acrylic on canvas
122 x 91.5 cm (48 x 36 in.)
2009
Private collection

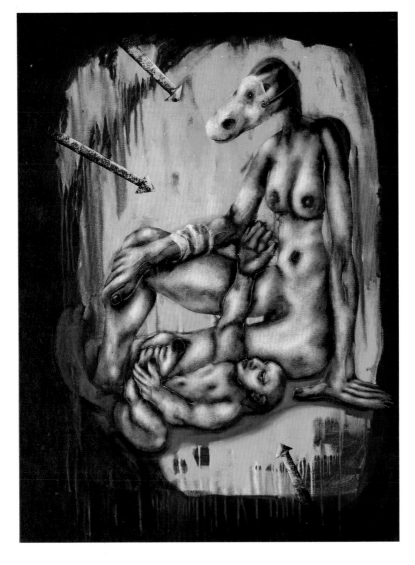

The Night Feed
Acrylic on canvas
122 x 91.5 cm (48 x 36 in.)
2009

It is with no small degree of relief that two works painted at the end of his stay in Durham, offer a little more hope. The triptych *Prayer*, faintly recalls Byzantine icons, each panel existing independently and presenting a single, powerful image on which to reflect. However when viewed together there is a sense of logic moving through them that moves from despair to prayer, and with prayer there is a vestige of hope. It is possible of course to rearrange the panels so they read as prayer first leading to confusion and ultimately despair, but this is not what the artist intended, confirmed by his signature on the right hand panel (*Prayer*), this being the traditional place for a triptych to be signed.

The final painting of his residency, *The Wheel of Fortune (after Goya)* is again an image that while far from jolly is not utterly despondent. The artist clearly intended to convey hope through his deliberate inclusion of a lit candle, a traditional symbol of hope, remembrance and rebirth. This work

Prayer (Triptych)
Acrylic on canvas
Each panel 30.5 x 25.5 cm
(12 x 10 in.)
2009
Private collection

was made after Francisco de Goya's *Los Caprichos* (1799), etching number 56, which addressed the rise and fall of man. The series of 80 etchings was made by Goya at a turbulent time in Spanish history when the country was suffering economic crisis and social repression. His intention was to explore the human condition, exposing corruption in the individual, and in the Church and State, and to denounce ignorance, oppression, superstition and injustice. In Gollon's painting, which interestingly draws on imagery from his earlier pre-Durham work, a wonderfully buxom angel surveys the world of human vice and folly with a maternal understanding. Beneath her watch, the god Pan has made a reappearance, part god-like and part human, while another figure buries his head in the ground, and a third, part man part child sucks its thumb carrying aloft the candle of hope. There is great cyclic movement in the physical structure of the work that creates a sense of vortex, and alludes to the notion that while humans are trapped within an endless world of their own making, it is one which has the capacity for change, be that for better or worse.

It is an apt painting to mark the end of Gollon's Durham stay, which resulted in 16 paintings executed in just three months. This relatively short period gave rise to a tremendous rush of creativity in the artist and provided an ample forum for his continued ideas on depiction of the nude. The University and all the people who helped Gollon so generously during his time there gave the artist a glimpse into a previously unknown world. A world of academic and intellectual brilliance balanced by enormous human warmth and encouragement, which gave the artist the confidence to produce cutting-edge works of such depth. Although Gollon's work produced at Durham reflects his evolving concept for the figure as representative of ideas and esoteric notions, it should be considered, much like his religious commission for *Fourteen Stations of the Cross*, as somewhat separate from the rest of his oeuvre. Durham and the IAS provided a very unique and unusual working environment for the artist, one isolated by academia and dedicated to intensely nurturing ideas of a very specific nature. As a result the works the artist produced are prevailingly negative, though offer occasional glimpses of hope, and are unrelieved by his customary ironic wit. They are however works of importance, personally to his career, and on a wider scale, since they reveal solid human truths with striking alacrity and without passing judgment.

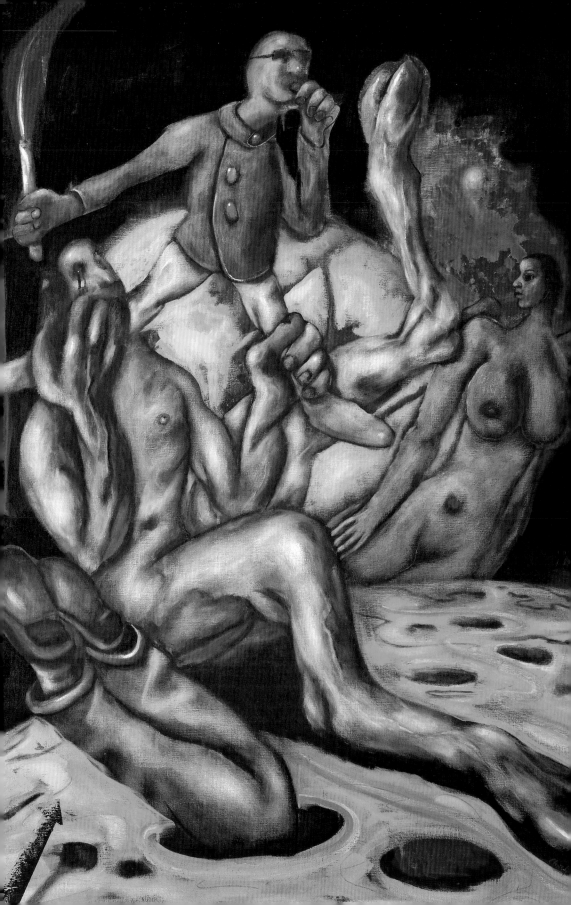

Although the tone of Gollon's paintings in palette and subject matter was markedly sober, the same could not be said for his time outside the studio. The closed environment of the IAS and the sharing of ideas contributed towards the multi-national group of Fellows (Gollon being the only Englishman) developing a strong and close allegiance. Whilst the corridors of Cosin's Hall were quiet, contemplative channels, life beyond rang with laughter, most frequently revolving around the local watering holes and restaurants. Gollon and the Fellows spent many long evenings together, with the artist taking great delight in introducing his foreign companions to the delicacies of British food. So it is that some of the world's leading international thinkers have now been enriched with the experience of horrors including bubble-and-squeak, black pudding and the ubiquitous spotted dick.

The Wheel Of Fortune
(After Goya)
Acrylic on canvas
122 x 91.5 cm (48 x 36 in.)
2009
Private collection

One colourful character, a Norwegian professor of philosophy who, although not a Fellow, had joined the group, provided much entertainment with his quirky humour. On meeting David Tregunna, he announced in a heavy accent that he only thought in concepts and was the author of 328 books, leaving Tregunna temporarily at a loss. On their last night in Durham he accompanied Gollon, Tregunna and others on a final excursion to the pub. As the night drew out they found themselves in the Shakespeare Tavern, Durham's smallest and most haunted pub, where the Norwegian announced in all sincerity that the ghosts were talking to him in French, though his own command of French was good and he was unafraid. Later he lost his wallet but determined to have one more drink managed to persuade the landlord to let him have one "on tick" (on a tab), becoming the first to achieve this honour. The night turned into a Gollonesque long one, which the artist and Tregunna bitterly regretted at 6am the following morning when, after three hours sleep they had to pack the van and scurry down to London in time for Gollon to be interviewed on BBC Radio 4. Stuck in traffic and running late, the artist had to leap from the van and run to Broadcasting House in Portland Place, London to get to his interview, just in time.

Gollon's Durham experience is one that helped to give shape and direction to ideas the artist had already been working on. It crystallised in his mind what he needed to continue with and what he needed to discard in his work. It was, in effect, one more leg of a journey that continues to unfold, surprising at times both audience and artist, and which contributed through cause and effect to his most recent works – works of light, colour and humour balanced with depth.

'Lawrence Gollon before the decision was taken to cast him as Jesus' (circa 2000) *photo by Chris Gollon*

'Taking a break from making etchings, Gollon with his daughter Alice in Glasgow, (1990s)' *photo by Anne Gollon*

'Gollon at his studio on Platts Eyot (circa 2001)' *photo by Ben Moulden*

'Gollon in his studio on Platts Eyot (circa 2001)' *photo by Ben Moulden*

'Gollon in his studio on Platts Eyot (circa 2002, with a detail of the painting 'The Family')' *photo (detail) by Giovanna Cantone*

'Gollon and Fr Alan Green' (2002)
*photo by Edward Lloyd (*www.edwardlloydphotography.co.uk*)*

'David Tregunna at IAP Fine Art (circa 2003)'
*photo by Christina Jansen (*www.cjansenphotography.com*)*

'Gollon (circa 2002)' *photo by David Tregunna*

'Chris Gollon (circa 2005)'
photo by Christina Jansen (www.cjansenphotography.com)

'Gollon in his studio painting 'Jesus Is Taken Down from the Cross' (2008)'
photo by David Tregunna

'Chris Gollon with David Tregunna in Puigcerdà, northern Spain (2008)' *photo by Anne Gollon*

'Gollon at the Masked Ball at St Mary's College, Durham University (2009) with *(front centre)* Professor Philip Gilmartin (Principal), Mrs Jennifer Gilmartin *(front right)*, Dr Gillian Boughton (Vice Principal & Senior Tutor) and *(back right)* Ms Catherine Brewer (College tutor)'
photo by Sue Crossland (www.PHOENIXPHOTOGRAPHY.ORG)

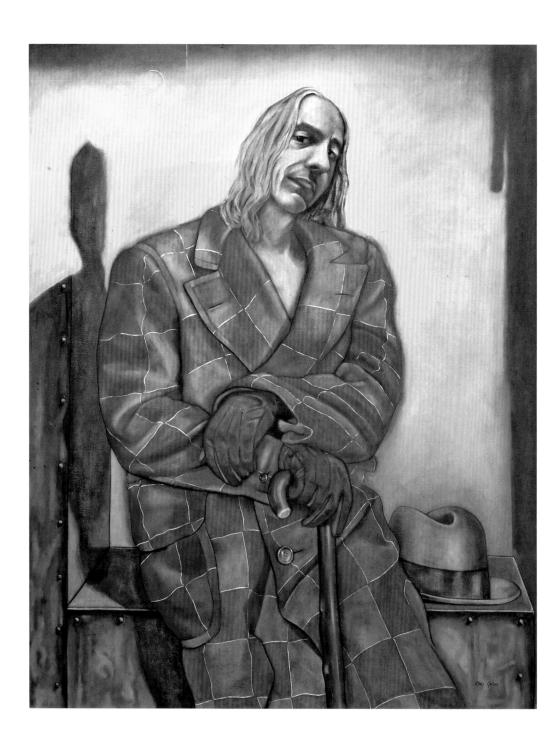

Chapter Eight

INFLUENCES AND TECHNIQUES

Having made the decision to forgo a formal arts education, Gollon maintains that as soon as something begins to resemble structured work he loses all interest. A telling admission, and one that explains his aversion to firstly his schoolwork and then the notion of attending art school, but most significantly reflects his attitude to his painting. The day that a painting becomes work to Gollon, is the day he moves on, with this attitude reflected through the immense freedom and creativity that is inherent in his work. On the occasions where this is missing, and the paintings become either contrived or overworked, invariably it means that Gollon is coming to the natural end of a phase, and shortly afterwards will move on in a new direction.

Gollon's first works were portraits of family and friends, often of Keith West from the band Tomorrow, and of various other members of the music fraternity. At this time, the artist had few contacts or friends within the art world, and existed, mostly by choice, very much on its peripheries, a position that he has largely retained. He was naturally gifted with an eye for line, but there is a limit to which natural ability can excel when starved of education. Gollon was aware of his limitations and while still resistant to art school, was determined to expand his technical knowledge. He had been further encouraged in this respect by his only friend in the art world, an academically trained artist, who had told him bluntly that he was, "above all a linear artist with a phenomenal ignorance of tonality".

Shortly after this Gollon found himself wandering around a second-hand bookshop in Richmond, London, searching for a suitable tome to help him. Having rejected the *How to Draw a Dog* and *Teach Yourself Landscape Painting in Six Steps* books he was starting to lose hope, when he heard the gravelly voice of a famous thespian discussing his recent lunch. Much intrigued, Gollon shamelessly eavesdropped on the comparable merits of a new Burgundy and a full-bodied Claret, until said thespian put down the book he was holding and departed the shop with a companion. Gollon picked up the discarded book, and turning it over discovered it was *The Materials of the Artist*, by Max Doerner, first published in the early 1900s.

For Gollon this was art school condensed into a single, essential volume, a volume that would be of immense influence on the development of his work from a *technical* angle. Doerner explains in great detail the technical development of traditional painting, the actual craft of painting, from the techniques and methods of different types of painting (oil, tempera, pastel, watercolour and fresco) to preparing canvases and panels, restoring works and preparing the artist's materials. His book has been widely used by artists over the years, particularly by Otto Dix. Gollon first became interested in Dix after the Dix retrospective at the Tate in London in 1992, and following this the work of the German artist was of tremendous influence on Gollon's early paintings.

Man With Yellow Hat
Oil on canvas
124 x 99 cm (49 x 39 in.)
1993
Private collection

Doerner holds Titian as one of the greatest technical painters, whose skill and subtlety was such that it is difficult to study the actual process of his painting. Instead he advises looking at the work of El Greco, who was himself greatly influenced by Titian during his time spent in Venice, to unravel the technical mysteries of oil painting. This Gollon did approaching his early paintings in a very traditional manner, as outlined by Doerner. He would first sketch his composition onto the canvas in tempera, next he applied an oil primer in a middle tone such as brown, finally he would build up the painting's surface using thin glazes of oil paint making strong use of white highlights. This method is seen in *Man with Yellow Hat* (1993), a poignant painting of Gollon's friend Keith Downey. Downey, who was a tremendous character, lived his life hard, and by the time of this painting was already dying. The flamboyant coat seen in the painting was one of Downey's favourites, which he frequently wore with a pair of snakeskin cowboy boots, and nothing else. Alternatively he would don a bus conductor's jacket, a bespoke one made by a tailor in Knightsbridge and accompany it with a silver-topped cane and black, leather gloves. Gollon has captured the dying man's expression with infinite subtlety in this painting; there is a prescience about Downey, who is aware of the demise of his body, yet his mind remains as sharp and wicked as it was.

Early paintings such as this, *The Magic Theatre* (c. 1993) – a subject he returned to again and very differently in the macabre and painterly triptych of 2000 – and the wonderfully whimsical *Captain Christopher* (1993) were built up using many layers of oil, applied thinly and smoothly to produce a highly polished and flat finish, sometimes adding a final layer of varnish. By the mid 1990s however, Gollon had moved away from oils, which take an extended period of time to dry, and had started to work almost exclusively in acrylic paint maintaining the same technique outlined by Doerner, and applying many thin glazes over a mid tone primer. He continued to produce works of a highly finished, polished nature, such as *The Onlooker* (1995), painted on masonite panel. Gollon favoured panels in the early days, and still appreciates the finish that painting on panel achieves, but they are extremely time consuming to prepare. Masonite panels require sanding in the first instance, followed by three or four layers of gesso priming before they are ready to paint on, similarly, wood panels also necessitate several layers of priming and can occasionally warp.

The Onlooker reflects Gollon's interest in Dix and in the artists of the New Objectivity Movement that developed in Germany in the early 1920s, including George Grosz (1893–1959) and Max Beckmann, though Beckmann did not consider himself affiliated with any art movement. New Objectivity grew out of, and away from, Expressionism and developed into two groups: the Verists whose satirical realism and use of distortion allowed them to emphasise the inherent ugliness of life, seen in Dix's, Grosz's and Beckmann's work; and the Magic Realists, whose quieter, more ordered work reflected influence of Neo-Classicist and Metaphysical art. The influence of the early paintings of Giorgio de Chirico is apparent in Magic Realist works, as well as in Gollon's *The Onlooker*. De Chirico was, along with Dix and Beckmann, an important early influence on Gollon, who referred to his

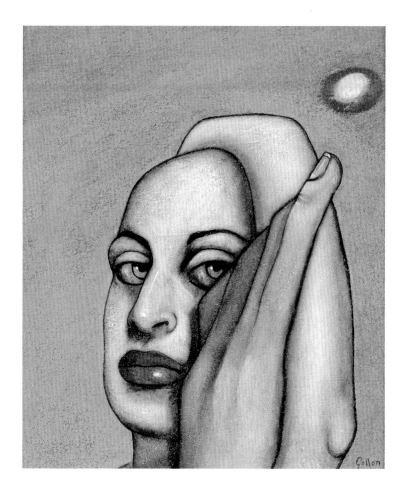

The Onlooker
Mixed media on panel
35.5 x 30.5 cm (14 x 12 in.)
1995
Private collection

work a number of times as can be seen in paintings including *The Giorgio de Chirico Band* (1996) – which also pays homage to Picasso's *Old Beggar with a Boy* (1903) – *Still Life After De Chirico* and the important *Still Life Homage to Pittura Metafisica*.

Early works such as *Man With Yellow Hat, The Onlooker* and *The Giorgio de Chirico Band* are strongly linear in style, and Gollon maintains an adherence to linearity for some years to come, eventually working in both linear and painterly manners simultaneously. This is seen to good effect through comparison of his *Fourteen Stations of the Cross*, which are predominantly linear, with other works undertaken during the time frame such as *At Le Bal* (2006). More recently the artist has moved away from this to embrace fully a free, painterly approach, seen particularly in his *Early Thoughts* and *Being Human* paintings although following this period he returned to a modified form of linearity as he began to explore still life subjects again. What consistently underpins his approach is a natural ability for drawing and an appreciation of the purity of line, seen to good effect in his etchings, such as *Magdalene* (2005). Interestingly, despite this talent for drawing, it is a process that he rarely undertakes, with the early, and in fact, not entirely successful charcoal drawing of *The Heeney Hoo Singer* (1997) being a rare exception. Even in this work though there is an apparent battle between line and expression; Gollon's drawing is best appreciated in his etchings, where the line becomes paramount. *The Heeney Hoo Singer* was inspired by an Irish girl called Molly Molly, who worked for Gollon (he is unable to recall why she vehemently insisted on double usage of her name). Molly Molly's father would frequent the local pub and come home drunk saying he had been down to see the Heeney Hoo singer. The Heeney Hoo singer it transpired was also a drunk, whose rambling shambles of songs all sounded as though he was singing "Heeney Hoo, Heeney Hoo" from whence he derived his name.

By the time of Gollon's first major series of paintings, *On The Road to Narragonia* (1995–1997), he was using a combination of tempera and acrylic paints, still working on building up the paint surface using multiple thin glazes, and occasionally applying a final single glaze of oil paint. With the highly finished and brilliant colours of Dix still in mind, he would also frequently finish the works using several layers of varnish. Although his paintings were still generally smooth in finish, he was also starting to introduce some areas of texture to the paint surface, either through expressive brushwork, or through the application of glass beads and sand to the increasingly thickly applied, wet paint surface. Texture has been an ongoing experiment with the artist, as can be seen in the painting *The Bearded Woman of Ventura (after Ribera)* (2005) exhibited in the *Sense and Sensuality Exhibition* at London's Bankside Gallery in 2005. Organised by the charity BlindArt, the exhibition included works by sighted and partially sighted artists and unusually encouraged visitors to interact with and touch the art works on display. The tragic-comic Gollon painting has a richly textured surface that includes applied sand.

The Heeney Hoo Singer
Charcoal on paper
38 x 56 cm (15 x 22 in.)
1997
Private collection

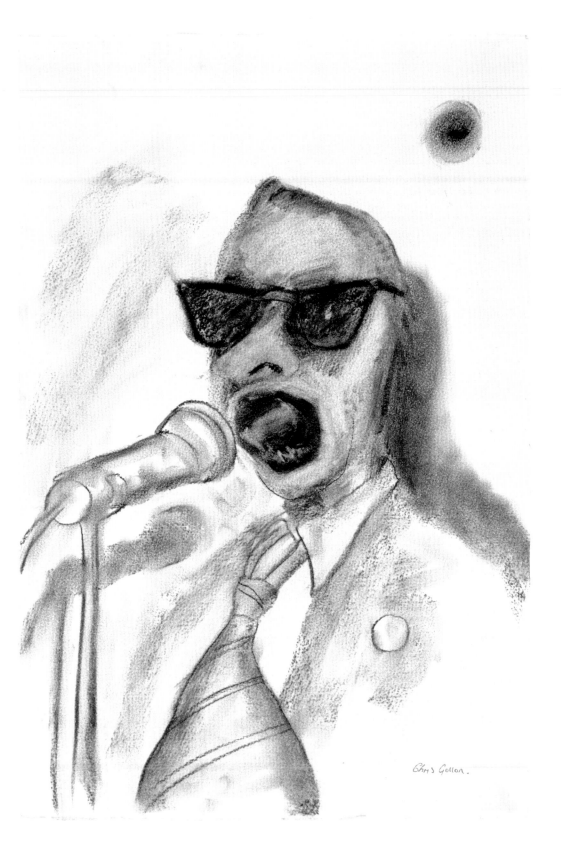

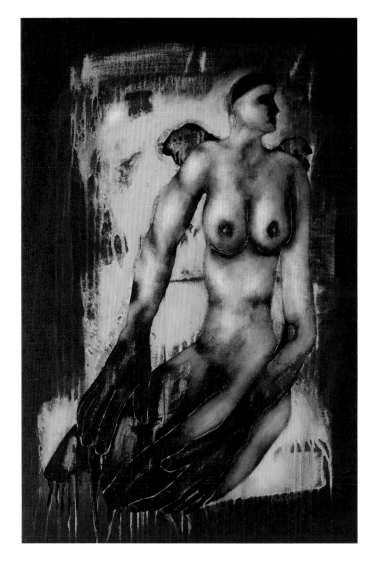

Study For Angels
Acrylic on canvas
66 x 61 cm (26 x 24 in.)
2009
Private collection

Gollon's interest in generating texture through paint effects has become
increasingly important, and would seem to reflect a shift in his painterly
priorities. As such a marked concern with painterly effects has matched
a decrease in the objective nature of his work, so while he still paints
recognisable subjects he is less concerned with the specifics of the object
(or the figure) and more preoccupied with what the painting is trying to say.
A particularly good example of this is *Study for Angels* (2009), where the artist
has manipulated his paint, interspersing impasto with thin areas, using his
scratching-in technique, spraying water onto the canvas to achieve a dribbled
effect suggestive of the dissemination of reality, and applying his paint with a
number of different tools including brushes, rags, the wrong end of his brush
and apparently a misappropriated tea towel. During the period 2008 to 2010
he quite frequently used a spray bottle of water to achieve this effect, having
earlier experimented with actual spray paint (seen in *Still Life with Stringed
Instruments II*), a technique used by Francis Bacon late in his career, but not
one Gollon has yet returned to.

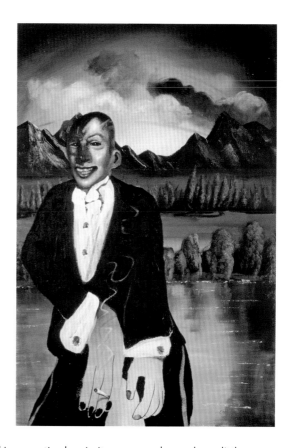

Stud Muffin III
Acrylic on canvas
91.5 x 61 cm (36 x 24 in.)
2001
Private collection

Gollon's specific working practice has in its essence changed very little over the years. Typically he works in acrylics and most often on canvas, although he has in the past used an acrylic-on-paper combination, seen for example in *Homeward Bound* (2000), and on the rare occasion has dabbled with watercolour. He rarely makes preparatory drawings for works, and if he does they are little more than sketches, surprisingly childlike in rendition. Their only real purpose being to determine the basic structure and composition of the work. Normally all his sketching is done directly onto the canvas, usually in black. He has two main methods of working, the first of which he now rarely uses. This involves painting the entire background of the picture first, then painting the figures or still life over the top. However with acrylics the paint dries very quickly, and once dry, leaves ridges, which will then show through whatever is painted over the top. One way to avoid this is to work up the painting within the 30 minutes or so before the acrylics have dried, something that presents an almost impossible time frame, or as Gollon tends to do, then paint the subject over the background in heavy impasto or dark colours. *Stud Muffin III* (2001) demonstrates this technique to good effect. The artist, who was again experimenting, has left portions of the painting such as the man's hands apparently unfinished, depicting them in outline only. This allows the landscape background behind to be seen clearly. It is a technique that actually works to great effect in Gollon's work, and can be seen again in the painting, *Portrait of Jon Bowles* (2002). Leaving some areas of the painting as outline adds to their abstract quality and gives them an unusual dimension.

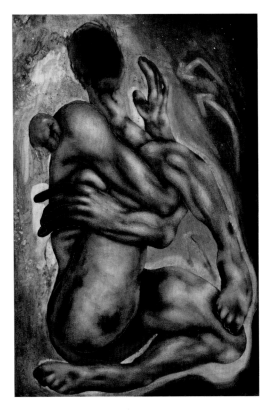

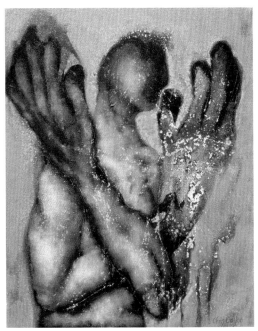

Expulsion Of Eve
Acrylic on canvas
91.5 x 61 cm (36 x 24 in.)
2008
Private collection

Man With A Trouble
Acrylic on canvas
51 x 40.5 cm (20 x 16 in.)
2008
Private collection

More often the artist starts at the top of the canvas by painting the sky or background, then moves down the canvas plotting in the scene in black and painting the middle ground. He then paints the figure in black and finishes the background, before returning to the figures to work them up properly, making strong use of white highlights. Increasingly the artist has been experimenting with textured backgrounds, lightly priming the canvas then applying the background effects with a very dry paint allowing areas of the textured canvas to show through. This is most apparent in his *Early Thoughts* and *Being Human* paintings and those that follow on. It can be seen to brilliant effect in the haunting *Expulsion of Eve* (2008) and *Man With A Trouble* (2008).

Gollon's treatment of backgrounds in his paintings has been an interesting and evolving process, which began with fairly objective scenes even if construed in abstract or surreal terms, such as the *Narragonia* paintings that place the figures and/or objects within a recognisable setting of sorts. His use of landscape settings is quite frequent from his early period and through into the millennium years, seen in *Stud Muffin III, Cover Version of Munch's The Scream* (2005) and to particular effect in *Landscape with Still Life* (2002). The influence of pre-Renaissance and early Renaissance landscape backgrounds is clearly evident in this painting and in a number of similar works, and it could be argued that they lie at the root of Gollon's distinctive visual language for his landscape, particularly his abstracted conical hill formations.

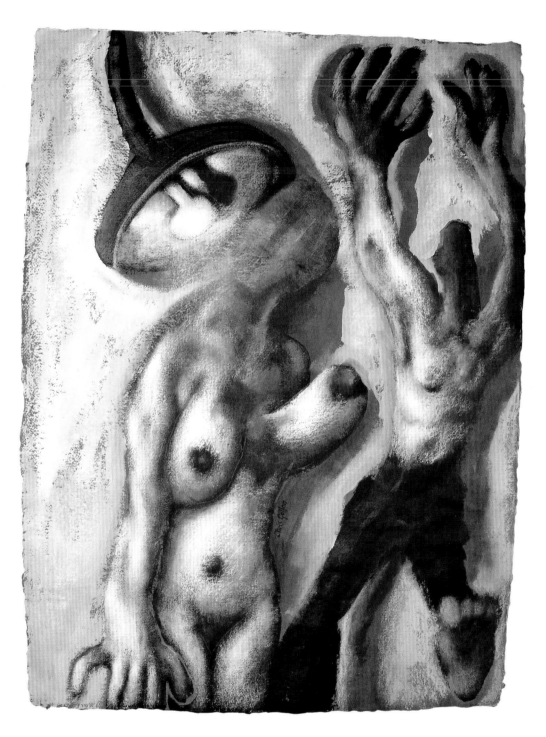

At Le Bal II
Acrylic on khadi paper
74 x 53 cm (29 x 21 in.)
2006
Private collection

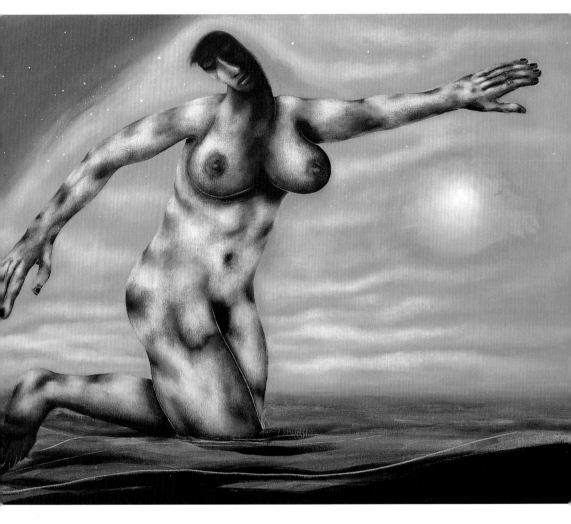

Venus II
Acrylic on canvas
91.5 x 122 cm (36 x 48 in.)
2008

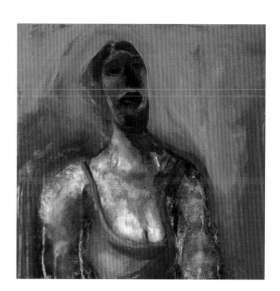

Woman With A Nice Figure
Acrylic on canvas
40.5 x 40.5 cm (16 x 16 in.)
2010

Towards the end of the millennium decade Gollon began to move away from clearly defined settings, reducing the amount of extraneous detail and removing any defined sense of perspective demonstrated in paintings such as *At Le Bal* (2006), *At Le Bal II* and other works in the *Is That All There Is?* series (inspired by the song of the same name sung by Peggy Lee), as well as in almost all his paintings of *Heads* (see *Ms Johnson* (2007) and *Slave To Love* (2007)) and three-quarter figure studies. Gollon has always maintained that the viewer has a certain responsibility to engage actively with a piece of art; that they should be encouraged to think about it, to come to an understanding of it and to form an opinion. By removing specific settings, which help to relate the narrative or message of his paintings, and reducing them to essentially a stage for his figurative and/or still life works the viewer is required to work a little harder if they wish to understand the piece.

Moving towards the end of 2008, he began to reduce his backgrounds further, often into two simple planes of colour, typified by *Venus II*, and a number of works in the *Early Thoughts* series. A sense of place is still indicated here, such as sea and sky, or earth and sky, but it is in such diminished terms that it merely offers a place to put his figures, and aids the aesthetic, rather than providing much in the way of helpful detail. Around the same time he also began experimenting with creating backgrounds to suggest an entirely different realm from our earthly abode. Using contrasting thick impasto and thin areas of paint applied with a dry brush, and allowing in places the canvas texture to peek through, he has been able to create the sensation of a celestial place, of volatile atmosphere and a mysterious world of ideas. In this way he removes his figures completely from any tie to corporeal reality and allows his expression of ideas and concepts greater freedom. At the end of 2009, and alongside his experiments with creating an otherworldly atmosphere, he again returned to using a simple fairly flat background with no detail at all such as that seen in the exquisitely tender

Perro Semihundido (After Goya)
Acrylic on canvas
91.5 x 61 cm (36 x 24 in.)
2006
Private collection

La Petite Mort, Woman with A Nice Figure and *Sketch for Portrait of a Soul*.
A pertinent aspect of Gollon's art, which also makes it incredibly difficult to
quantify in any sort of logical context is the apparently random manner in
which he addresses ideas. By his own admission, often he stumbles across
methods by happy accident, as for example in the case of *Stud Muffin III*,
where the hand has remained unpainted, and yet is thoroughly effective.
On other occasions collectors, friends and patrons have wandered into his
studio and given their opinion or told him to stop painting, for example, and
to prevent him from overworking a canvas. Generally Gollon, who has that
rare trait of humility seldom found in an artist of his stature, is open to such
comments. Often he will work through one idea, then abandon it and move
on to something else, before rediscovering the initial idea and returning to it,
but from a different angle. As such his technique and style, while continuing
to evolve steadily in terms of concepts, particularly over the past five years,
has bounced around stylistically.

Despite this continual shift and movement in his approach, he has retained
very strong imagery and a visual language that reappears throughout his
work. Rather than reflecting a lack of imagination this repeated use of
similar features, such as his distinctive conical hills, mirror-like water, use of
arrows (see *Cover Version of Munch's The Scream* (2005)) and magnification
circles (see *Perro Semihundido, After Goya* (2006)) makes his work markedly
Gollonesque and instantly recognisable, as well as providing a visual link

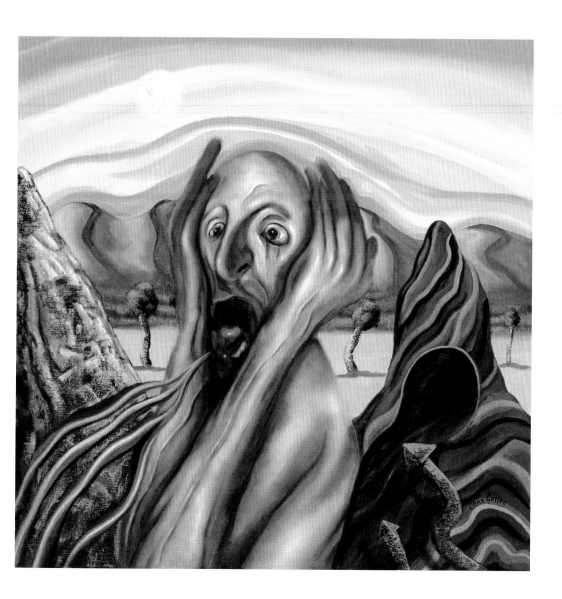

**Cover Version Of Munch's
The Scream**
Acrylic on canvas
66 x 66 cm (26 x 26 in.)
2005
Private collection

between works. This allows his paintings to be appreciated as one-off pieces, but also often provides a sense of series or of movement through his paintings. One of the most profound influences on the artist has been music, and in particular the music of The Beatles, Leonard Cohen and Bob Dylan. Gollon has frequently based his paintings, and indeed whole series of paintings, on lyrics plucked from any number of songs, old and new, and invariably paints to music. Dylan's music in particular has a sense of "moving along" of being on a road trip, and Gollon has often tried to recreate this sense of movement between paintings. Alongside this Gollon has a keen interest in film, again attracted to the sense of movement that sees a fluid transition from beginning to middle to end. Frederico Fellini's *Amarcord* and *Roma* indirectly inspired some of the *Narragonia* series; Ettore Scola's *Le Bal* inspired the *Le Bal* paintings (2006–2007); and Sam Peckinpah's *Pat Garrett and Billy The Kid* (accompanied by Bob Dylan's soundtrack) inspired a series of still lifes and landscapes including *Boot Hill* (2004).

The link between music, film and Gollon's painting is intrinsic and interestingly the artist has a very visual perception of music (discussed in Chapter Seven with reference to *The Gregorian Singer*). He explains how some years ago he went to see the flamenco guitarist Manitas de Plata (b. 1921), who was also one of Picasso's favourite musicians, perform at the Royal Albert Hall. Although he was sitting in the cheap seats perched up "in the Gods", as he sat and listened Gollon felt the music was coming towards him in a torrent, much like a furious surf, and the experience became auditory, visual and sensual all at once, which he found profoundly moving. After the performance Gollon and his family headed to a local Italian restaurant. Quite by chance Manitas de Plata entered shortly afterwards and, after some persuasion, gave an impromptu performance in the restaurant, allowing the artist to experience the music at close quarters. Gollon's perception of music in visual and tactile terms, and his appreciation of how a piece of music travels, from its beginning to its end was a concept that he wished to translate somehow into his art. He has done this with varying levels of success through the years, primarily in the methods outlined above, by series paintings with subtle but definitive links to create a sense of road trip in paint. Despite these paintings, the artist was still striving to find a way of translating and combining his experiences of music with his art, and it was with this in mind that he, and two filmmaker friends, Kim Scott MBE and Karl Roberts, came up with the idea for *Kaleidomorphism One*. This groundbreaking work, a neoglism and a new cinematic art form, has broken the genre boundaries and brought together over 500 of Gollon's art works with a mix of highly evocative music to form an 18-minute film. During the film the paintings are in nearly continual movement, coming forward, retracting, gliding across the screen, and creating what can only be described as Gollon's vision of a road trip in art. The film, made by JABOD and made possible through the help of one of Gollon's friends, Ray Peyre, was premiered on the opening night of the 2008 East End Film Festival, in London. *Kaleidomorphism One* is entirely new ground for Gollon and provides a truly extraordinary sensory experience.

Kaleidomorphism One is undoubtedly an acme within Gollon's career, and a concept that he will, over time, explore further. Of particular interest is the very palpable range of responses from humour to horror that the paintings are able to elicit when viewed in this filmatic context and against their background of music. They become a kaleidoscope of sound and colour that assail the senses with great force, and remain in the mind long after their physical presence has disappeared. Colour in Gollon's work is used to profound and dramatic effect. He has moved from his early days of having a "phenomenal ignorance of tonality" to becoming a master colourist and he uses it to great expressionistic extremes to wrest a response from the viewer, seen to amusing effect in *Cover Version of Munch's The Scream*. Gollon creates the huge range of his colours, from the burnt orange skies in *Perro Semihundido* to the blue torpor of *In the Afternoon* (2002) and the delicate iridescent twilight of *Study For An Evening Out with Max Beckmann* (2002), from a limited palette of Mars Black, Titanium White, Cobalt Blue, Cadmium Red, Cadmium Yellow and Phtahalo Green. He uses colour in a purely emotive fashion with only a passing acknowledgement of reality and often a tangible sense of enjoyment.

Study For An Evening Out With Max Beckmann
Acrylic on canvas
91.5 x 61 cm (36 x 24 in.)
2002
Private collection

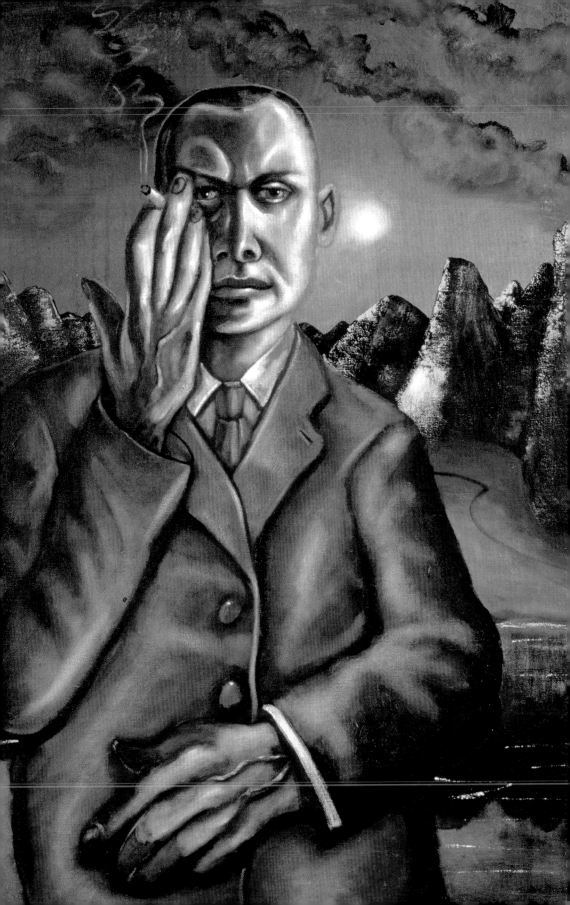

With this in mind it is interesting to note that the artist has also worked extensively in black and white, primarily in the medium of prints, and in acrylic monochromes, directly influenced by his prints.

Gollon's first foray into printmaking was in 1996 when he travelled up to the Glasgow Print Studio to undertake a hand-coloured etching with aquatint. In order to do this he needed the skilled experience of a trained etcher, Murray Robertson, who was also a friend of his. This first etching, *The Whisper* (1996), a subject that Gollon had also painted as part of the Narragonia series, was an arduous project, primarily because both artist and etcher embarked on it with severe hangovers, the result of a warm welcome to Scotland the night before, involving large amounts of Scottish whisky. While Murray was working on the etching, Gollon found himself with long periods of idle time, which inadvertently led to him making a series of monotypes that eventually far surpassed the original aquatint. Monotypes result in a one-off, unique print (unlike a monoprint[1]). To create a monotype the artist inks a plate, then removes areas of ink using a rag, a brush or cotton buds to reveal the design. The plate is then passed through a press, transferring the image to a piece of paper. During this process most of the ink is transferred, and it is therefore not possible to print a second image from the plate, making each one unique. On this trip Gollon made a number of monotypes to form the *Traveller* series, a haunting and at times comical collection of starkly black-and-white prints.

He made a second and greatly superior series of eleven monotypes in 2007 to form the *Basement Tapes*, again a haunting and eerie collection of figures that transcend those of the *Traveller* series. The *Basement Tapes* are, mostly, extraordinarily beautiful and marked by a reflective and sombre quality. He used an etching-like technique quite widely in these works, scratching out some of the outlines of his figures by using the wrong end of his paintbrush. This is a technique that Gollon has used in his paintings to great effect over a period of years, and one that was initially generated through early experiments in his printmaking. Other printmaking exercises have resulted in the series of four different silk screen prints based on the Henley Royal Regatta and undertaken as studies for the painting *Gollon at Henley*, commissioned by the River and Rowing Museum, Henley-on-Thames, and a series of three magnificent single-line, hard-ground etchings made at the Limberhurst Press in Cambridgeshire, in 2005. These three single-line etchings, *Magdalene*, *Sleeping Woman* and *Girl Praying*, which form the apotheosis of his prints to date, reflect a look back to his linear roots and demonstrate with unarguable bluntness the technical skill of the artist. Several years later he revisited the single-line approach, this time in a silk-screen print, to produce *Study for the Crucifixion* (2009), a slightly less successful venture, where the original breathtaking purity of line and form seen in 2005 is not as strikingly evident.

1 The terms monoprint and monotype are frequently interchanged leading to some confusion. A monoprint is made using an etched plate, a lithograph, collograph or serigraph, which can then be inked a number of times and in different ways to create works with the same basic structure, but with different aesthetic effects. Therefore a series of similar works are produced. See text above for definition of a monotype.

Magdalene
Etching, edition of 25
33 x 38 cm (13 x 15 in.)
2005

Basement Tapes I
Monotype
66 x 53 cm (26 x 21 in.)
2007

The artist's interest in line is one reflected through the consistent use of his scratching-in technique. Initially this technique was inspired through his printmaking experiments in 1996, and was then transferred to his paintings with great effectiveness. Using the wrong end of his paint brush the artist literally draws the outline he requires through his top layer of paint, while still wet, to reveal the colour underneath, which when combined with his painterly techniques produces a fantastically abstract quality. Once he has made the decision to use this technique, it requires some degree of initial planning in the preparation of his canvas to ensure that he has the correct colour of ground in the right place to allow the colour to be revealed when the topcoat is removed. A relatively early example of this is the touching painting *As Time Goes By* (2001) where he has scratched out the whole silhouette of the characters to reveal a rich, red undercoat. The work was inspired by the artist's memories of youthful promises to friends and lovers to meet at a certain spot as the old century was rung in to the new millennium. With humour the artist realised that none of these promises would be met, and wondered how many other people had broken, or indeed kept, as seen in the painting, similar whimsical vows to reunite.

Gods, Angels and Souls, painted at the end of 2009, reflects the artist's use of scratching in, in parts to reveal a red base. It also shows him evolving the technique to include much wider areas of the base coat revealed to accentuate parts of the figures. Their feet in particular are outlined with a wide band of pale undercoat, while in some parts he has also scratched away their outline to reveal both red and pale undercoats. This technique of larger revealed areas is seen in a number of his paintings from this time and while possibly less aesthetically successful, is an effective expressive tool. A further development in Gollon's art, that took place as a direct result of his print work, was his use of monochromatic colour schemes. This can be seen in a number of his paintings including an entire series that he undertook in 2007, which also reflect his use of scratching in. Works such as *Girl in Black Gloves* (2007), *At Ronnie Scott's* (2007) and *A Night Out with Vic Reeves* (2007) were then shown at Gollon's *Basement Tapes* exhibition in November of the same year, to demonstrate the influence of print-making techniques on painting.

To understand the influence of other artists on Gollon's work it is necessary to appreciate the mind of the artist, who characteristically absorbs all range of external influence from music, film, literature, artists (and passing humanity), assesses it, redefines it and reinterprets it within a Gollonesque framework. As such, little of his work in the last decade or so exhibits much in the way of obvious discernible influence. This defies a common tendency to both categorise artists into a group and attribute their style to the work of predecessors. Regarding the first there is no group that Gollon falls into, his early work could be loosely described as Abstract Realist, but from the turn of the century on he has defied any label. Turning to artistic influences, his early work was subject to the influence of twentieth-century German painters including Dix, Grosz, and most notably Beckmann, whose work Gollon has loosely referred to intermittently over the years, as well as the Austrian artist Egon Schiele (1890–1918). Beckmann's influence can be seen in the richly coloured and mysterious *Self Portrait* (1999), in which

As Time Goes By
Acrylic on canvas
61 x 91.5 cm (24 x 36 in.)
2001
Private collection

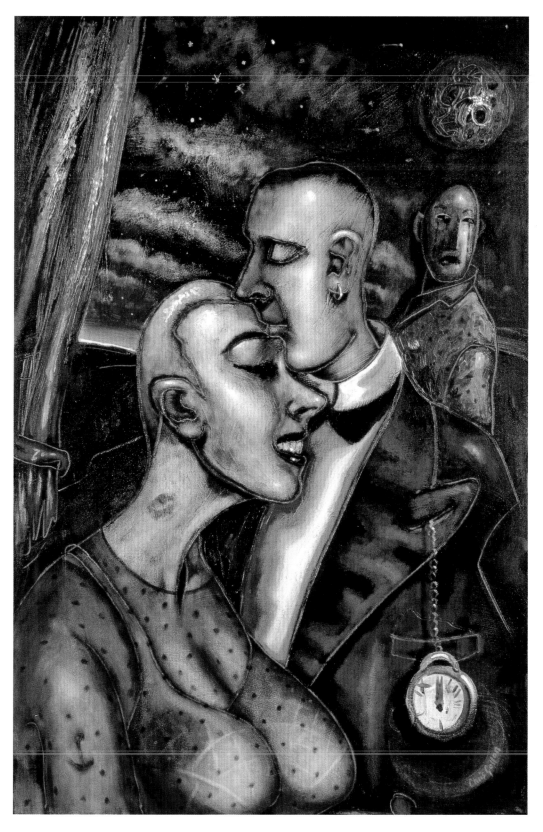

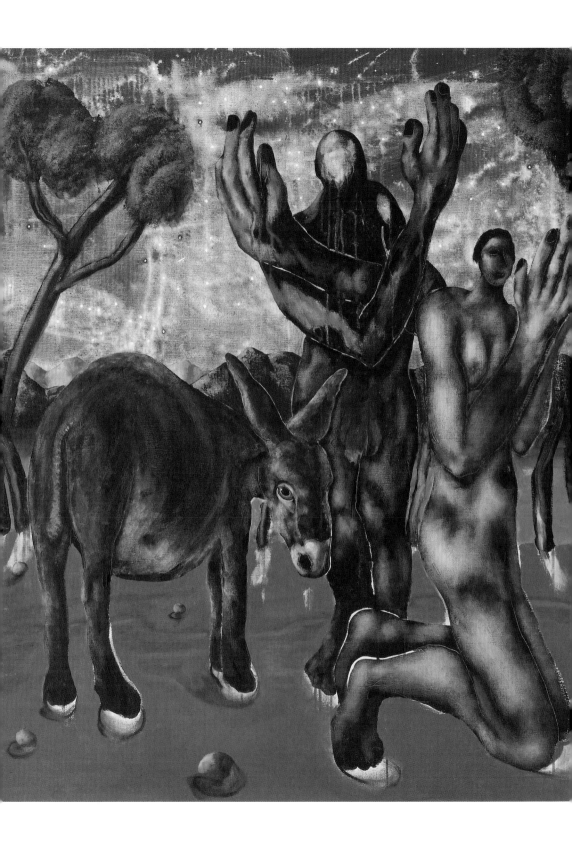

Gods, Angels And Souls
Acrylic on canvas
122 x 91.5 cm (48 x 36 in.)
2009

Study III Jealous Monk With
El Greco Sky
Acrylic on canvas
30.5 x 40.5 cm (12 x 16 in.)
2004
Private collection

Gollon is seen with a portrait of David Tregunna in the background; this painting is after Beckmann's *Self Portrait with Champagne Glass* (1919), while *Study for An Evening Out With Max Beckmann* faintly echoes Beckmann's *Self Portrait in Tuxedo* (1927). Rather than revealing a direct influence in terms of style or subject matter, Gollon's paintings that do refer to other artists, generally do so either as homage pieces (such as *Cover Version of Munch's The Scream*) or in a tongue-in-cheek manner. On occasion, and seen in works such as *Study III Jealous Monk with El Greco Sky* (2004), Gollon deliberately recalls the work of an earlier artist, but states his intention in the title of the work, making it quite clear that this is a deliberate re-interpretation of another's style. Other artists whose work has had passing influence on Gollon in the inaugural years of his career are Hieronymous Bosch and Pieter Brueghel the Elder, both notably in their figurative style and use of humour, the figurative style of Chaim Soutine and the still life paintings of Chardin.

It is the work of the Spanish artists, particularly Goya, El Greco (who was born in Greece but lived in Spain for most of his life), Cotán (see Gollon's *Still Life with Fish and Peaches* (1999)), Zurburán and Melendez, that has however had the greatest influence on Gollon's work. This is subtly manifested through a *sense* of Spanish art, through the tonality, a certain treatment of the paint and a dimly felt, but perceptible aura of Spain – a country where the artist spends a considerable amount of time. The faint Spanish feel is added to through Gollon's simple and appropriate choice of picture frames. All his frames are beautifully custom made by Adrian Davidson of Bethnal Green, and are either black or dark brown stained wood, or a combination of the two, which is particularly effective. The frames serve the paintings well, making a statement without in any way detracting from the actual works.

Still Life With Fish And Peaches
Mixed media on canvas
40.5 x 30.5 cm (16 x 12in.)
1999
Private collection

The work of Modigliani, Matisse and Picasso has also periodically affected Gollon's paintings and all three can be seen to great effect in *In the Afternoon*, which recalls Modigliani's *Nude Looking Over Her Right Shoulder* (1917), Matisse's *Large Reclining Nude* (1935) and Picasso's *Nude in a Black Armchair* (1932). Further influences include the Symbolist and Surrealist movements. These external artistic influences had their greatest effect on the artist in the early years, and more recently, certainly since the turn of the century, his work has become singularly unique in concept and execution. On occasion Gollon's work has, incorrectly, been likened to that of Francis Bacon. Although this is not the case, their paths have crossed in an extraordinary manner. One late night in the early days of his artistic career Gollon and David Tregunna spilled out of a bar in South Kensington, having entertained a group of collectors, and set off towards home. A man bundled up in a heavy overcoat in front of them was weaving his way along when suddenly he lurched off the pavement and into the path of taxi. He would have been run over had Gollon not managed to grab him and pull him out of the way. The man thanked the pair before hurrying – unsteadily – off into the dark. It was only as he disappeared that Gollon and David Tregunna realised it was Francis Bacon (who later died in Spain in April 1992) whose studio was at 7 Reece Mews in South Kensington.

Overleaf
In The Afternoon
Acrylic on canvas
61 x 91.5 cm (24 x 36 in.)
2002
Private collection

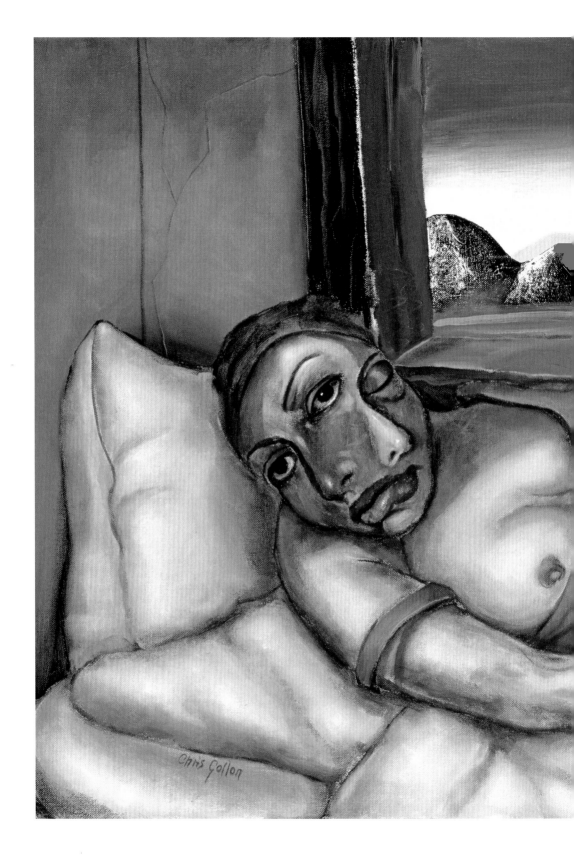

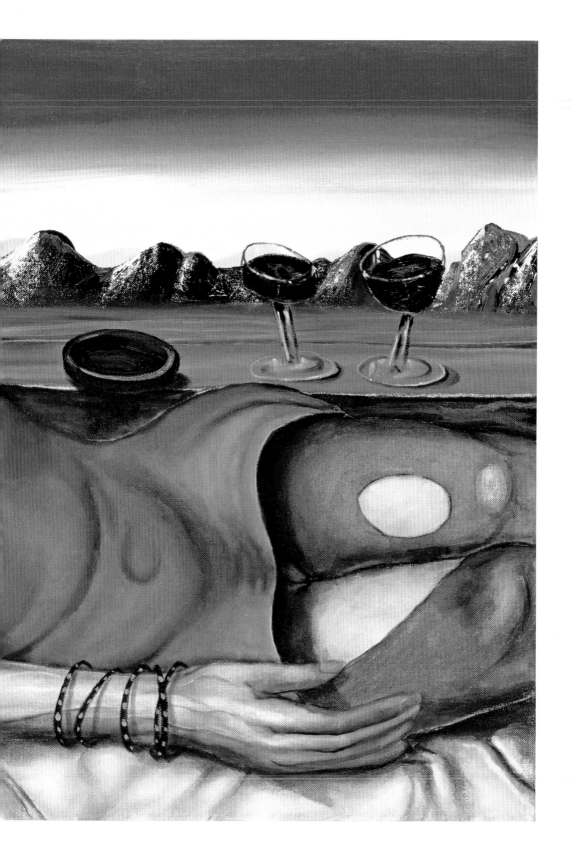

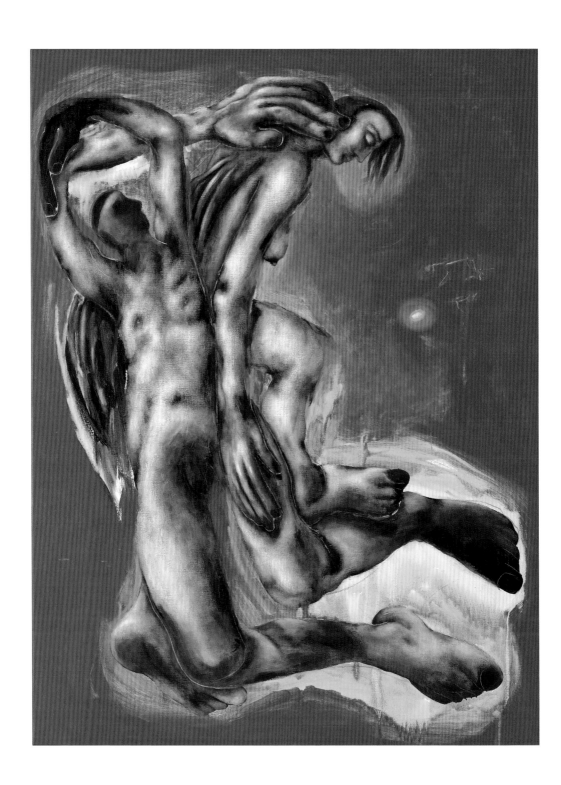

Chapter Nine

FINAL WORD

Gollon's three-month residency at Durham University's IAS presented a very different working environment for the artist; one of an extremely intellectual focus and routine that demanded a very considered, systematic approach, added to which was the specific subject matter of *Being Human*. These factors required Gollon to undertake substantial research and to work in a structured manner, the latter of which is particularly alien to him. The resulting paintings are extraordinary and provoking, they reveal the artist's evolving techniques including his use of water to create dribbling paint effects, textured paintwork and distortion of the nude taken to a new level. They are also considerably darker in subject matter and tone than his customary work. It is unsurprising that the paintings produced after Gollon finished his residency, and following his successful London exhibition based on *Being Human* are both an extension of, and a reaction to, this intense experience.

Most apparently obvious is the gradual shift in emphasis in these paintings, which start to abandon the darker notes of humanity and gods in favour of their lighter counterparts. As such, works of the second and third quarter of 2009 address the subjects of Love and of Souls, while some return to figures from classical mythology. These paintings are loosely grouped together under the title of *Gods, Angels and Souls*. One of the first in this series came about after a long conversation between Gollon and one of the Fellows over several pints in one of Durham's esteemed watering holes. The two men were discussing angels, an unusual topic for the pub, but one of relevance to both of them. Gollon has depicted angels since the mid 1990s, and they have consistently appeared in his work, almost always perceived in the same way. In his paintings they mostly exist on the peripheries, one foot in the human world and one in celestial realms from where they watch the follies of humans with an indulgent, kindly aspect, but are unwilling or unable to offer salvation in the face of adversity. The Fellow spoke of them in not entirely dissimilar terms, to him angels can suffer the same calamities as humans, such as falling in love, but they are hindered by their remoteness and unable to love as humans do. Following the conversation Gollon felt beset by angels, hearing about and seeing representations of angels, not just in his own works but in a totally random fashion: an illustration on a menu in a teashop, a film on television, the first book he picked up in a book shop and in his collection of music that he plays while painting.

Angels in Love (2009) came into being after Gollon listened to the song *Sea Breezes*[1] by Roxy Music, quite by chance when huddled back in his own unheated studio, and caught the lines, "But even angels there make the same mistakes, in love ...". The painting, which is beautifully lyrical following the preceding works, is Gollon's light-hearted version of angels suffering

Angels In Love
Acrylic on canvas
122 x 91.5 cm (48 x 36 in.)
2009
Private collection

1 From the album Roxy Music, released in 1972

their share of problems in love. Despite their woes, she truculently turns her back on him, he reaches out to her – an apology perhaps, he has over stepped the mark and been admonished – the figures remain closely linked and movingly tactile. This is a mere hiccup, in the grand scheme of love, one that is soon to be rectified. Of particular note is the great sense of movement here, which is not normally a feature of Gollon's work. The two figures appear to tumble freely through their atmosphere in a cyclic fashion that emphasises the tumultuous nature of their relationship, one marked by tiffs and passion. Gollon has continued to look at distorting the body and has increased the decorative nature of the male angel's blackened hand, but most moving is the depiction of his other huge hand that brushes his lover's diminutive face with tremendous sensitivity. The dynamics and tone of this gesture recall Gollon's *Satyr Mourning Over a Nymph* (2009), painted at Durham.

Still with Durham at the back of his mind, Gollon undertook a number of paintings of figures taken from classical mythology. The lingering influence of Durham on these works is seen primarily in the artist's methodology, since he was still reviewing subjects and then researching them before painting, while his normal working practice is far more organic and impulsive. Painterly techniques developed in the Durham works are also evident, particularly in the painting *Orpheus and Eurydice* (2009), another love story, though this one without a Hollywood ending. Greek mythology recounts how Orpheus's wife Eurydice was fatally bitten by a snake. Orpheus who was an accomplished musician played such a sad dirge that the nymphs and gods wept and urged him to travel to the underworld to use his music to persuade Hades and Persephone to allow Eurydice to return to earth. Orpheus did this and Hades and Persephone agreed to let her go on one condition, that he must walk in front of her from the underworld, and not look back until they had both reached earth. Overcome with anxiety Orpheus peeked back at Eurydice before they had both arrived on the upper world, and she instantly slipped from him back into the shadowy realms forever. Gollon has depicted Orpheus as he looks back with Eurydice already starting to fade, her face blacked out. He has used great delicacy in touch, seen here in the way Eurydice's finger curls against her husband's arm, but in this painting it is the irradiance of the background setting that captivates. Here the colourist has again risen juxtaposing the pure and crystalline blue of the landscape against a fiercely volatile golden atmosphere that pops and crackles with the fiery rays of another realm.

Humour starts to creep back into Gollon's work with *Icarus* (2009). Under Gollon's hand Icarus seems a most unlikely candidate for flight with his stout frame and solid, terrestrial trunk. In Greek mythology Icarus's father, Daedalus, crafted them both a pair of wings from wax and feathers so they could escape their imprisonment on Crete, by flying away. Icarus flew too close to the sun, which melted the wax on his wings, and he plunged to his death in what is now called the Icarian Sea. In Gollon's painting the ungainly Icarus is covered (rather humorously) in singed spots, but is rising up from the sea with sodden wings to have another go, perhaps offering a commentary on the inability of individuals to learn from their mistakes.

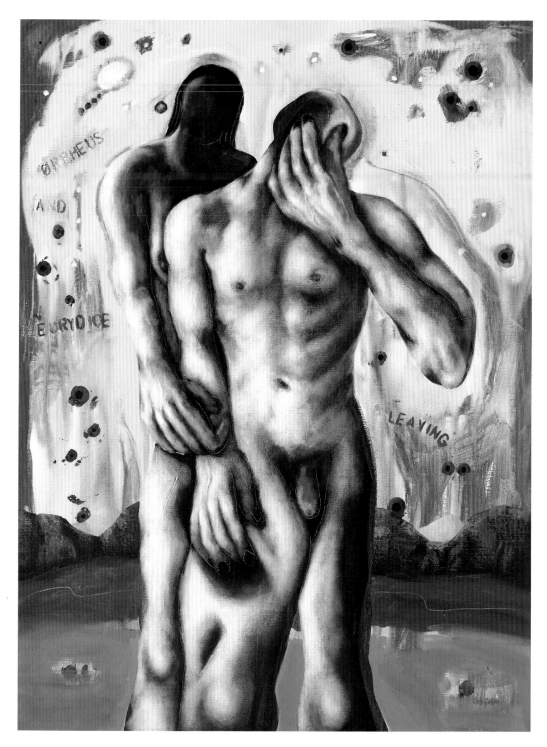

Orpheus And Eurydice
Acrylic on canvas
122 x 91.5 cm (48 x 36 in.)
2009

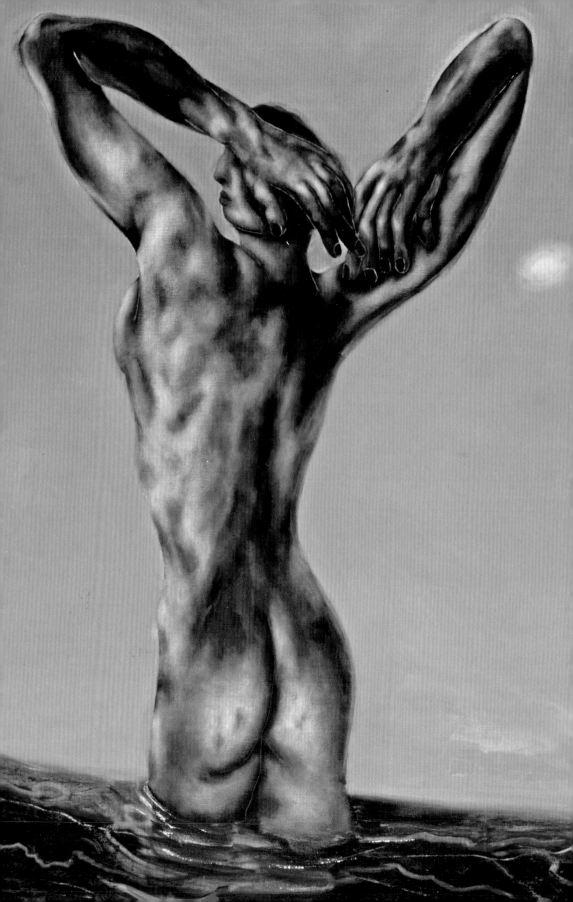

Isis
Acrylic on canvas
122 x 91.5 cm (48 x 36 in.)
2009
Private collection

Continuing with his ancient subjects Gollon next turned to Isis, a goddess from ancient Egyptian beliefs who was also widely worshipped in the Greco-Roman world as a goddess of motherhood and fertility. She features in the classical work of literature, *The Golden Ass*, by Apuleius (c. 125–c.180), a favourite of the artist, who refers to the same story in his painting *Gods, Angels and Souls* (2009), which includes a somewhat tarnished, golden ass. His depiction of the goddess in the painting *Isis* reflects earlier works such as *Mother* (2008), revealing strident, powerful women who are also disturbing. These women are ferocity crouched behind a veneer of benignity, and are caught poised on the tip of a question of their own asking: to protect, or to attack? As Gollon's Isis stretches with the easy languor of omnipotence she becomes simultaneously fascinating and frightening, the viewer cannot help but marvel at her although is loathe to have her turn and look upon them.

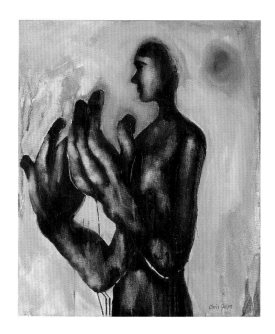

Who Gave Me These?
Acrylic on canvas
61 x 51 cm (24 x 20 in.)
2009

The depiction of hands as expressive tools often used to relay emotion in the absence of facial features has become almost a trademark of the artist, and has featured in his work since the early days. More recently he has evolved and expanded his depiction of hands to the extent that on occasion they become focal to the message of the work. It was with some relish that the artist found himself involved in a conversation with one of the professors and one of the Fellows at Durham regarding the proportions of hands. The professor stated that classical ideals of beauty defined small as beautiful, particularly in the depiction of male genitalia, since it suggested control and temperance over passion and waywardness. The argument could be convincingly applied to hands, with the supposition of large hands indicating coarseness applied to body and soul and so representing physicality, while small hands relate to the mind and control, so representing academia. At this the Fellow, a leading academic, held up her large hands before her and questioned where they had come from, since clearly they should not belong to her. For Gollon the conversation was extraordinary since his perception of hands is as an expressive extension of the soul and a pivotal emotive tool, which at times seem to work autonomously from the body such is their vivacity. Huge, distorted hands in a Gollon canvas can be exquisitely moving, beautiful and tender or violent and infinitely ridiculous or marked with humour. The conversation later inspired the painting *Who Gave Me These?* (2009) where a beautiful woman gazes in despair at her massive hands, which appear to gaze back at her somewhat forlornly.

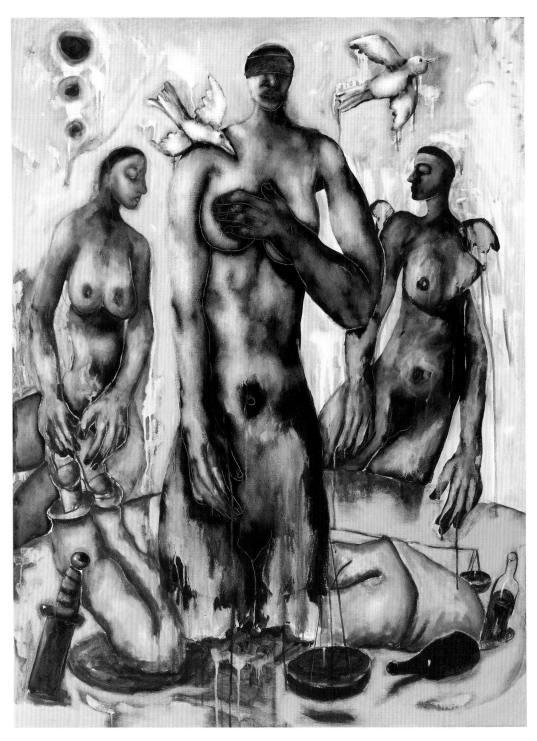

Justice II
Acrylic on canvas
122 x 91.5 cm (48 x 36 in.)
2009
Private collection

Shortly after completing this painting Gollon was approached by the producer of the BBC1 culture programme *Imagine*, presented by Alan Yentob. The team were putting together a documentary on the *Own Art* scheme, run by the Arts Council of England, which makes art more affordable. The scheme allows people to borrow up to £2,000 interest free to put towards contemporary art, to be paid back in ten monthly instalments. Gollon had been recommended for the programme by one of his collectors, the human rights lawyer Tasaddat Hussain who had used the scheme in the past to fund his large art collection including a number of Gollon's paintings. Hussain had been considering commissioning the artist to do a painting based on the subject of Justice to hang in his office, and it was decided that this commissioned work should form part of the programme with Gollon being filmed as he prepared and painted it, with Hussain using the Own Art scheme to part pay for the work. Gollon is usually cautious regarding commissioned works since he is an artist who will only paint creatively and not "to order", and energetically resists being told what he should and should not include in a work. The extent of Hussain's demands, however, lay only in the subject matter, and the artist was given total autonomy providing Justice lay at the core of the painting's theme.

Gollon's research discovered that during the Renaissance Justice was represented as female – and often blindfolded to indicate an absence of prejudice. She was often accompanied by a dove, scales, the sword of power and by another female figure who represented Benignity, who tries to temper Justice. The artist took these elements as his starting point and, unbeknownst to Hussain, actually began two paintings of the subject to allow the lawyer a choice. Both paintings combine elements of Gollon's earlier works – such as his figure with its head buried – with those of his current style, presenting a union of linear and painterly techniques. Both works also take their basic structure from Gollon's painting *The Wheel of Fortune (after Goya)* (2009), executed during his time in Durham.

Hussain, who was delighted to have a choice, eventually chose the second painting, which was also the artist's favourite. In the first painting Gollon felt his figure of Justice appears to be too much like a victim, and while this in itself might provide a stark commentary on the nature of justice in the present times, it was not the artist's intention. In the second work, Justice is omnipotent, flanked on one side by an angel and on the other by Benignity. Before her lie two sinners with their heads buried in denial, with the scales of Justice balanced precariously on the upturned bottom of one. The programme was aired in early December 2009.

Shortly afterwards Gollon received a phone call from Windsor & Newton, the UK-based manufacturers of artists' materials, who had seen a tube of their paint in Gollon's studio when it appeared on the *Imagine* programme. The company, which was founded in 1832, has had a long history of involving leading artists in their creative processes, and invited Gollon to visit their factory with a view to developing a new colour of paint. Whilst the details are still to be finalised, the artist is keen to investigate the possibility of a new infinite matt black.

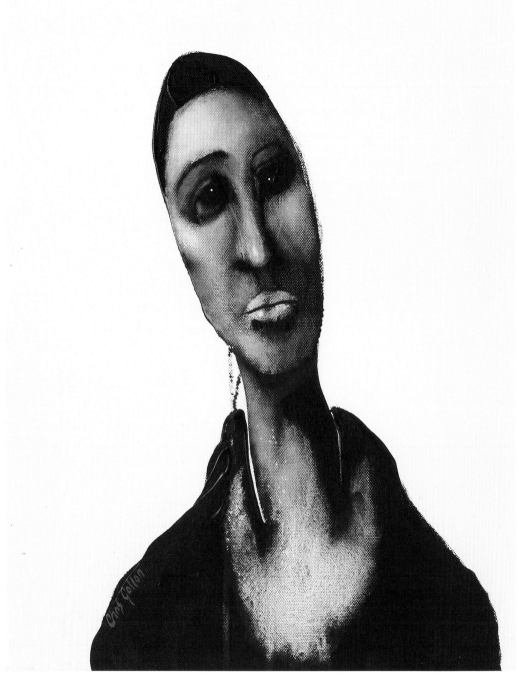

Sketch For A Woman
Acrylic on canvas
45 x 35.5 cm (17.75 x 14 in.)
2010

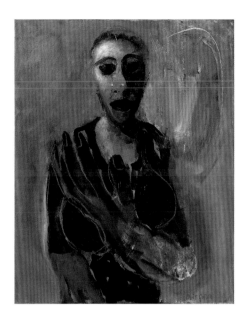

Sketch For A Sensitive Soul
Acrylic on canvas
51 x 40.5 cm (20 x 16 in.)
2010

Gollon increasingly incorporates black into his paintings, building up his paint layers to achieve a sense of depth and infinity, in a manner that faintly recalls Mark Rothko (1903–70). This is seen to startling effect in the unusual *Sketch for a Woman* (2010), undertaken entirely in black and set against a hard, white background. The choice of a one-dimensional and unforgiving backdrop is a bold one on the part of the artist, who has only ever used a white background in a handful of head studies in the past. In this particular painting it works superbly and simply emphasises the captivating quality of the female study. In characteristic fashion Gollon has managed to make a rather ordinary looking woman extraordinary: from the luminous, intelligence in her eyes achieved using a single dab of white, to the swell of her cheek bone and the slender configuration of her neck, this time created through smudging the paint using his thumb. The work combines areas of thin, sketchy paint that allows the canvas texture to show through with deep layers of black that lend it enormous substance.

Sketch for a Woman was one of a number of small figure studies the artist undertook that explore the depiction of various fragile emotions and, with the exception of *Sketch for a Woman*, are marked by a strong use of dark, rich colour. This is particularly evident in the lightly humorous and bombastic *Woman with A Nice Figure* (end of 2009), where brilliant opulent red collides with rich, earthy terracotta in a mini-drama of colour. He uses the same textured deep terracotta in *Sketch for a Sensitive Soul* (2010) and here pairs it with his infinite black, making strong use of his scratching in technique to outline the figure's voluptuous breasts and hand. A surprising detail is his inclusion of demarked fingernails, not normally present in his depiction of hands, which in this instance serve to instantly feminise the sketchily painted appendage. This painting again reflects the artist using a much more studied and condensed use of white highlights than is typical for him, seen to such effect in the *Sketch for a Woman*, and used here to bring a tear to life as it gathers speed on its downward descent.

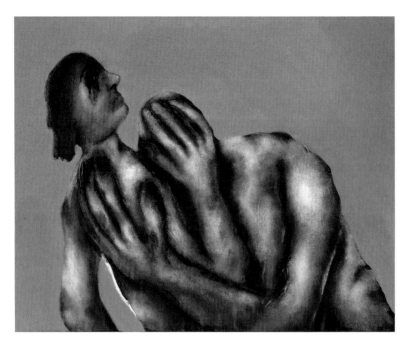

La Petite Mort
Acrylic on canvas
40.5 x 51 cm (16 x 20 in.)
2010
Private collection

One of the last paintings in this series is *La Petite Mort* (2010), "the little death", a popular French metaphor for an orgasm. Rarely are Gollon's paintings sexually explicit, or even blatantly erotic, although they are frequently seductive, and this is no exception. Even the title is clothed in decency since its French translation is infinitely more delicate and refined than the English equivalent. The painting was inspired many years previously when the artist was staying in Luxembourg. While there he met a French sculptress who took him to see her partner, also a sculptor, at work in their foundry. The artist cannot quite recall how it transpired, except that wine was involved, but before long the three new friends were discussing love – in purely academic terms. The French girl, who was not unattractive, turned to Gollon and announced that a man should approach every act of love making as if it were his last, and if he was unable to produce sufficient enthusiasm and passion then she would leave him in a heartbeat. The girl's partner smiled at Gollon knowingly and with an inclination of his head acknowledged his own skills, while Gollon returned to his hotel to reflect on his methodology. The painting produced so many years later is both touching and humorous, and rather ambiguous. It is unclear if the woman is satiated or disappointed, and is she pulling her lover towards her or, as seems more likely, pushing him away? Gollon has left it deliberately open to be read as the individual chooses.

By the time of these paintings Gollon had again established his own working methods (haphazard, random and organic) and had, in essence, moved away from the academic influence of his experience at Durham. These works are more reflective of his pre-Durham paintings although they reveal the continuing development of his style and painterly techniques; they are

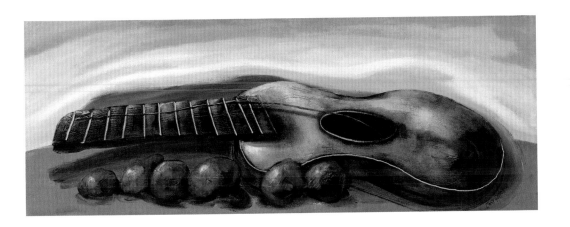

**Still Life With Guitar
And Fruit**
Acrylic on canvas
30 x 76 cm (11.75 x 30 in.)
2010
Private collection

a more genuine account of his painting. Following on from his series of figurative works he returned to still life painting, which he does habitually, sparked on this occasion by the random sighting in a book of one of his favourite paintings, Soutine's *Hen and Tomatoes* (*c*.1924). Gollon, who was already an admirer of Soutine, first saw the painting some years ago in Germany, and it is a work that the artist has found himself looking at in reproduction frequently. Most recently he was searching through his piles of books looking for a recipe when he came across the painting again, and shortly afterwards began painting *Still Life with Guitar and Fruit* (2010), the enigmatic *Still Life with Wine, Cheese and Fruit* (2010) and *A Drink to Soutine* (2010). The unifying element in these paintings is his treatment of the fruit, which becomes more painterly, richer and more expressionistic through the second work and into the third. It is the colour that is paramount, a colour with its foundation in Soutine's work, which reaches an apogeal climax in the third still life, *A Drink to Soutine*. This painting is in every sense the artist's finest still life to date. It is indeed a rare thing when a still life can assume such importance and bring together with perfect balance line, colour, depth, feel and in this case, atmosphere. The colour is quite extraordinary, exquisite in every sense, making this in aesthetic (rather than conceptual) terms one of the artist's most successful works. A further inspiration for it was a conversation that Gollon, who is an accomplished cook, had with leading chef Bjorn van der Horst regarding the colour and history of food. The presentation and colouring in food is of great importance, and over the years Gollon has referenced his own dishes and images in cookery books for ideas when approaching his still life paintings. Van der Horst is known for his inventive recipes and the strong emphasis he places on the aesthetics of his dishes; unsurprisingly he is also an enthusiastic art collector and owns a number of Gollon's paintings including the still life/landscape combination, *Tortilla Flat (homage to Steinbeck)* (2007). The two men spent a fruitful afternoon inspired by fine wine and an excellent lunch, discussing the importance of colour in their relative arts, as well as the work of John Steinbeck, a favourite author of both the chef and the artist.

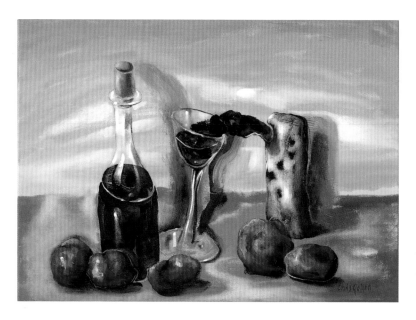

Still Life With Wine, Cheese
And Fruit
Acrylic on canvas
40.5 x 56 cm (16 x 22 in.)
2010
Private collection

Over the past couple of decades Gollon's art has evolved, shifted,
developed and changed in a very organic manner, while keeping at its
foundation a basic respect for humanity. From inauspicious beginnings
and against a barrage of knock backs, he can now be considered one of the
most innovative and genuinely creative artists of his time, who pairs an
extraordinary talent for linearity together with a phenomenal understanding
of colour and painterly techniques. Gollon's art is not always easy, it is
rarely pretty and never facile. It is primarily art of substance, particularly
his figurative work, that raises questions and is most appreciated by those
willing to think, and also to laugh. He has the rare ability of being able to
address infinitely difficult emotional topics but balances his depictions with
subtle and often ironic humour. Gollon does not laugh at us, but with us,
and it is this fundamental empathy for the human condition, paralleled
by an understanding of it, that benchmarks his work. His most significant
contributions to contemporary art have been through his experiments with
figurative work and his re-interpretation of religious painting. To date his
religious paintings have been used in reproduction across Europe, North
America, Australia and even Sri Lanka, and in October 2010 he will be
exhibiting at Wallspace, London, in an exhibition dedicated to a survey of
public religious works of the last twenty-five years, alongside Antony Gormley
(b. 1950), Henry Moore, Tracey Emin and others.

Gollon is an artist who is quietly shaping the future of contemporary art; he
is a painter first and foremost, and one of extraordinary technical skill who
is bringing art back to its painterly foundations and moving it forward with
weighty concepts and big ideas.

A Drink To Soutine
Acrylic on canvas
50 x 61 cm (19.75 x 24 in.)
2010
Private collection

CURRICULUM VITAE

Solo exhibitions

2010 *Gods, Angels & Souls*, IAP Fine Art, London
2009 *Being Human*, IAP Fine Art, London
 Studies for Stations of the Cross, IAP Fine Art, London
2008 *Early Thoughts*, IAP Fine Art, London
 Gollon At Henley, River & Rowing Museum, Henley-on-Thames
 Kaleidomorphism One, East London Film Festival
2007 *Basement Tapes*, IAP Fine Art, London
 Chris Gollon: Recent Paintings, Institute of Advanced Study, Durham University
 A Reflection on Still Life, IAP Fine Art, London
2006 *House of Sleep*, Thompson's Gallery, London
2006 *Is That All There Is?*, Toni Heath Gallery, London
2005 *Einstein & The Jealous Monk*, Huddersfield Art Gallery, W. Yorkshire, exhibition and unveiling of acquisition in permanent collection
2005 Domogallery, New Jersey, USA (opened by Sir Phillip Thomas, British Consul General, NY)
2004 IAP Fine Art, Cork St, London (2 solo exhibitions)
2002 IAP Fine Art, Island Gallery, Hampton-on-Thames, London
2001 IAP Fine Art @ Arndean Gallery, Cork St, London
2001 River & Rowing Museum, Henley-on-Thames
2000 *Fool's Paradise: The Return*, Huddersfield Art Gallery, W. Yorks
1999 IAP Fine Art, London
 Gallery K, London
1997 Galerie Simoncini, Luxembourg (opened by Princess Sibilla and the British Ambassador)
1996 *Road to Narragonia*, Lamont Gallery, London
1995 Galerie Christiane Cloots, Brussels (opened by the British Ambassador)
1994 Bretton Hall, West Yorkshire
1993 Ferens Museum Gallery (Fine Art Gallery of the Year 1993)

The Seer (Detail)
Mixed media on panel
122 x 61 cm (48 x 24 in.)
1997
Private collection

Group exhibitions

2009 *Lost Heritage*, Gallery K, London, Cyprus, Athens
2008 Newcastle & Gateshead Art Fair, Sage Centre, (IAP Fine Art)
Thompson's Gallery, London W1
2007 *Sense & Sensuality*, Bankside Gallery, London and then Richard Attenborough Centre,
University of Leicester
Toni Heath, London
Thompson's Gallery, London
Cambridge Art Fair, (IAP Fine Art)
2006 *ANON*, mixed exhibition at London Art Fair with Mario Testino, Tracey Emin, Julian Opie, Paula Rego
2005 New Jersey Center for Visual Arts, USA
2005 Manchester Art Show, MICC G-Mex Centre, (IAP Fine Art)
2004 *Presence: Images of Christ for the Third Millennium*, St Paul's Cathedral, London
2002 Art on Paper Fair, Royal College, (IAP Fine Art)
The Kiss, Gallery K
2001 Sotheby's, London, mixed exhibition with Sam Taylor Wood, Maggi Hambling, Martin Maloney,
Elizabeth Blackadder, Eileen Cooper & others.
The Kiss, Gallery K
1999 ART'99
IAP Fine Art, London
Maternity, Gallery K, London
1998 Connaught Brown, London
Glasgow Art Fair
ROOT, Chisenhale Gallery, London
1997 ART'97, Chicago
ART'97, London, *Shadow of Life* exhibition with Maggi Hambling, Peter Howson,
Richard Wentworth curating chaired by Dr Judith Collins, Asst Keeper of the Modern Collection,
Tate Gallery
Air Gallery, London
Barbican, London
1996 ART'96, London, (Lamont Gallery)
Glasgow Art Fair (Glasgow Print Studio)
1994 *The Kiss*, Gallery K
1989 Spink & Son, London

Public collections

River & Rowing Museum, Henley-on-Thames (purchased with the aid of the
Victoria & Albert Museum, London)
Huddersfield Art Gallery, W. Yorkshire
Institute of Advanced Study, Durham University
University of Hull
Church of England (14 *Stations of the Cross*, Church of St John on Bethnal Green,
a grade-one listed church in London, designed by Sir John Soane)
St Mary's College, Durham University

Bibliography – Media

2009 *Imagine* BBC1 television programme following Chris Gollon through a commission
Stations of the Cross by Sara Maitland (Continuum, London & New York)
Being Human, paintings by Chris Gollon (Durham University) with texts on Gollon's work by Fellows of
the Institute of Advanced Study and art historian Tamsin Pickeral
Being Human, (Talentbox Productions, London) film by Achim Jedelsky & Martin Koddenberg
Lost Heritage catalogue (Gallery K)

2008 *The Dog: 5,000 Years of the Dog in Art* by Tamsin Pickeral (Merrell, London & New York)
Kaleidomorphism One, film by Chris Gollon & JABOD premiered at East End Film Festival

2004 *Presence: Images of Christ for the Third Millennium* catalogue

2001 *Chris Gollon: New Images* catalogue (IAP Fine Art)

1999 *Maternity* catalogue (Gallery K)

1997 *Road to Narragonia* catalogue (IAP Fine Art)

Selected reviews

2009–2010
Messenger of St Anthony magazine
BBC1 *London TV News*
BBC Radio 4 *Sunday Programme*
Aesthetica magazine
Artists & Illustrators magazine
Art of England magazine
The Tablet
Church Times
Catholic Herald
Common Ground

2008 *The Times*
Financial Times
BBC Radio 4
The Today Programme
The Guardian
USA Today
Galleries magazine

2004 *Galleries* magazine
Daily Telegraph
The Guardian
The Tablet
Art & Architecture magazine

2003 *The Week*
The Times

2002 *The Times Magazine*
The Evening Standard
Galleries magazine
The Guardian

2001 *ITV London Tonight*
The Times

2000 *Sunday Times*
Sunday Telegraph

1999 *Sunday Times Magazine*

1998 *SKY News*
The Scotsman
What's On

1997 *Flash Art*
MAG: Museums & Galleries Guide
Harpers & Queen

1996 BBC1 TV
The Big Issue
Galleries magazine
ART Review
BBC World Service
Time Out

1995 *L'Echo*
Tele Bruxelles
RTBF
Radio Bruxelles Capitale

1994 BBC1 TV & Radio
The Independent
BBC Radio North

Kaleidomorphism One (video still)
Blu ray film installation (18 mins), which
is only for gallery or museum display.
Also in a limited edition of 100 dvds, each
signed by Chris Gollon
© Chris Gollon & JABOD 2008.

INDEX

Photograph of Chris Gollon's painting *Jesus is Laid in the Sepulchre*, Station XIV, in situ in the Church of St John on Bethnal Green. (Courtesy of Guy Lockwood, 2009)